W9-AMP-047

CHICAGO BEARS

JAN -- ▚▚

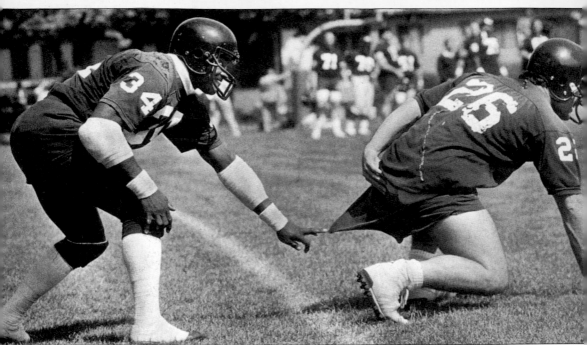

The Chicago Bears and the city of Chicago collectively were in a good mood during the 1985 training camp, as they were about to take the world by storm. Here Hall of Fame running back Walter Payton plays one of his trademark practical jokes on best friend and backfield mate Matt Suhey. Photographer Jim Maentanis happened to be there to preserve this moment that eternalizes the spirit of Payton. Payton and Suhey formed a halfback-fullback combo from 1980 to 1987, when Payton retired. Both were punishing runners and blockers, and great receivers in Mike Ditka's offense that utilized both positions heavily. The two remained close friends until Payton tragically succumbed to a liver disease in 1999. Payton and Suhey's story is tragically similar to that of Gale Sayers and Brian Piccolo, two Bear running backs of an earlier era. (Photo courtesy Jim Maentanis.)

On the Cover: Background and back cover photos courtesy Bob Baer, Brian Urlacher photo courtesy Mike Proebsting.

CHICAGO BEARS
HISTORY

Roy Taylor

ARCADIA

First Printed 2004.
Reprinted 2004.

Published by Arcadia Publishing
Charleston SC, Chicago IL, Portsmouth NH, San Francisco CA

Printed in Great Britain

Library of Congress Catalog Card Number: 200407706

For all general information contact Arcadia Publishing at:
Telephone 843-853-2070
Fax 843-853-0044
E-mail sales@arcadiapublishing.com
For customer service and orders:
Toll-Free 1-888-313-2665

Visit us on the internet at http://www.arcadiapublishing.com

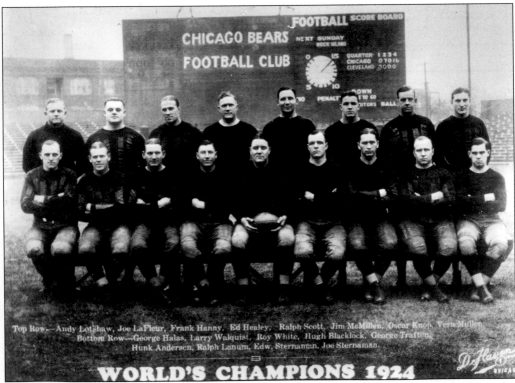

The 1924 Bears pose in front of the Cubs Park scoreboard. This interesting photo proclaims the Bears "World Champions." Four NFL teams claimed the league championship that year, but it was eventually awarded to the Cleveland Bulldogs. (Author's collection.)

CONTENTS

ACKNOWLEDGMENTS

I am very fortunate and blessed, as I have been able to follow practically every week of Bears football for the past 26 years as a fan and budding journalist. Although I've followed the team closely, this book would not have been possible without the assistance of many fine people and resources. I'd first like to thank Jeff Reutsche and Arcadia Publishing for giving me this opportunity to realize a dream. It's been a pleasure working with a fellow Bears fan.

I'd certainly like to thank my partners who contributed their great photography to this book. Bob Baer's (www.sportsartbybob.com) images from 1985 to 1995 have been featured, and I thank him greatly for his contribution. Other photographers who contributed to the book are Keith Schuth (www.caasportsmarketing.com), Todd Buchanan (www.toddbuchanan.com), and Mike Proebsting (www.walloffamephotos.com).

Jim Maentanis contributed his classic shot of Walter Payton which immortalizes the spirit of the late running back (see page 2). For more information on organ donor awareness, and to find out how to get your own copy of the photo, contact Jim at jimmaentanis@earthlink.net.

Ed Sprinkle, Ronnie Bull, Doug Buffone, Al Baisi, and Cathy Core shared their personal Bears stories with me, and I appreciate it.

Many written resources were helpful. These included Richard Wittingham's *The Chicago Bears, an Illustrated History*; George Halas' *Halas by Halas*, with Gwen Morgan and Arthur Veysey; *Cooper Rollow's Bears Football Book*; Gary D'Amato and Cliff Christl's *Mudbaths and Bloodbaths*; John Mullin's *Tales From the Chicago Bears Sidelines*; Kevin Lamb's *Portrait of Victory*; and *Total Football II, the Official Encyclopedia of the NFL* by Bob Carroll. Also helpful were Armen Keteyian's *Monster of the Midway*; Jeannie Morris' timeless *Brian Piccolo, a Short Season*; and *Monster of the Midway* by Jim Dent.

Chicago Bears media guides, my personal library of issues of the *Bear Report* dating from 1980 to 2001, archives of the *Chicago Tribune*, and issues of what used to be the Bears newsletter, *Bear News*, also helped. Thanks and acknowledgements also go to NFL Films and their amazing chronicles of many eras of Bears history. Various specials and interviews from ESPN and WTTW Chicago were also utilized.

And, of course, I'd like to thank my family. Thanks to my father, for taking me to my first Bears game when I was eight years old, stoking the first flames of my passion. To my parents collectively, for raising me to pursue my dreams. To my wife, for losing her husband for countless hours as I do this. And to my son, may you have dreams to pursue yourself one day— as long as they don't involve the Green Bay Packers.

INTRODUCTION

In September 2004, the Chicago Bears Football Club will play their 85th season of professional football. Considered by many to be the most venerable franchise in the National Football League, the team was first organized as a humble sports club for a grain company in Decatur, Illinois, and now plays in the NFL's most modern stadium in the third largest city in the nation.

George Stanley Halas, raised in Chicago and educated at the University of Illinois at Urbana-Champaign, jumped at the opportunity to coach the A.E. Staley Company's football and baseball teams in 1920. After a year in Decatur, Staley offered to keep the franchise afloat for one more season if Halas would move it to Chicago, where such a business model might be sustainable.

That previous year, in 1920, Halas had suggested to other semi-professional team owners that a league be formed to ease the burdens of scheduling. Representatives of twelve teams congregated at Ralph Hay's Hupmobile auto agency in Canton, Ohio, and in a matter of hours they created the American Professional Football Association.

The cost to each of the twelve franchises to join the new league was $100. While the true value of an NFL franchise today is difficult to estimate, it is guessed that the Chicago Bears would fetch upwards of $1 billion for the descendents of Halas, were they to decide to sell the team today.

Between this inauspicious beginning and the current NFL climate of multi-million dollar signing bonuses, the Chicago Bears fielded some of the most colorful characters the sporting world has ever seen . . . generating the one-of-a-kind stories which revolve around this cast of legendary athletes.

This book celebrates eighty-five seasons of a unique football family. From the league's creation, to the seven world championships won in their first 27 seasons; from a "barnstorming" tour across the country to solidify professional football's place in our culture, to the rough-and-tumble Bears teams of the 1950s; from championships in 1963 and 1985, to unforgettable legends such as Brian Piccolo and Walter Payton. The Chicago Bears have been an enduring icon of American culture, not just a football team. The entire world watched as the group cut a record and music video in 1985, and the nation laughed as Bear fans were parodied on Saturday Night Live during the team's glory days in the 1990s.

An old adage has it that Chicago is a "Bears town." The Bulls may have won six championships in the 1990s, and legions of bleacher bums may love to visit Wrigley Field, but there is nothing like a Sunday of football in the fall at Soldier Field. *Chicago Bears History* celebrates the exciting, disappointing, heartwarming, and heartbreaking stories from 85 years of Chicago Bears football.

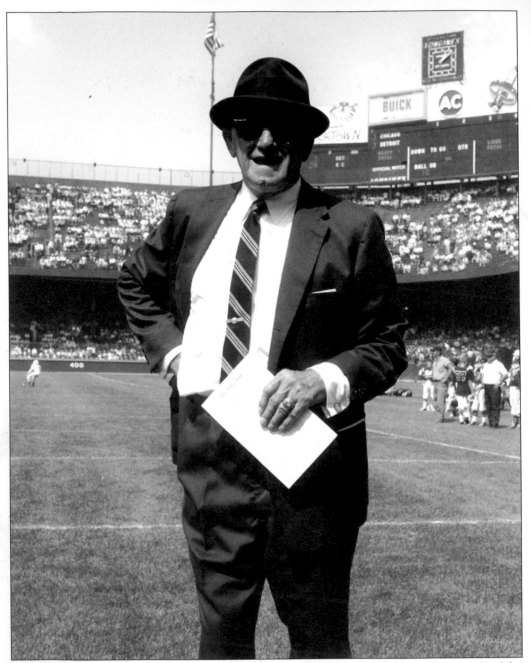

George "Papa Bear" Halas, a founding father the National Football League and patriarch of the Chicago Bears, poses before a game at Detroit's Tiger Stadium. Halas was involved with the Bears in one capacity or another from 1920 until his death in 1983, and to this day the team wears his initials—GSH—emblazoned on its uniform. (Author's collection.)

ONE

The Early Chicago Bears
1920–1946

223-76-33 Record
Seven World Championships

The early history of the game of American football is sketchy, at best. It is generally agreed that the game known as "American football" has its origins with collegians in the 19th century. Many college students began playing a game derived from "English football" (rugby) and soccer (known as football throughout the rest of the world).

Walter Camp is generally known as the father of American football. Camp was Yale University's first football coach, and served in that role from 1876 to 1910. He organized the sport, standardized many of its rules, and edited the football rulebook until his death in 1925. American football was played regularly in the late 19th century, but remained a largely collegiate sport through the early 1900s. After 1910, many local football "clubs" began to organize, often times sponsored by corporations or municipalities.

George Halas: Founder of the National Football League

George Stanley Halas was born on February 2, 1895, to a family of Bohemian immigrants in Chicago. Halas grew up in the city, learning a rigorous work ethic from his family. While working hard at school and in various family businesses, he also developed a love for any sport in which he could participate. He would go on to study engineering at the University of Illinois in Champaign, join the Tau Kappa Epsilon fraternity, and play on Illinois' great football teams, coached by the legendary Robert Zuppke.

Halas heard the words he would never forget from Zuppke at the team's awards banquet following his freshman year: "Just when I teach you fellows how to play football, you graduate and I lose you." According to Halas, these words would govern his actions over the next several decades.

In January 1918, Halas was six credit hours away from gaining a degree from Illinois, but decided that he "needed to serve the country that had been so good to the Halas family." He enlisted at the Great Lakes Naval Training Station to fight in the first World War, and asked to be assigned to a submarine chaser in the Atlantic Ocean. Illinois decided to forgive Halas' remaining six hours and mailed his degree to him in June.

Instead of sending him to sea as he wished, the Navy assigned Halas to the sports program at Great Lakes. While enrolled in officer's training school, Halas joined the center's basketball, baseball, and football teams, and soon he, Paddy Driscoll (Northwestern), and Charlie Bachman (Michigan State) were coaching the football team.

The three former collegiate stars organized games between Great Lakes and some of the nation's college football powerhouses—Illinois, Notre Dame, Purdue, Iowa, and Rutgers among them. After dominating the collegiate schedule that fall, Halas' team was invited to play in the Tournament of Roses New Year's Day game, the only time armed services teams were ever invited. On January 1, 1919, the Great Lakes team defeated their opponents, Mare Island (another Naval team), 17-0 in front of 27,000 fans. Halas was named most valuable player of that game, and his name began to grow on a national level.

The naval ensign was discharged from service in March 1919, and returned home to his mother in Chicago. Halas vowed that if America ever found itself in a war again, he would make "a more military contribution." Having read stories of the Rose Bowl win in the local newspapers, Mrs. Halas became concerned that her son would be hurt in this violent game. The younger Halas therefore assured his mother that he was through with football and would instead devote his sports passions to the game of baseball.

Baseball did indeed turn out to be Halas' next pursuit and, ironically, it caused his most debilitating injury. When Halas was a junior at Illinois, New York Yankee scout Bob Connery had asked him to try out at their spring training camp in Jacksonville, Florida. Halas did not agree, telling Connery he wanted to wait until he finished college. But after his stint in the Navy, he decided to give this new career a try. Halas played outfield at spring training and impressed Yankees manager Miller Huggins with his speed and arm strength. Huggins responded by awarding him a spot on the roster at $400 per month, a princely sum at the time. Just prior to signing, however, Halas had injured his hip sliding into third base, an injury that would plague his baseball career on an ongoing basis.

While playing with the Yankees against the Detroit Tigers, Halas learned another lesson that would remain with him throughout his years. New York's pitcher and catcher egged Halas on to taunt one of his idols, Ty Cobb, while he was batting. Cobb promptly asked Halas to meet him after the game outside the stadium, and Halas brashly accepted. The rookie then took his time exiting the locker room, hoping Cobb would not make good on his promise. Alone, Cobb did indeed meet Halas outside the stadium, and simply said "I like your spirit, kid, but don't overdo it when you don't have to." The veteran would later advise Halas to "direct your energy positively, don't waste energy being negative." Halas later remarked, "I should have changed my ways, but no, it was not the last time I made a chump of myself." Perhaps several veteran NFL officials would agree.

Halas continued to battle his hip injury while playing for the Yankees, and when at bat had a hard time hitting curveballs. After a miserable game played in Chicago, New York sent him to their minor league affiliate in St. Paul, Minnesota. Upon his demotion, a young player named Babe Ruth would take his place in the outfield.

Despite improving his game in Minnesota, with the entrenchment of Ruth in the Yankees' lineup Halas decided to forego a baseball career after the 1919 season. Thinking about a more practical life, he returned to Chicago and secured an engineering job, building bridges with the Chicago, Burlington and Quincy railroad.

Always known as an honest man with integrity, Halas could not keep the promise to his mother, his commitment that he was done with football. In his words, he "ached for the excitement of a good game, for the competition, for the challenge to the muscles, for the joy of victory." The new railroad engineer traveled to play for a semi-professional football team in Hammond, Indiana in his free time. This team played many games in the fall of 1919, one of them against the Canton Bulldogs, featuring legendary athlete Jim Thorpe and owned and managed by Ralph Hay.

While the season playing semi-professional ball "deepened his love for football," Halas was beginning to accept the fact that his future might lie in railroad engineering. That was, however, before the biggest break of his life came along.

Halas received a phone call in March 1920 from George Chamberlain of the A.E. Staley Company, which was located in Decatur, Illinois. The previous year, the Staley Company had formed a semi-professional football club that had fared well against the local competition, but the owner now wanted to develop it into a unit that could compete with the best semi-pro teams in the nation. This effort would garner publicity for his business and improve employee morale. Chamberlain asked Halas if he would take a starch-making job on staff with the Staley Company, at the same time coaching football, playing on their baseball team, and creating a basketball team. Halas leapt at the offer, after learning that he could recruit the best players and practice on company time.

On March 20, 1920, in Halas' words, he "ceased to be a railroadman" and embarked on a

journey that would lead not just to Decatur, Illinois, but also to the transformation of Sunday afternoons in America.

The American Professional Football Association: 1920–1924

Halas relocated to Decatur, 170 miles southwest of Chicago, and began weighing shipments of corn as they arrived at the Staley plant. After examining the company's sports facilities, which included a baseball field (the pitcher's mound would need to be leveled), grandstands, and locker rooms, Halas set about creating his 1920 Decatur Staley football roster.

The previous season, the Staley team had signed six collegians who played under assumed names. This had long been a covert semi-pro practice and would remain so. Decatur's main rival, nearby Taylorville, had commonly employed the services of Ohio State football players and this was well known, despite those players attempts to mask their identities by covering their faces with tape.

In what Halas called "the first professional football recruiting trip," he set off in August in search of players. On this trip, he signed Edward "Dutch" Sternaman, a former Illinois player, and other collegiate football alumni. He also ended up keeping three of the 1919 Staleys. All told, he assembled a roster of eighteen men to play football in 1920. One player he could not recruit was his teammate Paddy Driscoll from Great Lakes. Driscoll had already signed with the semi-pro Chicago Cardinals (then called the Racine Cardinals after a Chicago street name).

Halas worked through the rest of the summer of 1920 designing his playbook, and searched for a better solution for scheduling games. Until that time, games had been scheduled in a haphazard manner, and teams and players often ceased to exist in their original roles by the end of the season. Frequently, requests in writing to schedule games with other teams were not answered. To solve these problems, Halas wrote to Canton Bulldog manager Hay, and proposed that representatives of several semi-professional teams meet to create a professional football league. Hay discussed this proposal with other organizations, and was appointed temporary chairman of the effort. A meeting between all teams was scheduled for September 17, 1920. This became the day to which the birth of today's National Football League can be traced.

Halas traveled that September to Canton with Morgan O'Brien, a Staley administrator. The meeting was held at Hay's Hupmobile showroom, where representatives gathered on the running boards of the automobiles, for lack of better arrangements. In addition to Decatur and Canton, cities represented by teams that joined the meeting included Cleveland, Dayton, Akron, and Massillon, Ohio; Rochester, New York; Rock Island and Chicago (Cardinals), Illinois; Muncie and Hammond, Indiana; and Racine, Wisconsin.

In a short amount of time, the American Professional Football Association (renamed the National Football League in 1922) was born. Franchisees were charged an entrance fee of $100 each. Membership in this league would prove to be very fluid in its early years, as Massillon would quickly cease to exist. Teams from Buffalo, New York; Detroit, Michigan; and Columbus, Ohio, as well as another Chicago franchise (the Tigers) would soon join.

Halas and O'Brien returned to Decatur, and on October 3, 1920, played their first game as the Decatur Staleys in the American Professional Football Association. Halas and Sternaman served as both players and coaches. Interestingly, although the owners felt a structured league was a requirement to operate, many games in the early years would be played against non-league teams. For example, in 1920 the Staleys played teams from Moline, Kewanee, and Rockford, Illinois and Minneapolis, Minnesota, as well as the APFA teams from Rock Island, Chicago, and Hammond.

The Staleys finished the 1920 season with a record of 10-1-2, losing only to the Chicago Cardinals in a game played in Normal Park on Chicago's south side. The most notable game during that season was Decatur's matchup at Rock Island on November 7. Halas' crew had beaten the Independents several weeks previous, and bad blood between the locals and the Staleys remained. Rock Island locals had been boasting that their team would do their utmost to ensure that Bear star George Trafton would be knocked from the game. They even went so far as to say that Rock Island's star running back Fred Chicken would do the damage. Instead, Chicken ended up being injured by Trafton, and left the game to receive nineteen stitches. The

contest finished in a 0-0 tie, and on the final play Halas designed a play that had Trafton running the ball. Trafton stayed on his feet, and as time expired he continued to run to the exit, not stopping until a motorist transported him across a bridge to the Staleys' hotel in Davenport, Iowa. Halas had given Decatur's share of the gate receipts ($3,000) to Trafton to hold until they reached their train. In doing this, Halas reasoned that were Trafton chased by angry Rock Island fans, he would run for his life better.

Decatur met Akron for the unofficial first championship game of the APFA, and the contest finished in a scoreless tie, so no official champion was listed in the first year of this disorganized league.

The 1920 season was successful both on and off the gridiron for members of the team, and each player received $1,900 for their efforts. However, the following year, 1921, would not prove to be a good year for the American economy. For this reason, A.E. Staley called Halas to his office and told him his company could not continue to finance the athletic endeavors. He proposed that Halas should take the team to Chicago to continue to play in the league. Staley offered to give Halas $5,000 in seed money if he would keep the Staley name for one year and promote his company in the media and in game programs. Halas was thrilled at the opportunity, and made Sternaman his fifty-fifty partner.

The new co-owner's first order of business in Chicago was the task of finding a place to play. Halas approached William Veeck, owner of the Chicago Cubs, and inquired about the possibility of his Chicago Staleys playing football at Cubs Park (later named Wrigley Field). Seeing that the stadium sat unused outside of baseball season, Veeck consented, proposing the Staley club pay him 15 percent of gate receipts for each game. The percentage would escalate to 20 percent when receipts equaled $10,000. Halas agreed, as long as his club could keep the proceeds from the sale of game day programs. Veeck would agree only if he kept the concessions money. The deal was struck, and remained in place until the Bears left Wrigley Field—the site to this day of more NFL games than any other stadium—after the 1970 season.

Halas and Sternaman set up official team headquarters at the Blackwood Hotel on Clarendon Avenue in Chicago, just down the street from Cubs Park. The 1921 Staley season began on October 10, with a 14-10 victory over the rival Rock Island Independents. Halas and Sternaman's club waltzed through the eleven-game season with a 9-1-1 record and were named league champions. This season is recognized as the Chicago Bears' first world championship.

A 1921 development of note was that the Green Bay Packers, an independent football team in existence since 1919, joined the APFA. They had played the two previous seasons as a club team, affiliated with the Indian Meat Packing Company in that Wisconsin city. After the 1921 season, APFA president Joe Carr fined them $50 for using college players, which was against league rules. Packer manager Curly Lambeau paid the fine and promised to adhere to league guidelines. The following year, the Packers were almost forced to fold due to poor economic conditions. In response, the city of Green Bay formed a non-profit corporation that would own the team, an arrangement that still exists.

Back in Chicago, the Staley owners were elated to have paid all the bills for the season with seven dollars remaining after expenses. Since their obligation to A.E. Staley had been satisfied, Halas and Sternaman wanted to settle on a new name for their team. After first considering naming the team the Chicago Cubs in honor of the assistance they had received from Veeck, they decided that because football players are bigger than their baseball counterparts, surely their team should be named the Bears. The Chicago Bears Football Club was officially incorporated on May 2, 1922.

During the 1922 season, Halas made the first player "trade" by acquiring tackle Ed Healey from Rock Island. No players were dealt to the Independents; Halas simply purchased his contract for $100. Halas called Healey the most versatile tackle in the history of the game, and he remained with the Bears for the duration of his career. Healy was elected to the Pro Football Hall of Fame in 1964.

The Chicago Bears finished the 1922 season with a 9-3 record, and in 1923 their record was

9-2-1. The 1923 season might not have been memorable if not for a play by Halas against Jim Thorpe's all-Native American team from LaRue, Ohio. On a muddy field in Chicago, Halas returned a Thorpe fumble 98 yards for a score, a play that would stand until 1972 as the longest return of a fumble in league history.

In 1924, the Bears finished 6-1-4, losing in the final standings to the Cleveland Bulldogs. More importantly, gate receipts from fans watching Bears games in Chicago exceeded $100,000 for the first time. During the early years, Halas "had to rob Peter to pay Paul," in the words of Hall of Fame player and coach Mike Ditka. Halas secured many loans to ensure his franchise would make it through to the following year, which it always did. In fact, Halas even rejected an offer from an outsider to purchase his team for $35,000 after the 1922 season.

In its first five years, the Chicago Bears had changed names and cities and morphed from an athletic club on a $1,000 budget to a professional sports team earning a six-figure income from paid attendance. The American Professional Football Association was created, and became the National Football League two years later. The American public, lovers of the sport of college football, were beginning to embrace professional football for the first time. The future looked bright for Halas, his Bears, and the NFL, but the dichotomy between "amateur" and "professional" players would first grow larger.

A Legend and a Sport are Born: 1925

Despite the gains professional football and the Chicago Bears had made over their first five years, in 1925 football was still a questionable proposition at the professional level. College stadiums sold out handily, with capacity crowds in the tens of thousands, while in Chicago the pro teams were lucky to sell 6,000 seats for any given game.

Despite this, the Roaring Twenties were in full swing, and by and large the economy was prospering. Average Americans yearned for entertainment, and movie houses were one of the most popular destinations to this end. Sandwiched between movies, newsreels in theaters often showed clips of college football exploits from the previous weeks. Featured throughout the nation was college football's most exciting player, Harold "Red" Grange from the University of Illinois. The Wheaton, Illinois native, who spent his summer toting ice to customer's homes, played running back for the Fighting Illini, and was entering his senior season there in 1925.

In November 1924, Halas, his business associate Ralph Brizzolara, and their wives took a car trip to watch Grange play. By the end of the game, of which Halas could not remember the outcome, he was determined to coax Grange to play for the Bears. In October 1925, Halas became acquainted with a Chicago theater owner, Frank Zambrino. Zambrino had a friend in Champaign named C.C. Pyle who owned a theater house, and Pyle was thinking of approaching Grange with the idea of becoming the collegian's manager. Pyle proposed that if he were able to persuade Grange to go along with his wishes, Grange would join the Bears, and the team would conduct a nationwide "tour" to promote the game of professional football. Halas was intrigued.

In November, when the running back was attending a movie, Pyle asked Grange to come to his office. He promised the "Wheaton Iceman"—or "Galloping Ghost," as he was known for "disappearing" towards the goal line—that he would make $100,000 if he joined the Bears and played during the proposed tour. Grange had never thought of playing professional football, but agreed to keep the prospect in mind. Pyle's cut of the deal was 40 percent.

Soon Halas and Sternaman met Pyle at the Morrison Hotel in Chicago to discuss the matter in secrecy. Halas declared immediately that he would like Grange to join the Bears for the final two games of the 1925 season. Pyle's vision was to embark on a tour of the east and southeast United States following the season, bringing the game to the masses who yearned to see the Galloping Ghost. After two days of intense negotiations the deal was struck. The Bears agreed to split any profits from the tour equally with Pyle and Grange.

Prior to Grange's final collegiate game against Ohio State, word had spread that he had signed a contract to play for the Bears. All parties denied it, but the college sporting community called for Grange's ouster from the Illinois team if he indeed was turning professional. Illinois' athletic

director refused. Following the game in Columbus, Grange caught a train to Chicago, where he signed a contract with Halas and Sternaman. Two other professional teams, New York and Rochester, had gone to Chicago to lure Grange for themselves, but knew they were too late when they looked out the window and saw the press conference announcing the Bears' signing.

The following week, the Bears sold 36,000 tickets for their Thanksgiving Day game versus the Cardinals, but Grange's play was not outstanding. This was due to the punting of Paddy Driscoll, the same player with whom Halas had competed in the Navy. Halas coveted Driscoll for his own team, but up to that point had been unable to wrest him away from the Bears' cross-town rivals.

The next week, Grange rushed for 140 yards against the Columbus Tigers, and a professional football legend was born.

Two days after the regular season finale, the Chicago Bears embarked on their famous "Barnstorming Tour," in which Grange had signed to participate. Never before, and never since, has a professional football team embarked on such a frenetic performance schedule. The Bears, with Grange and Pyle in tow, traveled to New York , Pittsburgh, Detroit, Chicago, Coral Gables (FL), Tampa, Jacksonville, New Orleans, Los Angeles, San Diego, San Francisco, Portland (OR) and Seattle. All told, the tour had played 16 games in a month and a half, and not only had Grange become a star, but he'd become "rich" by the standards of the day. While Halas and Sternaman gave themselves salaries and bonuses totaling $35,000 for the 1925 season, Grange made well over $100,000, and more than that in endorsements for various products. Grange even signed a deal to star in a Joe Kennedy movie the following summer.

The Barnstorming tour had exceeded its goals. Not only was it profitable, but it put the game of professional football in front of hundreds of thousands of fans, coast to coast. It was not without its detractors, however. Immediately upon his return to Chicago, Athletic Director G. Huff and Head Coach Bob Zuppke from Illinois met Halas. The Bears had stayed within the rules by not signing Grange until his college career was finished, but college officials were concerned that he had dropped out to take employment before graduating. Amateur football legend Pop Warner was outraged, and coach Amos Alonzo Stagg of the University of Chicago even rescinded varsity letters earned by players who turned pro. To placate the collegians, that offseason the NFL enacted rules forbidding teams from tampering with college players until the class in which they were enrolled graduated.

Halas then focused on retaining Grange as a player for the future. Pyle agreed that his prized client should continue to play for the Bears, but this time asked for a 1/3 ownership stake in Halas and Sternaman's franchise. The Bears owners refused. They were willing to pay this marquee player a percentage of profits, but would never turn over a piece of ownership. Rebuffed, Pyle declared his intentions to create a rival franchise in New York City, and when the NFL refused, he started his own pro football league, the American Football League.

As it turned out, Red Grange and C.C. Pyle, who created windfalls of cash and put football on the map, would almost tear the National Football League apart the following season with their new AFL. This new league formed with Grange playing for Pyle's New York Yankees, and eight additional teams. One was created in Chicago, the Bulls, and, ironically, its existence benefited the Bears. The Bulls outbid the Chicago Cardinals for the right to play in Comiskey Park, forcing the NFL franchise to perform at the smaller Normal Park. Because of the smaller venue, the Cardinals could not afford to pay their (and the NFL's) star player, Paddy Driscoll. In order to keep Driscoll in the NFL, and to ease the Cardinal's pain, the Bears signed Driscoll to their richest contract to date, and Halas finally had his wish to have his friend playing for his team.

Unfortunately, though, Dutch Sternaman's younger brother Joey left the Bears to run the Bulls. Dutch proposed that Halas purchase his half of the club, but, regrettably, Halas did not. From that point on, Halas and Dutch would remain at odds over many issues, which would lead to an ultimate unraveling of the relationship.

Throughout 1926, the Yankees and Grange consistently outdrew NFL teams, shrinking the pot for the elder league; but the other AFL teams were not as successful. After 1926, the AFL folded, and the Yankees joined the NFL.

14

Redskins owner George Preston Marshall called the Bears "crybabies."

Newly motivated following the loss to Washington, the Bears tore through Cleveland and the Cardinals, scoring 78 points in the process. The team's 8-3 finish set them up for a NFL Championship game rematch with none other than Marshall's Redskins. Halas had plastered his locker room with press clippings of Marshall's comments the final two weeks of the season. Bookmakers put 7-5 odds on the Bears prior to the game's opening coin toss, and Marshall blistered at the gamblers' lack of respect.

Chicago won the toss, and 55 seconds into the game, Bill Osmanski crashed off left tackle, never to be stopped, scoring on a 68-yard touchdown run. That run, which started with a misdirection fake to halfback McAfee, "was just the beginning of a long day for the Redskins," according to Baisi.

After two more touchdown runs and a pass from Luckman to Ken Kavanaugh, the score was 28-0 at halftime. That lead was nothing compared to the drubbing that would occur in the second half. Seven touchdowns later, the score ended up at Chicago 73, Washington 0. The beating was so bad that referees asked Halas to refrain from kicking extra points on the last two scores; the home team had run out of footballs to kick into the crowd on the extra points. The Bears were again kings of professional football following the 1940 season, and achieved the honor in grand fashion.

The year 1941 is remembered for the December attack on Pearl Harbor, and the United States' entrance into the second World War. Football-wise, Chicago Bear fans remember it as the year the T Formation truly hit its stride. It is even mentioned in the Bears' fight song, "Bear Down, Chicago Bears," which was written and released by Al Hoffman that season.

Chicago scored 396 points in 1941, outscoring their opponents by 249, an average of almost 23 per game. This type of dominance was, and is, unique in professional football. Halas' 1941 team, which included players like Osmanski, Turner, Luckman, McAfee, Stydahar, Fortmann, and new backs Hugh Gallarneau and Scooter McLean, finished the season with a 10-1 record, tying Green Bay. As a result, for the first time, a divisional playoff was scheduled at Wrigley Field, taking place one week after the Pearl Harbor attack. That December 14th on Chicago's north side was bitterly cold, as usual, and the Bears out-dueled the Packers 33-14. One week later, they dismantled the New York Giants 37-9 to take their second straight NFL Championship.

After these blissful two years of football for Chicago's players, the time came for them to dutifully serve their country. Lost to the war effort were stars such as McAfee, Norm Standlee, Ken Kavanaugh, Dick Plasman, Stydahar, and Baisi.

Midway through the 1942 season, the coach left as well, keeping his promise to serve his country in a "more military way." George Halas' naval reserve unit was called to duty in the Pacific, and he entrusted the rest of the season—and all seasons until he returned—to assistants Hunk Anderson and Luke Johnsos. Bears business matters were turned over to longtime friend and stockholder Ralph Brizzolara.

The 1942 Bears season was by most accounts near perfect, like 1934. As in 1934, the team finished the regular season undefeated, but lost the championship game. That year proved to be a dominating year for the team's offensive and defensive units. Although they scored 20 points less than the previous season, finishing with 376, their opponents only scored 84 points against them. They finished 11-0-0 for the regular season, but lost a championship rematch with the Redskins in Washington, 14-6.

As it is currently difficult for any NFL team to repeat as champions, so was it then. Sid Luckman admitted that it was hard for the team not to look at themselves as invincible after winning 18 straight games. The team did not play together, he admitted, contributing to the loss.

1943 opened as the first year since their inception that the Chicago Bears played without George Halas on the field, the sidelines, or in the owner's box. The war effort took its toll on professional football, both financially and personnel-wise. Some teams, such as Cleveland, were forced to suspend operations for several years. Others, like the Pittsburgh Steelers and the

Philadelphia Eagles, had to merge. For one year, they played as the Phil-Pitt Steagles.

Bear co-coaches Johnsos and Anderson had to maintain full-time jobs and coach football on the side. College talent provided to the NFL suffered, as so many young men were overseas fighting the war. Johnsos was so desperate that he actually called retired Bronko Nagurski and asked him to come back to play fullback for the team. After some trepidation, Nagurski agreed, but would play tackle instead of fullback.

The war brought still other changes. St. John's Military Academy was no longer available to the Bears for training camp, so in 1944 they began a long-standing relationship with St. Joseph's College in Rensselaer, Indiana. The Bears would continue to train in the summer there until 1974. Johnsos related that one of the best things about this arrangement was the fresh meat on which they were able to feast, since the college raised its own cattle. Feasts in Rensselaer would be a time-honored tradition to the very end.

To keep Halas informed about the state of the team, Johnsos would send his boss a telegram if the Bears won a game, but send a letter if they lost. Thankfully in 1943, there were more telegrams than letters. The Chicago Bears of 1943 finished 8-1-1, scored 303 points, and would again face the Washington Redskins for the NFL Championship, this time in Wrigley Field. Mirroring the 1940 season, their only loss had been to Washington in the second-to-last game of the season.

Perhaps the greatest game of that campaign happened during its final week. The Bears were trailing the Cardinals 24-10 in the third quarter. Chicago's "other" team had not won a game all season, yet looked to put the Bears away. Johnsos and Anderson decided to insert Nagurski at fullback, and the aging legend took the game over. The Bears won 35-24 in one of the most memorable days in the history of the franchise.

Where great Bears runners such as Grange and McAfee were nimble, quick "gallopers," Nagurski conjurs up the image of a man tough enough to eat steel and spit nails. The fullback/tackle's legend grew further in this 1943 season, as if it weren't great enough already. Although Nagurski saved the season, it was Sid Luckman who truly dominated the year. He set the Bears' standard for quarterback play that year by posting a passer rating of 107.8, a record that has not been broken. Additionally, he threw 28 touchdown passes, a mark that would stand in Chicago until 1995.

The sum of all this greatness ended up in a third Bears' championship in four years, which came after the 41-21 victory over Washington. Nagurski would score his final touchdown in that game, and then retire for good.

The 1944 and 1945 seasons were not memorable for the Bears, having lost so many star players to the war effort. They did finish in second place in 1944, but posted their worst record ever in 1945, 3-7-0. Some of the aforementioned stars, including owner/coach Halas, returned from duty toward the end of the season, allowing the team to win their final two games. Halas and the city of Chicago hoped that with their return, the Bears would once again return to dominance.

And return to dominance they did. The end of the world's greatest war brought back most of the players of Chicago's 1940–1941 title teams, including George McAfee, Bulldog Turner, Hugh Gallarneau, Bill Osmanski, Ken Kavanaugh, Ray Bray, and Al Baisi. The team plowed through the regular season of 1946 with an 8-2-1 record, and they defeated the New York Giants 24-14 in the league's title game.

The close of the 1946 season ended the most victorious era of Chicago Bears history. In those 27 years, the team won over 68 percent of their games and brought seven NFL championships to Chicago (one as the Staleys, six as the Bears). Thanks to men like A.E. Staley, George S. Halas, Dutch Sternaman, and countless others who believed in the league, professional football was alive and thriving.

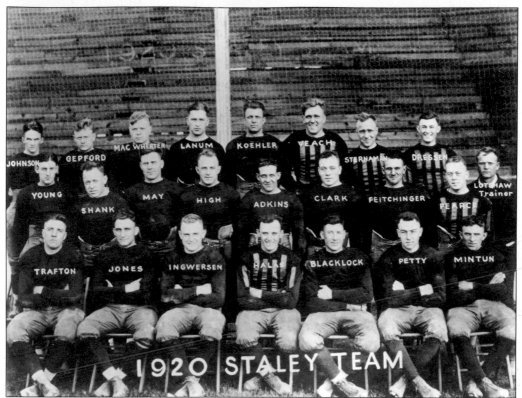

Pictured is George Halas' first professional football team, the 1920 Decatur Staleys. This team would pack up their uniforms the following year and move to Chicago. (Author's collection.)

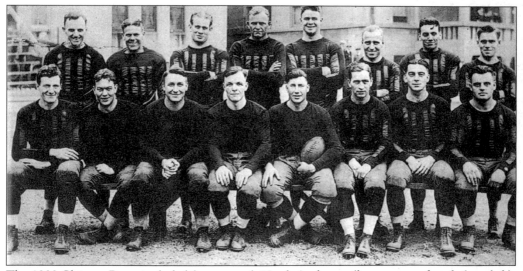

The 1922 Chicago Bears included future coach Hunk Anderson (bottom row, fourth from left), George Halas (top left), and brothers Dutch (top row, third from right) and Joey (top right) Sternaman. (Author's collection.)

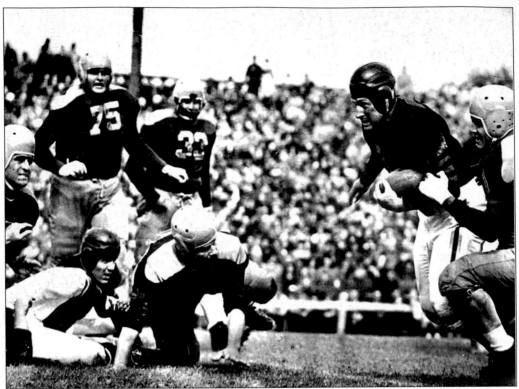

(*Also on cover*) Bronko Nagurski carries the ball against the Packers in Green Bay, sometime during the 1930s. The legendary Hall of Fame fullback/tackle rushed for over 3,500 yards, scored 25 touchdowns on the ground, and threw for 7 more in his 9-year career. (Author's collection.)

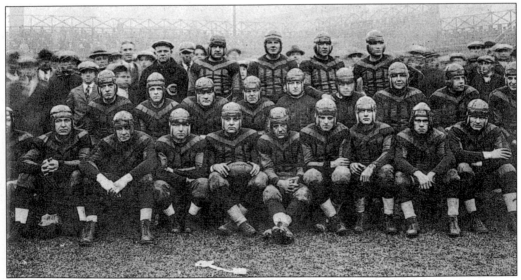

This photo shows the 1925–1926 Chicago Bears "Barnstorming Tour" team. Red Grange looks uncomfortable in his place in the middle, to the right of owner/coach George Halas. (Author's collection.)

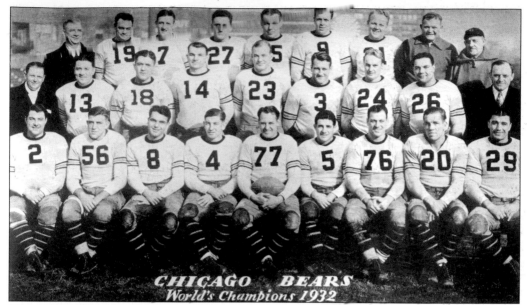

The 1932 NFL Champion Bears team won the title on an 80-yard field inside Chicago Stadium. Head Coach Ralph Jones is pictured at top right in the baseball hat. (Author's collection.)

Sid Luckman, Chicago Bears quarterback from 1939 to 1950, was chosen by the Bears in the first round of the 1939 draft after George Halas acquired the draft pick from the Pittsburgh Steelers. A year later, they would win the first of several championships throughout the 1940s. More than 50 years after he retired, Luckman is still the leading passer in Bears history, as he threw for over 14,000 yards and 137 touchdowns in his career. He wore the uniform number 42 with the Bears, although he is shown wearing number 19 in this photo. (Author's collection.)

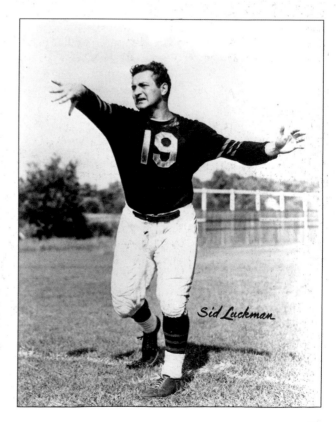

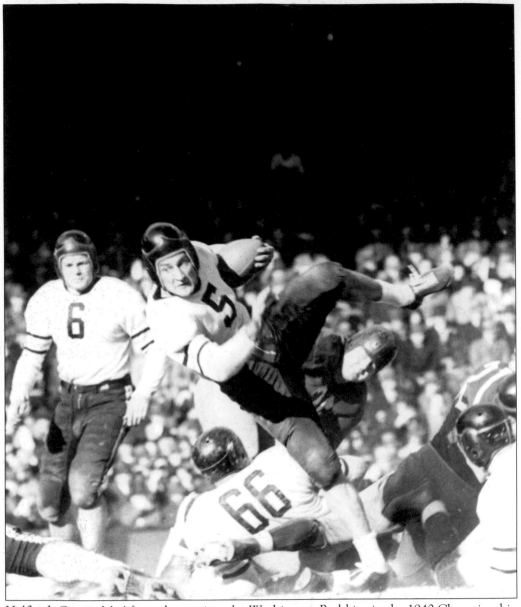

Halfback George McAfee rushes against the Washington Redskins in the 1940 Championship game. Other Bears in this photo are Bulldog Turner (No. 66, on the ground) and Gene Ronzani (No. 6). Several weeks prior to this game, the Bears had lost to the Redskins, whose owner George Preston Marshall called the Bears "crybabies." The Bears responded to trounce Marshall's team 73-0 in the most lopsided championship game in NFL history. McAfee teamed with fullback Bill Osmanski to create a feared backfield, and was inducted into the Pro Football Hall of Fame in 1966. The number 5 is retired by the Bears for McAfee. (Author's collection.)

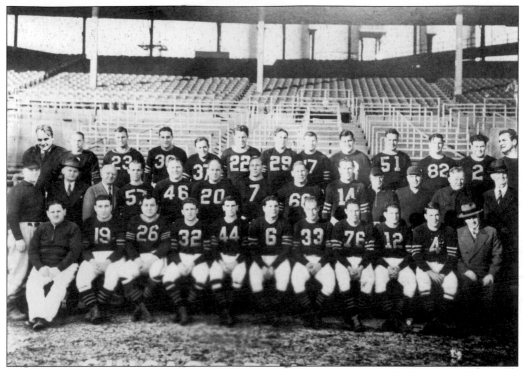

The 1944 Chicago Bears' starting roster was depleted by many players' service in World War II. Ed Sprinkle (No. 7) is pictured here in his rookie year. To the right of Sprinkle is Hall of Famer Clyde "Bulldog" Turner (No. 66) who brought Sprinkle to the Bears. (Author's collection.)

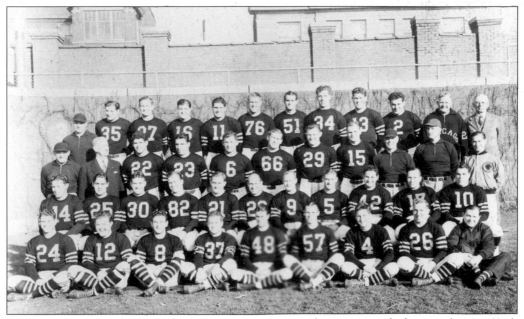

The 1941 Bears won the NFL Championship for the second year in a row by beating the New York Giants 37-9. Pictured consecutively here in the second row is the core of Chicago's offense, Bill Osmanski (No. 9), George McAfee (No. 5) and Sid Luckman (No. 42). (Author's collection.)

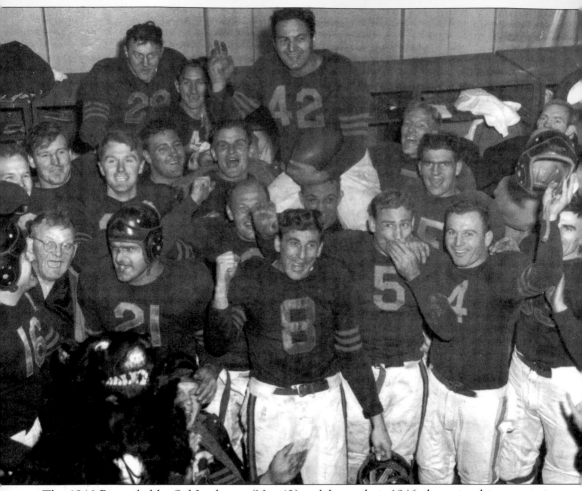

The 1946 Bears, led by Sid Luckman (No. 42), celebrate their 1946 championship game win over the New York Giants. The Bears had dominated the NFL in the early 1940s, but many teams lost most of their stars to the war effort. When many of Chicago's top players returned in late 1945, the Bears returned to championship form. Also pictured in this photo are Rudy Mucha (No. 16), Chuck Drulis (No. 21) and George McAfee (No. 5). Ed Sprinkle shouts with joy just to Luckman's left. (Author's collection.)

TWO
Monsters of the Midway
1947–1963

130-75-5 Record
One World Championship

Before the 1941 season, the Bears acquired the "Monsters of the Midway" nickname. Individually, if not as a club, this nickname may never have been more fitting for the Bears than it was during the era of 1947–1963. After winning the NFL championship game in 1946, the Chicago Bears entered a period for which they are remembered most for the players and personalities they fielded rather than the number of playoff appearances or championships they won.

While the 1947–1963 Chicago Bears only played in two championship games, winning one, this was not a dark era by any means. Despite the lack of titles, the team suffered through only three losing seasons over the 17 years.

After indicating in 1933 and again 1946 that he would only coach a year or two, George Halas remained the Bears' field general from 1947 through 1955, and 1958 through 1967. He relinquished the role to his top assistant, Paddy Driscoll, in 1956 and 1957. Driscoll took the Bears to the NFL championship game his first year, then stumbled the following season, forcing Halas to take back the reigns.

Chicago seemed to finish not far off of first place in the Western Conference, year after year, during this era. The cross-town rival Chicago Cardinals were their first nemesis, followed by the Baltimore Colts, and then the Green Bay Packers. Finally, in 1963 the Bears stormed back, defeating Green Bay twice, then taking the Western Conference and the NFL Championship title.

This era of Bears football rivaled the mid-1980s in producing colorful characters and hard-nosed hitters on and off the football field. While legends such as Luckman, Osmanski, McAfee and Turner slowly faded away towards 1950, they were replaced by other timeless stars in George Connor, Ed Sprinkle, Johnny Lujack, George Blanda, Bill George, Harlon Hill, Johnny Morris, Willie Galimore, Doug Atkins and Mike Ditka.

Domination and Intimidation with no Reward: 1947–1955

Norm Van Brocklin, legendary Los Angeles Rams quarterback, told NFL Films what it was like to face the Chicago Bears of the 1950s. "When I came into the league, the Chicago Bears were known as the intimidators of the league," he recalled. "No one wore facemasks in those days, and I got into the locker room, and noticed all these guys taping all these pads all over their bodies. I was just a rookie, and I asked the guy next to me, 'what's everybody getting all this gear on for?' He said, 'Son, you're in Wrigley Field, get every pad you can get on and look around for some more, because you're really going to need them.'"

This statement signified the brand of football the Monsters of the Midway played. Vic Sears, Philadelphia Eagle, said the Bears "were the meanest, toughest team I ever played against."

On teams known more for the prowess they brought to the football field rather than the number of championships they won, perhaps no one was known to be more intimidating, mean and ruthless on the field than defensive end Ed Sprinkle. Sprinkle played college football at Hardin-Simmons University in Abilene, Texas, the same school from which Bulldog Turner hailed. According to Sprinkle, Turner was four years older than he, and the two never played

college football together. One year, however, Turner returned to Abilene to train in the offseason. Noticing Sprinkle's talent, Turner talked the 6-foot-1, 190-pound self-described "farm kid" into traveling to Chicago to try out for the Bears. Sprinkle did, and was offered a contract.

"I was naïve enough to think at the time that being offered a contract meant I had made the team, which of course I learned wasn't the case," Sprinkle said. As World War II was being fought around the globe, he signed up for several different programs in the Navy, but for various reasons ended up discharged to his local draft board in 1944. This allowed him to commit to football full time that year.

In training camp at Rensselaer, Indiana, that year, Sprinkle was sure he would be cut from the team. According to the legendary defender, "Bulldog Turner walked up to coaches Johnsos and Anderson, and told them if you cut Ed Sprinkle, you'll be getting rid of the best football player on this team. And if you let him go, I'm walking too." Shortly after this conversation, Turner approached Sprinkle and said, "can you learn to play offensive guard by tomorrow?" Sprinkle did, and he made the 1945 and 1946 teams as an offensive lineman.

It has been said that when George Halas returned from fighting the war, he looked at Sprinkle and said, "this little guy is going to get killed, let's move him out to defensive end." Thus began a devastating 12-year career for the man who would become known as "The Claw." Frank Filchock, quarterback for the New York Giants and Baltimore Colts said of the Bears, "They'll get you. Ed Sprinkle, he'll cut you to shreds." Filchock should know, as Sprinkle broke his nose with a devastating hit during the 1946 championship game.

"I hit him and broke his nose, and he threw the ball up right into the hands of Dante Magnani, who returned the interception for a touchdown." That was one of many great plays in the 24-14 championship victory. "That game and my career was a lot of fun, I'm very thankful to have had the chance to play with the teams I did," Sprinkle said. He added that he feels the camaraderie was unequaled when compared to today's game, and "the players really felt close to our fans, which I don't think is the case anymore."

After winning that last championship in 1946, the Bears would go on to win 61percent of their games but not another conference or NFL title for 17 years. "We had some good years during my career, and we always had a winning record, except '52 and '53, but we just didn't get over the top," Sprinkle recollected.

Nineteen Fifty, in particular, was the closest the team would come to winning another championship in Sprinkle's career. The Bears had defeated the Los Angeles Rams twice during the regular season, but had to travel to the L.A. Coliseum for the conference playoff game. They lost in this third matchup of the season, 24-14. "It probably had a lot to do with us going out there," according to The Claw, "and we just couldn't get anything going."

Sprinkle gained the nickname, The Claw, for his trademark clothesline tackle of opposing running backs, quarterbacks and linemen. "One time we were playing the Rams, and I was playing offensive guard. [Bob] Waterfield was playing defensive halfback at the time [he was also a great quarterback] and he came through with his elbow and broke my jaw. Maybe that's where I learned I wanted to get even with quarterbacks," he said with a laugh.

While many players of his era gave Sprinkle the reputation of playing "dirty" for his ferociousness on the field, he insists he did not play outside of the rules: "I guess I got the reputation for being a dirty player, but I never played dirty. I just played hard football. I didn't bite anyone, or kick anyone, or any of that stuff that goes along with being a dirty player. I did put players out of the game with hard hits, but I don't think that's playing dirty."

Some of the opponents he intimidated sounded off on the contradiction that was Ed Sprinkle. Don Paul of the Rams called Sprinkle the "most feared pass rusher in football." Van Brocklin called him a "hundred ninety-pound rattlesnake." San Francisco 49er Bill "Tiger" Johnson may have summed it up when he said, "Ed Sprinkle was kind of a Jekyll and Hyde. Off the field, a wonderful guy. On the field, his character did change. He was a punishing football player."

Sprinkle was by all means not the only rough and tough Chicago Bear of his time. From 1947 to 1955, the Bears lost some of their legends, only to add to their roster players of equal

character and historical notoriety. By the early 50s, illustrious players such as Luckman, Turner, Osmanski, McAfee and Bray had retired, but were replaced by equals such as defensive end Doug Atkins, linebackers Bill George, Joe Fortunato and Larry Morris, receivers Jim Dooley and Johnny Morris, and two-way lineman Stan Jones.

Two interesting moves were made when the Bears picked up receiver Harlon Hill and running back Willie Galimore from tiny colleges in the South (risks that would pay off in the end, anticipating a draft pick out of small-time Jackson State a few decades later). Hill played for Florence Teacher's college in Alabama, while Galimore prepped at Florida A&M. Both would attain legendary status in the pros.

Another interesting situation occurred at the quarterback position in 1948. That year, Halas drafted Bobby Layne, the All-American quarterback from Texas. The Bears seemed loaded at this position, since they were still being led by Sid Luckman, and had drafted Notre Dame's Johnny Lujack with their top pick in 1946. The three Ls—Luckman, Lujack and Layne—would prove to compose the Bears' first of many quarterback controversies. Luckman started and led the team through the 1948 season, and the other two Ls played sparingly, with Lujack throwing six touchdown passes and Layne, three.

Another part of the Layne story that is up for debate was how the fun-loving quarterback's lifestyle fit in with owner/coach Halas. Layne loved to have a good time, so much so that Baisi swears he saw the rookie drinking a martini from his usual spot on the bench. This controversy would not last long, as Halas felt there was an abundance of talent at the position. Halas "sold" Layne to New York following the quarterback's rookie season, and the golden-haired boy from Texas would come back to haunt Chicago through the 1950s as a member of the Detroit Lions. This situation became especially difficult when Luckman retired and Lujack was lost to injury in 1951.

Another NFL (and AFL) icon was drafted in 1949 to replace Layne. He was George Blanda, who would quarterback the Bears at various times through the 1950s, as well as play placekicker. The future Hall of Famer went on to play a remarkable 28 seasons in the NFL and AFL, finally retiring after the 1975 season. The "three Ls" at the quarterback position in Chicago would turn into the "three Bs" during the '50s, as Blanda, Zeke Bratkowski and Ed Brown alternated at quarterback during much of the decade.

The intimidation the Bears players wielded on the field was learned from none other than their head coach and owner, George Halas. Many opposing NFL players have shared stories of Halas running on the field to argue with officials and, on his way back to the sidelines, getting in a covert kick to a player's backside or stepping on their fingers with his trademark brown shoes. Sprinkle loves to reminisce about the time the Bears were playing the Green Bay Packers. "Green Bay had a tackle from Michigan that had a cute little moustache," Sprinkle said, "and Halas told us that he'd give five dollars for every hair anyone could pluck. I came back to the sidelines, counting the hairs in my hand," he said, chuckling.

Another Halas icon, his fedora hat, often ended up thrown or smashed on the ground if Halas didn't agree with officials' calls. While the coach would always try to stay in the referee's good graces, often picking up their dinner tab if they dined in the same restaurant on the road, he was ruthless to them in the stadium. Sprinkle recalls that Halas yelled a nastier version of "You Stink!" at the refs once when they were walking off a ten-yard penalty against his team. The referee turned, looked at Halas, and walked off another ten yards. The official then asked, "How do I smell from here?"

While to a man Halas is described as a great coach and wonderful human being, it is not possible to talk to one of his former players and not hear of contentious contract negotiations. According to Sprinkle, Halas was "all business" when it came time to talk money. "He would always want to make you uncomfortable, nervous when you had to go see him to talk about your contract"

And it seemed that the owner employed different tactics with each player he was interrogating. According to Al Baisi, when asked for a raise, Halas would tell the player to try to make the postseason, and if it happened, the player could consider the extra pay for playoff

games his raise. Ed O'Bradovich always found that the coach would make a list of all the player's mistakes during the season, while ignoring his strengths. O'Bradovich made a critical interception in the 1963 championship game, but when it came time to talk contract, Halas would only acknowledge the mistakes he had made that year, not his triumphs.

For Sprinkle, there came a year where he refused to accept the low pay Halas was offering. "You're making the same as everyone else on the team," Halas told him. Sprinkle countered that he wouldn't believe it until he saw the contracts of Sid Luckman, George McAfee, and Bulldog Turner. The owner refused. Finally, just days before their first game at Green Bay—for which Sprinkle had to be signed in order to play—Halas produced a few contracts. "He kept shuffling them all around so I couldn't really see whose they were or really how much they were for," the lineman said. "But I told him fine, I'll play for the highest of those contracts." The deal was done.

Sprinkle recalls his last contract negotiation with Halas. It turned out the player and coach were $200 apart on the contract for the entire year, just a $16 difference in pay per game. "I said coach, can't you just give me the $200 so I can say I got what I wanted just once in my entire career?" Sprinkle said. "Halas refused and said 'I just can't do it, Ed.' That's just the way he was." This is amazing, considering that Halas regarded Sprinkle as the best defensive end he had ever seen.

Mike Ditka would make a famous statement in the 1960s, when he proclaimed that Halas "threw nickels around like manhole covers." In a recent interview, Ditka kidded, "No, he didn't throw nickels around like manhole covers. He threw pennies around like manhole covers." After the comment, Ditka made sure to point out that Halas had a benevolent side that many didn't know; he helped several players through dental school, and when running back Brian Piccolo battled cancer in 1969, pledged to cover all the costs.

Regardless, old habits die hard, as they say. Even in his final years, Halas couldn't help trying to get the better of brash younger players in contract negotiations. When Jim McMahon was drafted in 1982, the 86-year-old Halas opened monetary discussions by proclaiming that the QB was too short, couldn't see, and had bad knees, so "maybe you [McMahon] should just go play in Canada," the aging owner said. "Then why the hell did you draft me," McMahon thought.

A Legend Departs, then Returns to Right the Ship: 1956–1962
So as Sprinkle described, the Bears plugged along from 1947 to 1955 with varying degrees of success. They had mostly winning records, and put the fear into opposing players. But they couldn't get over the top. After the 1955 season, which Chicago started 0-3 but rebounded to win eight of their last nine, Halas decided to give retirement from coaching another try.

Though Halas was officially retired from coaching, he could never completely get away. That year he began his tradition of not being able to keep himself off the sidelines, and several times in 1956 he moved down to man the Bears' phones on the sidelines.

The coach to whom Halas turned over the reigns was long-time assistant Paddy Driscoll. The new head coach beefed up his lieutenants, adding former Bear players Sid Luckman and George Connor, and a running backs coach in Chick Jagade. Veteran coaches that returned were Bulldog Turner, Phil Handler, Luke Johnsos, and Clark Shaughnessy.

Among the young Bears players that would begin to emerge that season were running back Rick Casares and receiver Harlon Hill. Casares had led the NFL in rushing the previous season, his rookie year, and would leave his mark in Chicago along with so many other legendary runners. Hill, the unknown speedster from the south, would amaze Americans with several unbelievable catches.

Through the early 1950s, the Chicago Cardinals and Los Angeles Rams most often stood between the Bears and the postseason, but in 1956 it would be the Detroit Lions and Bobby Layne. Considering the eventual rivalry that season would bring to the two teams, it seems ironic that the schedule had them playing both of their games in the final three weeks of the season. In the 21st Century, this would truly be a network television programmer's dream come true.

Chicago lost their first game to the Baltimore Colts 28-21. They rebounded, winning the next two. In week four, they demolished the Colts in a rematch, 58-27. This game was Hall of

Fame quarterback Johnny Unitas' first, and turned out to be forgettable for the eventual legend. The Bears won four more games in a row, then tied the New York Giants. In the Giants game, Harlon Hill made what many believe to be the greatest catch in the history of football—diving, bobbling, then pulling in an Ed Brown pass for a touchdown. After the New York tie, they traveled to Detroit for a first-place showdown with the Lions.

The Bears lost that game 42-10. The Lions were led by Layne's two touchdown passes, a rushing score, and the six extra points he kicked. As a result of this game, the Bears slipped into second place. They won the following week and faced Detroit again in the season finale for the Western Conference title.

According to Richard Whittingham's 1979 book, *The Chicago Bears, an Illustrated History*, fans hung banners that proclaimed "We Want Lion Blood!" and the Lions brought four Detroit police officers with them to protect their bench. Fistfights filled the playing field as well as the Wrigley Field stands before the game was over. Bobby Layne was knocked out on a ferocious hit by Ed Meadows, which prompted Lions coach Buddy Parker to claim he heard rumors of the Bears' intention to harm Layne throughout the preceding week. Halas called the claims "ridiculous," and the Bears went on to win 38-21, no doubt helped by the absence of Detroit's star quarterback. The win gave the Bears the NFL Western Conference Championship.

Despite basking in the glory of their first conference title since 1946, the Bears faced a long day in the 1956 NFL Championship against the Giants in New York. In conditions that rivaled the 1934 "sneaker" game, the Bears lost 47-7.

The eventual championship loss was heartbreaking, but individually some Bear players stood out that season. Rick Casares and Ed Brown led the league in rushing and passing, respectively, and Harlon Hill gained over 1,000 yards receiving in a 12-game season—a remarkable feat.

Driscoll continued on as Head Coach of the Bears in 1957, but the team slipped, with a record of 5-7. The biggest development in '57 was the play of rookie Willie Galimore, who split carries with Casares and rushed for 538 yards and four touchdowns. Casares was beaten for the NFL rushing title by a rookie in Cleveland by the name of Jim Brown.

After the poor performance in '57, Halas decided to once again reclaim the coaching reigns. He demoted Driscoll to assistant coach and added assistants Chuck Mather and George Allen. Halas' first goal, as he described in his autobiography, was to rebuild the defense with the goal of winning one more championship before he retired, this time for good. Notable additions that year were halfback/flanker Johnny Morris, once a record-holding track star, and guard Abe Gibron, a veteran from Cleveland.

New defensive innovations Halas brought to the Bears in 1958, to add to his already large list of game-changing ideas, were color-coding blitzing linebackers (the term "red dog" began here). He also installed a zone defense for the first time. These new defensive theories would assist talented defensive players added to the team to create a unit that dominated the league.

In his first season back, Halas turned the Bears from a losing team to an 8-4, second-place ballclub. They finished 8-4 again in 1959, while they added players such as linebacker Larry Morris, safety Richie Pettibon, and kicker Roger Leclerc. In 1960, the Bears slipped a bit with a 5-6-1 record. In the 16th round of the draft that year, they added a key receiver in John "Bo" Farrington, but would wait until the following year to build the true final pieces toward a world championship.

Those final pieces started with 1961's top choice, Pittsburgh end Mike Ditka. Also added through the draft were center Mike Pyle, and defensive backs Roosevelt Taylor and Dave Whitsell were picked up. Halas traded with Los Angeles to acquire new starting quarterback Bill Wade, who only had a first name that fit in with the Bears' most recent "three Bs" of Ed Brown, Zeke Bratkowski, and now Rudy Bukich. Bratkowski had departed in 1960, and Brown in '61; Bukich was added in 1962. Unquestionably, though, Wade was now the starter.

Defensively, the additions of Taylor and Whitsell helped the Bears defense begin improving. Although the team lost the 1961 opener to the Minnesota Vikings, in that franchise's very first game, they would make a mockery of a powerful offense later in the year. Prior to the season's

sixth game, the San Francisco 49ers had been dominating the league offensively with their new "shotgun" formation. Halas and his defensive assistants devised a plan for middle linebacker Bill George to blitz constantly around the 49er center, and as a result the innovative San Francisco offense was shut down and out. The Bears won the game 31-0, and other teams would mimic the Bears' strategy to put an end to San Francisco's first "West Coast Offense."

The Bears ended the 1961 season on a high note, when they avenged the opening loss to Minnesota with a 52-35 victory. In the first of many honors to be bestowed upon Mike Ditka, he was named NFL Rookie of the Year for the season after he caught 56 passes for 1,076 yards and 12 touchdowns.

In 1962, the Bears bettered the previous season's record, finishing 9-5. And for the first time since the 1940s they made a modification to their uniform, adding a white "wishbone" C to their helmet. It's not totally clear where the idea for the logo came from, but it mirrors the logo of the University of Chicago's "Maroons" football team, which disbanded in 1939.

Important from the standpoint of momentum, they won five of their final six games in '62 after being thoroughly beaten by the eventual champion Green Bay Packers. Two drubbings by the Bears' biggest rival may have provided impetus for revenge the following season. Rookie running back Ronnie Bull followed Mike Ditka as NFL Rookie of the Year for the season. Spirits were high at the end of '62, but a worl championship was around the corner.

Champions Again: The 1963 Season

According to George Halas, his team entered the 1963 season "feeling a touch of destiny." The team returned most of its stars from the previous year and added a new offensive coach—former receiver Jim Dooley. Returning halfback Ronnie Bull had been named 1962 Rookie of the Year, and he teamed with Willie Galimore, Joe Marconi, and Rick Casares to form a fearsome unit in the backfield. Johnny Morris, Mike Ditka, and John Farrington were the receivers, Bill Wade provided dependable quarterbacking, and the offensive line was solid.

On defense, George Allen and Clark Shaugnessy's unit had been steadily improving since 1958, and 1963 would turn out to be the year it all came together for the defenders. The defensive line was rugged with the likes of Doug Atkins, Ed O'Bradovich, and Stan Jones, switched over from offense the previous season. Few linebacking corps in NFL history rivaled this team's, which featured Bill George, Joe Fortunato, and Larry Morris. The secondary was a hard-hitting, playmaking unit, comprised of Dave Whitsell, Roosevelt Taylor, J.C. Caroline, Bennie McRae, and Richie Pettibon.

Despite the optimism in Chicago, the archrival Green Bay Packers remained the team to beat in the Western Conference and the NFL. The Packers had won the previous two NFL championships, led by quarterback Bart Starr and running backs Jim Taylor and Paul Hornung. Halas predicted that the Bears would need to defeat Green Bay twice to have any hope of winning the NFL title.

The season began on a sun-drenched Sunday in Green Bay. The Packers had not lost a game at home since the Bears defeated them in 1960. The game was a close contest, with the Bears playing predictable, ball-control offense. At halftime, the contest was tied 3-3, until Marconi took control of the game with determined running, resulting in a touchdown and a 10-3 Bear lead. After this, the defense took over, intercepting two Starr passes to seal the victory. One-half of Halas' requirement for the season had been met in its opening week.

Over the ensuing four weeks, Chicago played as dominating football as they had over the previous decade. They first traveled to Minnesota, beating the Vikings 28-7, and then beat Detroit 37-21 at Tiger Stadium. The Lions game featured a spectacular touchdown catch by Johnny Morris, who beat legendary Lion defender Dick "Night Train" Lane to the ball. Also contributing were Ditka with a touchdown catch and Richie Pettibon, on a 66-yard interception return for a score.

The following week the Bears hosted Baltimore in their home opener, and trailed for the first time all season when the Colts went ahead 3-0. Ronnie Bull then scored on a 44-yard

touchdown pass from Rudy Bukich, leading to a 10-3 Bears victory.

October 13th was Mike Ditka's day at the Los Angeles Coliseum, where the third-year pro caught four touchdown passes to lead the Bears to a 52-14 annihilation of the Rams. The Bears had started the 1963 season 5-0 and looked unstoppable.

Then came a trip up the California coast to San Francisco to take on the league's worst team in the 49ers. Chicago was shocked to see their team fall behind 17-0, then eventually lose 20-14 in the upset of the season. The defeat was puzzling, after the Bears had beaten their previous opponents by an average of 18 points per game.

The team did not relent, and in the following weeks they defeated Philadelphia and Baltimore. The Eagle game featured interceptions by Caroline, Witsell and Taylor, and against the Colts a rumbling 63-yard swing pass gain by Marconi. The victory over the Colts set up a first-place showdown between the Bears and Packers at Wrigley Field on November 17th, one week before the nation was shocked by the assassination of President John F. Kennedy on a Dallas street.

Spectators at a filled-to-capacity Wrigley Field knew they were in for a thrilling game from the opening play. Green Bay kick returner Herb Atterly took the opening kickoff, only to be cut down inside his 20-yard line by a streaking J.C. Caroline. After forcing a quick punt, the Bears traveled the length of the field to kick a field goal. Another field goal, this one a lengthy 46 yards, by kicker Roger Leclerc, put the Bears up 6-0. With the Bears leading in this conference showdown, fate soon seemed to be on Chicago's side. On the following kickoff, Atterly seemed to break into the clear as he neared the Bears' 40-yard line, but John Farrington forced a fumble that was recovered by the kicker. Several plays later, Galimore broke free on a 27-yard touchdown run, putting the Bears solidly ahead at 13-0.

Two more field goals in the second half, along with a touchdown sneak by Bill Wade put the Bears ahead 26-0. Green Bay would muster a lone touchdown to make the final score 26-7, and the Bears owned first place in the Western Conference by a game over the NFL's defending champions.

The following week the NFL considered canceling its games to mourn the death of the president, but decided to carry on. The Bears were faced with maintaining their lead over the Packers at all costs, despite the mood of the country. They traveled to Pittsburgh and were engaged in a back-and-forth battle with the Steelers. Trailing 17-14 in the fourth quarter, spectators witnessed the play by which Mike Ditka and the '63 Bears would be remembered. Backed up in their own territory on second-and-long, Wade threw a short out pattern in the left flat to his tight end. Six broken tackles, an arm drag, and 63 yards later, Ditka laid sprawled on the ground, out of air. He may have single-handedly saved the Bears' season, as Leclerc kicked a game-tying field goal, preventing the loss.

On December 1st in Chicago, the Bears again fell behind, this time to the Vikings, by a score of 17-3 at halftime. And again, for the second week in a row, Chicago caused key turnovers to get back in the game. Most notable was a fumble recovery by Roosevelt Taylor, setting up an 8-yard touchdown pass from Wade to Marconi. The touchdown made the score 17-17, and the Bears wound up with their second 17-17 tie in two weeks. While not victories, the ties were helpful as they were not counted in a derogatory manner in the standings.

A week later, the Bears looked at an opportunity to avenge the loss in San Francisco earlier in the season. They would have no problem doing so. After Ed O'Bradovich forced a fumble in the first quarter, Willie Galimore burst through the middle of the line for a 51-yard touchdown. Shortly thereafter, Richie Pettibon made his 23rd career interception, breaking the Bears' all-time mark held by Don Kindt. Marconi then did his best Galimore impersonation, breaking a long touchdown run of his own. In the fourth quarter, Taylor got into the record book himself by snagging his eighth interception of the season, returning it 30 yards for a score. The Bears won 27-7.

Finally, on December 15th , Halas would find out if his Bears had turned a corner and had a shot at bringing home an NFL championship for the first time since 1946. That day they would face the Detroit Lions, a game that would indirectly decide the championship of the NFL's Western Conference. Despite having beat Green Bay twice during the season, due to the standings, if the Bears lost, the conference title would belong to the Packers. Although out of

the race themselves, Detroit had ended Cleveland's hopes in the Eastern Conference the previous week, so the Lions, playing the "spoilers," were not to be taken lightly.

A packed house at Wrigley Field thought the Bears were off to a fast start to the title. After forcing Detroit to punt on their first possession, Billy Martin stood back to receive at his own 22. Martin caught the punt and raced up the left sideline to what looked to be a 78-yard touchdown return. However, the official ruled him out of bounds at Detroit's 40. Undeterred, Chicago's offense drove inside Detroit's 10 on a Wade-to-Morris pass and a Galimore sweep. The drive still stalled, and the Bears were forced to kick a field goal.

After leading 3-0 through the second period, Chicago was shocked back to their senses when a Wade interception was returned 42 yards for a touchdown by the Lions. In the third quarter, the Bears went ahead 10-7 on a 51-yard touchdown pass from Wade to speedy Johnny Morris. The second half would be paced by a methodical drive featuring short slant passes, and after a fumble recovery by Stan Jones, Mike Ditka scored to put the Bears ahead 17-7. Refusing to give up, Detroit drove the length of the field, scored a touchdown and narrowed the difference to three points.

After several possession changes, Detroit had one last shot with 53 seconds remaining in the game. They completed a short pass before QB Earl Morrall was intercepted, a pick that was returned by Dave Whitsell 39 yards for a touchdown. The Bears set a team record with 39 interceptions on the season, and Chicago won the Western Conference for the first time since 1956.

On December 29, 1963, the Chicago Bears played host to the New York Giants in a rematch of the 1956 NFL Championship Game. Since that game, New York had returned to the NFL Championship four times, the Bears none. The game would be a matchup of the Giant's NFL-best offense and the Bears' top defense. The Giants were led primarily by aging but still spectacular quarterback Y.A. Tittle and receiver Frank Gifford.

The thermometer read nine degrees at kickoff that day. Halas and his staff had covered the field with hay the night before, then covered the hay with tarps and blew hot air underneath it in an effort to keep the surface from freezing. When the tarps were removed and the hay raked away prior to gametime, the field was indeed soft. But in the uncovered chill, it froze again into a surface as hard as concrete.

New York scored quickly. They went up 7-0 on the game's opening drive when Tittle hit Gifford with a touchdown pass. Later in the first half, linebacker Larry Morris intercepted Tittle, returning the ball deep into Giant territory, setting up a Bill Wade sneak to even the score at 7-7. New York added a field goal before the intermission to set up a 10-7 contest in the third quarter.

The Giants returned the second half's opening kickoff 47 yards, and after several Tittle completions, New York threatened again. Chicago's defense would stiffen, and a Whitsell interception prevented a New York score. The Bears offense, led by Wade and Marconi, drove into scoring position, but the threat stalled when a field goal attempt by Leclerc went wide.

In a game with many defensive plays-of-the-game, later in the third period defensive lineman Ed O'Bradovich sniffed out a Giant screen pass, intercepted the ball, and returned it to the New York nine-yard line. After a key third-down completion to Ditka, Chicago had the ball on the Giants' one, where Wade snuck in for his second rushing touchdown of the contest. Chicago led 14-10, but a full period remained.

After an uneventful fourth quarter, New York had one more shot with 1:24 left in the game. Much like the game that decided the conference championship several weeks before, this one would come down to the game's final drive. On four consecutive short passes, Tittle drove his team to the Chicago 39-yard line. From that point on the field, 10 seconds remained. The aging legend lofted a pass to his right, aiming for the end zone and receiver Del Shofner. The pass was off the mark, the receiver was double-covered, and the ball dropped straight into the hands of Richie Pettibon. After Wade downed the ball, time expired, and the Bears would witness their final championship victory within Chicago city limits.

The 1963 Bears were the original "cardiac kids" of football. They did win several blowout contests, but more often than not their brutal defense stepped up to save games. Hall of fame defensive end Doug Atkins later reminisced, "we were completely loose. We laughed at everything that year, and how we won, I don't know."

Ed O'Bradovich would say, "We proved you can win a championship on defense." While it was the defense that saved the day more often than not, Wade added, "we gave people fits offensively. Our turnover ratio was one of the best in the league," which always gives the defense the edge.

The next day, Chicago mayor Richard Daley planned a celebration at city hall, and everyone in town was welcome. Thus, the city of Chicago celebrated its first pro football championship since 1946 in the bitter cold.

The 18-year period of Chicago Bears History (1946–1963) was not filled with championships, but was not a dark era, either. George Halas steadily commandeered the Bears' course until he thought he was through in 1955. After a near-championship followed by a season of doldrums, Halas returned to continue to innovate the game of professional football. Men who played for the Bears during this era spawned some of the most colorful stories professional sports will ever know. The Monsters of the Midway ended this era with a dominating defense and a spunky offense that left its mark on the NFL in 1963, and looked to rival the dominant Green Bay Packers of the 1960s as the decade's greatest franchise.

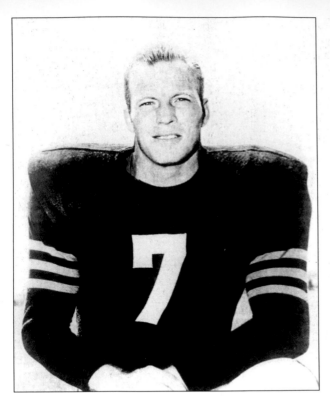

Bears defensive end Ed Sprinkle poses for a picture. "I got the reputation for being a dirty player, but I don't think just playing tough football makes you a dirty player," Sprinkle said. He played football at Hardin Simmons College in Texas, and was brought to the Bears by Hall of Famer Bulldog Turner. Sprinkle was a dominating defensive end who recorded many quarterback sacks, but they were not counted as a statistic during his era. He played for the Bears from 1944 to 1955. (Author's collection.)

Quarterback/kicker George Blanda joined the Bears in 1949 and would play with the team until 1958. After leaving the Bears, Blanda played in the AFL, then the AFC, finally retiring in 1975 after 28 NFL seasons. In his Bears' career, Blanda passed for over 5,000 yards and 48 touchdowns. He also was a kicker and still ranks fourth on the Bears all-time field goal list with 88 and scored 541 total points. He was inducted into the Pro Football Hall of Fame in 1981. (Author's collection.)

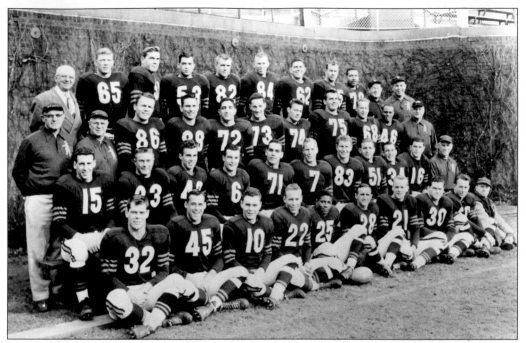

The 1953 Chicago Bears featured future head coach Jim Dooley (second row, third from left) and Hall of Famers George Connor (No. 71), George Blanda (No. 16), and Bill George (No. 72). (Author's collection.)

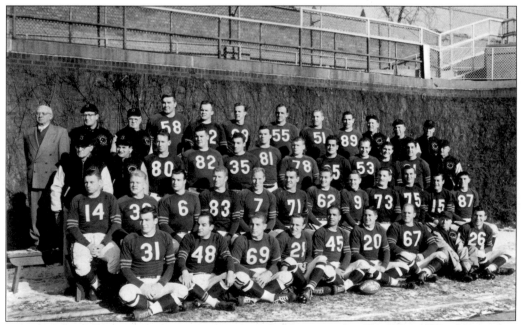

Among others featured in this 1955 photo of the Bears are Joe Fortunato (No. 31), rookie Rick Casares (No. 35), who retired after the 1964 season as the Bears all-time leading rusher with 5,675 yards—still ranking him third today—and Hall of Famers Doug Atkins (No. 81) and Stan Jones (No. 78). (Author's collection.)

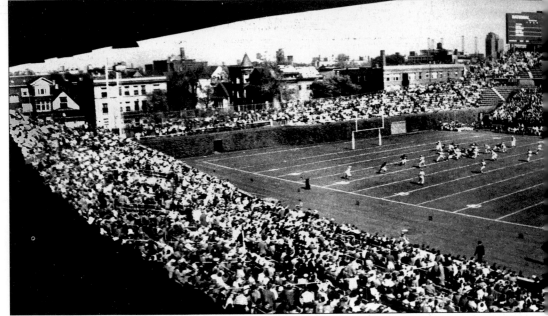

This photo shows a spectator's view from the Wrigley Field stands, sometime during the 1950s or 1960s. When George Halas and Dutch Sternaman moved their Decatur Staleys to Chicago in 1921, they approached William Veeck of the Chicago Cubs and worked out a deal to play

The Bears drafted tight end Mike Ditka in 1961 from the University of Pittsburgh. Ditka won Rookie of the Year honors his first season. The Hall of Fame tight end played for the Bears until 1966, when he was traded to the Philadelphia Eagles for quarterback Jack Concannon. It was a well-known fact that Ditka and owner/coach George Halas had personal issues, but that did not stop Halas from making Ditka his final coaching hire in 1982, a year before his death. (Author's collection.)

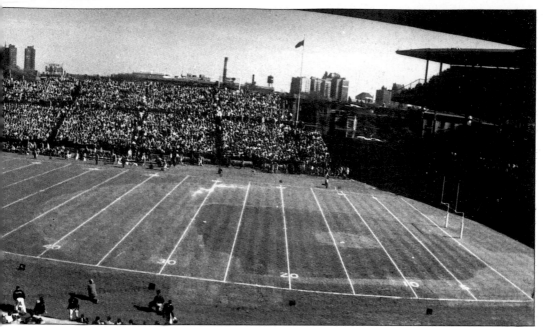

in Cubs Park, later renamed Wrigley Field. The Bears would continue to play there until 1970, when they were required to move to a larger venue at Soldier Field on Chicago's lakefront. (Author's collection.)

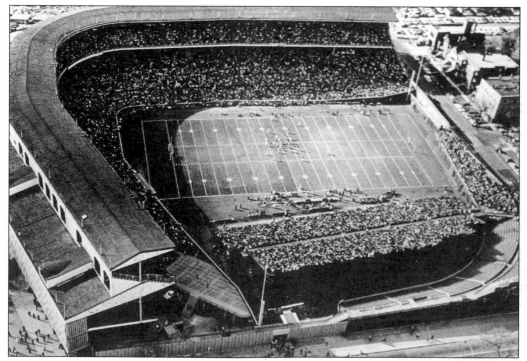

Wrigley Field is shown here setup in football configuration with temporary seats rolled in over the right field bleachers. The Bears moved the same temporary seats to Solider Field, where they were used in the north end zone until that stadium was remodeled in 1980. (Author's collection.)

39

Bear receiver Johnny Morris (No. 47) helps Mike Ditka stretch while future head coach Jim Dooley looks on. Morris is still the Bears' leading all-time receiver with 356 catches, 5,059 yards and 31 touchdowns. Morris, who was revered in Chicago for his play, became a sports anchor in the city, covering the Bears during the heyday of Mike Ditka's teams in the 1980s. (Author's collection.)

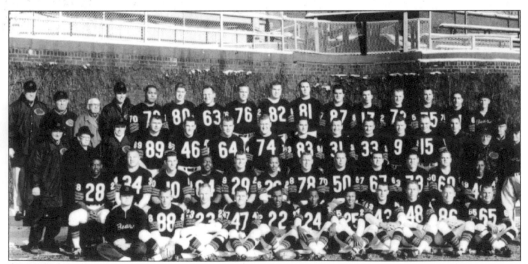

The 1963 NFL champion Bears pose in front of the famous Wrigley Field ivy. The '63 team overtook the Green Bay Packers, who had been dominating the NFL up to that point. It would be the final Bears Championship at any level until they won the NFC Central crown in 1984. (Author's collection.)

40

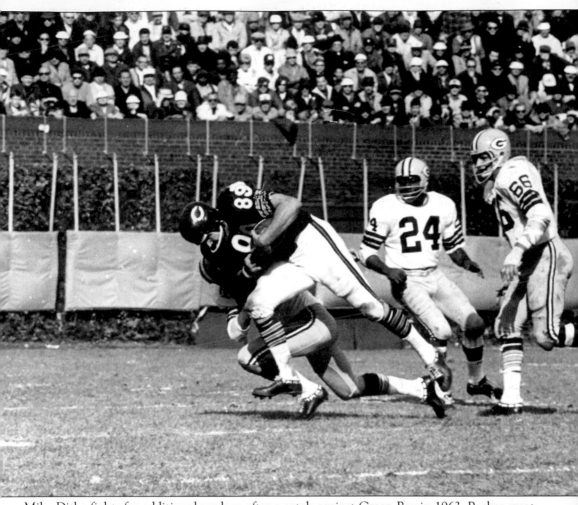

Mike Ditka fights for additional yardage after a catch against Green Bay in 1963. Packer great Ray Nitschke (No. 66) stands to the right. Ditka's receiving played a large role in the Bears' 1963 championship, as he totaled 794 yards and eight touchdowns. (Author's collection.)

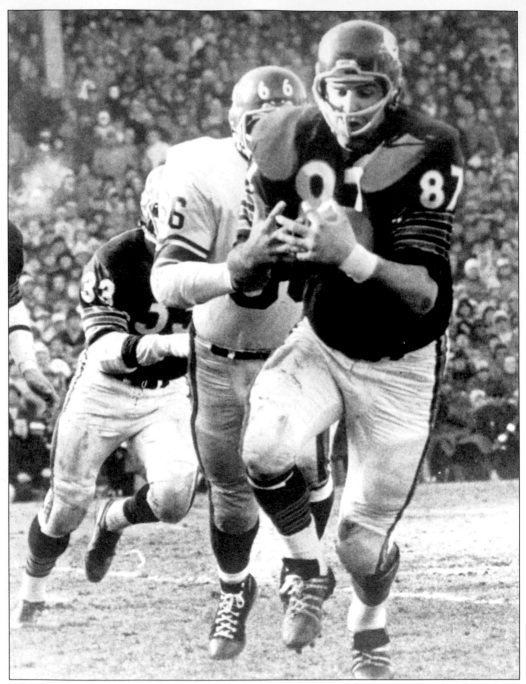

Ed O'Bradovich returns an interception deep into New York territory in the 1963 NFL Championship game against the Giants. The defensive end grew up in the Chicago area, went to the University of Illinois (like Dick Butkus, George Halas, and other Bears), and played for the Bears from 1962 to 1971. O'Bradovich has been a passionate Chicago Bears follower in Chicago since his retirement, most recently covering the team with Doug Buffone for a popular Chicago sports radio station. (Author's collection.)

THREE

New Legends, Tragedy, and Mediocrity 1964–1981

107-149-4
Two Playoff Appearances

The Chicago Bears entered the offseason prior to the 1964 campaign full of jubilation as a result of their 1963 World Championship victory. To that point, the rival Green Bay Packers had been the NFL's strongest team, and Chicago had defeated them handily twice. To some, it looked as if the Bears had supplanted the team to the north as the league's team of the decade. It didn't take long to find out otherwise. Despite some close encounters with postseason play, the Bears slipped steadily in the standings. By the end of the decade, Chicago ranked among the NFL's worst teams for the first time in their history.

By then, George Halas had retired for good, handing the coaching reigns over to first one long-time assistant, then another. Business-wise, he named his only son George Jr. "Mugs" president of the club in 1963. Halas claimed to be removed from the day-to-day operations of the team, although many of his players would argue to the contrary.

Though they both have a place in NFL lore for their personality, neither of Halas' successors could bring consistent winning records. Continual problems at the quarterback position became newspaper headlines more often than news of Bear victories. Those headlines would also report on Bear tragedies three times during this era.

By 1975, the younger Halas decided it was time to trust a non-Halas to run the team, and hired a reputable career football man in Jim Finks to become the Bears' Vice President and General Manager. Finks would hire the right coaches, draft the right players, modernize operations and bring cheerleaders to the Bears' sidelines for the first time.

By 1981 the Chicago Bears were teetering on the brink of mediocrity and were ready to make changes once again. But they certainly had turned a corner, thanks to Finks.

Spinning their Wheels: 1964–1968

According to his autobiography, George Halas was a happy man following the 1963 championship: "It proves that if you live long enough, everything nice you want to happen will happen." When asked if he would now retire, Halas said, "I guess I will have to hang on. Anyway, where could a sixty-eight year old find another job?" Thus, Halas set his team's sights on defending their world championship, which is what the club intended to do as they entered that summer's training camp in Rensselaer. First tragedy, then injuries of all shapes and sizes, would derail that effort.

On the evening of July 26, 1964, Halas noticed that star running back Willie Galimore and receiver John "Bo" Farrington were absent from the team's 8 p.m. "chalk talk." Halas learned that the duo had gone out for a couple of quick beers. As it turned out, the players ended up not heading back to camp until after 10 p.m., and raced back in an attempt to make the mandatory 11 p.m. curfew. Just over two miles from camp, the players' car missed a sharp curve, careening off the road and ejecting both from the car, killing them instantly. Galimore was 29, Farrington 28. They were young men in the prime of their lives and key members of the NFL's championship football team. Halas addressed a team trying to cope the next day, and suggested

that they dedicate the 1964 season to the young players' memories.

Despite any good intentions of doing so, fate would not have it that way. The Bears went on that season to suffer one of the most injury-plagued campaigns in the team's history. The defense was hit particularly hard and would give up 379 points over the course of the 14-game season. Lost to various maladies were linemen Doug Atkins and Ed O'Bradovich, and the entire '63 linebacking corps of Bill George, Joe Fortunato, and Larry Morris. After finishing 11-1-2 and winning the conference and NFL championships in 1963, the Bears sank to 5-9 and sixth place out of seven teams that ill-fated season.

Nineteen Sixty-Four would be the last season for fullback Rick Casares, who left for the Washington Redskins after setting the Bears' all-time rushing record with 5,675 yards and 49 touchdowns. Although not regularly mentioned when Chicago Bear Hall of Famers are discussed, Casares has been called "the toughest man that ever played for the Bears" by notables such as Mike Ditka and Doug Buffone.

Given the age of many Bears' starters in 1965, Halas knew he would need an influx of stars for the coming season to turn things around. Even if he drafted wisely, there was now another hindrance to gathering talent. Over the 45 years of organized professional football in America, countless rival leagues had sprung up to compete with the NFL. Many lasted just one season, and sometimes that one season would allow one or two of their more successful teams to sneak in to the NFL. But in 1965, the latest American Football League had started to make serious inroads into the NFL's market share. The AFL began serious price wars to bid for all college graduates and even underclassmen, and were successful much of the time. As a matter of fact, the Bears would lose one of their 1965 first-round selections to the AFL, tackle Steve DeLong from Tennessee. Another notable selection, fourth-round fullback Jim Nance, would sign with the Boston Patriots.

But thankfully for the NFL and Chicago Bear fans, the other two first-round selections were retained. The first pick was All-American linebacker Dick Butkus from the University of Illinois. The other was halfback Gale Sayers of Kansas. Halas intended to start both immediately out of necessity if not due to pure talent. Iconoclastic middle linebacker Bill George has said that the first time he saw Butkus in practice, he knew his career as a Bear was over. Also drafted in 1965 was a pair of Big Ten college standouts, fullback Ralph Kurek from Wisconsin, and receiver Dick Gordon from Michigan State. Former Bear offensive lineman Abe Gibron was brought in as an assistant coach.

Also added as a free agent prior to the '65 season was the nation's leading rusher in 1964, running back Brian Piccolo of Wake Forest. Deemed to be too small and too slow by every other NFL team, Halas called a press conference to announce the signing of the nation's top runner. In the 1965 Bears' team highlight film, narrator Jack Brickhouse called Chicago "the toughest team in the NFL," no doubt thanks to their flashy rookie running back and bruising, terrorizing new middle linebacker.

The season, however, certainly didn't start with any panache for the team. The Bears were crushed at San Francisco in their opening game by a score of 52-14, then lost the following week at Los Angeles, 30-28. At Green Bay in the third week of the season, Chicago trailed 23-0 in the third quarter, when the season started to turn in their favor. Behind competent quarterbacking by starter Rudy Bukich, and the running of Sayers and second-year pro Andy Livingston, the Bears mounted a comeback. It would fall short, with the Bears losing 23-14, but at the same time the team started to ease the skid that had carried in from the previous season.

The Bears had lost five straight, which included their last two of 1964, but were primed for a turnaround as they opened their home schedule on October 10th. That day they beat the Los Angeles Rams 31-6. The first half of that game was dominated by Livingston's running and receiving. In the third quarter, Sayers burst onto the scene with a spectacular 80-yard scoring reception. The defense then stepped up with several fumble recoveries, and Chicago sealed the victory.

If the first win in the fourth week of 1965 was exciting, the following week's contest at Minnesota was pure exhilaration. Not only that, but Chicago's shining first-rounders punctuated the day. The Bears took a 14-0 first quarter lead behind touchdowns from Ronnie Bull on a run, and Johnny Morris on a reception. The Vikings kicked a field goal, then on the legs of quarterback Fran Tarkenton, scored a touchdown to diminish the Bear lead to a fragile 14-10. Chicago still held a 17-16 lead in the third quarter when the fireworks began. Minnesota scored a touchdown to take their first lead of the day, 23-17, before Sayers caught a Bukich pass for a touchdown, pulling the Bears ahead once again by a point.

Minnesota drove the length of the field, but were pinned with fourth down inside the Bears' five-yard line. Tarkenton rolled out on fourth down and scored, just outrunning Butkus for the touchdown. The score was then 30-24 Vikings, midway through the fourth quarter.

On the ensuing kickoff Sayers, the other rookie, returned the ball into Vikings territory. Ronnie Bull took over and on several key runs drove the Bears into scoring position. And with Sayers' second touchdown reception of the afternoon Chicago again pulled ahead, 31-30.

Minnesota was still not finished, however, driving relentlessly down the field to score another touchdown with just over two minutes remaining in the game. With the score 37-31, the Chicago rookies took over. Sayers returned Minnesota's kickoff following the touchdown 96 yards for another score, giving the Bears a 38-37 lead. The Vikings were driving once again until Butkus intercepted a Tarkenton pass, effectively sealing the victory for the Bears. Sayers the added his fourth touchdown of the game, which ended with a score of 45-37 and a win for Chicago.

After the roller-coaster victory in Minnesota, the 1965 Bears rolled up victories in seven of their following eight games. They didn't save their best for last, because in the final game of the season they lost at home to the Vikings. A Chicago victory combined with Baltimore and Green Bay losses would have given the conference title to the Bears. Instead, Chicago finished with a 9-5 record and a third-place finish in the conference. Green Bay, whom the Bears had defeated handily at home, went on to win the conference championship over Baltimore and the NFL crown over the Cleveland Browns.

The Bears and Sayers did save their best for second-to-last that season. On December 12th, they faced the San Francisco 49ers, who had embarrassed them in the season's opening game in California. That game remains the muddy contest by which all muddy contests are judged to this day. It had been raining in Chicago and the field was a quagmire. Only one player on the field seemed to have footing, and that player was Sayers.

The rookie first ripped off four touchdown runs of 50, 21, 7, and 1 yards, and scored on an 80-yard screen pass. Halas then took him out of the rest of the game, which was a blowout. He returned to the field to score on an 85-yard punt return. When the game was over, Sayers had scored six times, tying an NFL record that was shared with two other players. Also adding touchdowns in the contest were Mike Ditka, Jimmy Jones, and Jon Arnett. At the end, the score was 61-20.

The Bears didn't qualify for the postseason in 1965, but Rudy Bukich led the NFL in passing, Sayers was voted Rookie of the Year, and the Bears were voted the year's Outstanding Comeback in Sports. The offense also scored a tremendous 409 points—a Bears record that would stand for 20 years.

In 1966, the National Football League announced the biggest news in its history; it planned to merge with the rival AFL. Starting that season, both leagues would meet in a postseason playoff game to decide the champion of football. Although the leagues did merge that year, they would not play a combined schedule until 1970.

This was good news especially for the Bears, as before the merger they lost their first-round draft pick to an AFL team for the second year in a row. The AFL continued to bid aggressively against the NFL for college talent, and the Houston Oilers successfully took defensive tackle George Rice away from the Bears. Perhaps the most enduring draft selection for the 1966 Bears was fourth-round linebacker Doug Buffone, who was destined to play in just short of three different decades for Chicago.

Halas and his team were confident going in to 1966 after their rebounding, offensively powerful '65 campaign, but were disappointed to finish the season with a 5-7-2 fifth-place record. Tempering the disappointing finish was the fact that Sayers continued his dominance of the record book by leading the NFL in rushing with 1,231 yards and eight touchdowns. He took two more kickoffs back for scores, and dazzled everyone in sight with his now-trademark moves. In fact, in 1966 Sayers set a new NFL record for combined yards with 2,440. He was truly living up to his nickname, the Kansas Comet.

With Buffone's entrance, another legend retired when Joe Fortunato left the game following the '66 season. Buffone related what it was like to join the bruising Bears of the mid-1960s: "I went up to Rensselaer with the college all-stars to scrimmage the Bears after my senior year at Louisville, and playing outside linebacker, I had to line up across from Mike Ditka. I was thinking, man, I'm going to have to go through this every week across from this guy?"

As it would turn out, Buffone would only have to face Ditka the punishing blocker for one season of practice. The Chicago-Ditka relationship came to an end after the 1966 season, when the five-time pro bowl tight end was traded to the Philadelphia Eagles on April 26, 1967. Ditka had been fighting through shoulder and foot injuries throughout his fourth and fifth seasons but maintained his production, averaging 57 receptions per year through 1965. In '66, however, the tight end and his coaches, including Halas, began feuding, and he caught only 32 passes.

To make matters worse, at a player luncheon in 1965, Ditka and Johnny Morris made statements backing quarterback Rudy Bukich over Bill Wade, who was the current starter. Halas was incensed, and demanded that both players apologize publicly. Morris relented, but Ditka did not. The same year, Ditka made his famed comment that the owner/coach "threw nickels around like manhole covers," and just four days before the tight end became a free agent, Halas pulled the trade that sent Ditka to the Eagles for quarterback Jack Concannon. Concannon became the Bears' primary quarterback for 1967, finishing the season with a poor 50.9 pass rating. For the most part, Concannon's poor play mirrored Chicago's season, which in '67 ended with a 7-6-1 record, good for second place in the new Central Division of the NFL's Western Conference. If the Bears had not started the year 2-5, things may have been different. Sayers' performance tailed off during the season, as he finished third in the NFL in rushing. Sayers was hampered part of the campaign by injuries, giving Ronnie Bull and Brian Piccolo more opportunities to handle the ball.

The defense was still solid in '67, however, allowing opponents the worst completion percentage in the league, as well as forcing the NFL's second most turnovers. Middle linebacker Dick Butkus continued to crush opposing ballcarriers, and with his solid play Buffone became a key part of the defense in his second season. This unit seemed to be making a successful transition from the '63 team to the future, as only one starter, lineman Ed O'Bradovich, remained from the championship team.

The year 1968 would bring several historic coaching changes, and to this development the Bears would not be immune. Following the Green Bay Packers' second straight world championship victory, legendary coach Vince Lombardi announced his resignation. And on May 27, 1968, the Bears' George Halas, then 73 years old, announced that he was finally retiring for good. Halas said, "looking at practical realities, I am stepping aside now because I can no longer keep up with the physical demands of coaching the team on Sunday afternoons." He indicated that he couldn't keep up with the referees, in particular, and he said specifically that he "began to wonder if the referees were speeding up or I was slowing down."

Halas would turn over the head coaching reigns to former Bears player and assistant Jim Dooley. Dooley was well prepared, having served as the Bears' offensive coordinator from 1963 to 1965, and coordinating the defense in 1966 and 1967. When asked at the press conference announcing his hiring what the Bears needed to win a championship, Dooley quipped "our 1963 defense and our 1965 offense."

Foreshadowing many different eras of poor drafting in Chicago, the Bears' first-round pick in 1968 was Mike Hull, a fullback. After acquiring so many dominating runners over the years—

from Grange to Nagurski, Casares, Galimore, Bull, Marconi, and Sayers—Hull was a bust. The first-rounder would gain only 202 yards with the Bears in three seasons, and 207 in his seven-year career. Also acquired in the draft that season was quarterback Virgil Carter, who would be called upon to serve in his rookie season.

Speaking of the quarterback position, 1968 would truly begin a long tradition of revolving signal-callers for the Bears. On the roster that season were the aging Rudy Bukich, starter Concannon, third-stringer Larry Rakestraw, and Carter. The Bears won four of their five preseason games that year, including their first appearance in the NFL's Hall of Fame Game. Perhaps too much energy was expended before the regular season began, as Chicago lost their first two. In game three against the Vikings, the Bears won 27-17. In that matchup, however, both Concannon and Bukich were injured, forcing Rakestraw to be elevated from third-stringer to starter.

Rakestraw commanded the offense the next two weeks, both losses by large margins. The following week, Dooley called on Carter, the rookie, to take the reigns, and he responded with two straight wins over Philadelphia and Minnesota.

On November 3rd at Green Bay, the Bears faced a 3-3-1 Packer team that was slipping after their back-to-back title seasons. After 60 minutes of play, the Bears won 13-10 in spectacular fashion. With 38 seconds remaining in the game and the score tied at 10, Green Bay punted from their end zone. Bears' assistant Abe Gibron reminded head coach Dooley that a little-known NFL rule would allow a team a free kick after a fair catch, so the coaches told returner Cecil Turner to call a fair catch at any cost. Turner did as his coaches directed, and called the fair catch at Green Bay's 43-yard line.

Having seen the Packers do this against the Bears a few years back, the Bears were ready with their kicking unit, and placekicker Mac Percival booted a 43-yard field goal to give the Bears the victory. After the game, defensive end Willie Holman told the *Chicago Tribune*, "I didn't know what the hell was going on, I've never heard of such a play."

The rookie quarterback Carter was hailed for his third victory, Sayers punished the Packer defense with 205 yards rushing, and the Bears had rebounded from an 0-2 start to an even 4-4 record after eight games. Sayers was on a tear that season, averaging 6.2 yards per carry, and was on pace to rush for almost 1,500 yards. Unfortunately, his season was about to end.

On November 10th at Wrigley Field, the Bears met the 3-5 San Francisco 49ers. Chicago jumped out to a 17-0 lead in the second quarter, when one of the hits that will live in infamy to Bear fans occurred. Carter pitched out left on a sweep to Sayers, who after a two-yard gain was tackled low and powerfully by 49er Kermit Alexander. The hit struck Sayers squarely on his right knee as it was planted, tearing all of its ligaments. After the hit, Sayers jumped to his feet, but quickly learned he couldn't put any pressure on it. Sayers was lost for the season, and his comeback from the injury turned out to be remarkable by 1960s standards.

After Sayers' injury, Ronnie Bull and Brian Piccolo would fill in. The injury led to the first significant playing time for Piccolo, and he ended the season with 450 yards rushing. That year, Piccolo would remark that he wouldn't get 60 yards at a time like Sayers, but given the ball 10 times, he'd get the 60.

Chicago defeated San Francisco, then lost two more. After beating the New Orleans Saints and Los Angeles Rams, they returned to Wrigley Field to face the Packers once more, a game that would give the Bears the division crown with a win. Out of the running themselves, the Packers scored three consecutive touchdowns and led the Bears 28-10 in the fourth quarter. The Bears rallied furiously, scoring three touchdowns on the legs of Ronnie Bull and Dick Gordon, but eventually lost 28-27.

The Bears finished the 1968 season, one of the most exciting non-championship campaigns in their history, with a 7-7 record, one game short of division champion Minnesota.

Time for Change: 1969–1974

The Chicago Bears, their fans, and running back Brian Piccolo in particular had every reason to be optimistic about the 1969 season. The club had lost out on a division championship by

just one point in the 1968 season finale. Rookie quarterback Virgil Carter had come on in relief of the ineffective Larry Rakestraw and had performed brilliantly until he, too, was injured. The Bears' defense still dominated opponents at times. It featured a young middle linebacker with Hall-of-Fame potential in Dick Butkus and a few holdovers from the dominating 1963 unit.

After poor performances and benchings the previous season, Rakestraw did not return to the team. Head Coach Jim Dooley felt the quarterback position was in good hands with Carter battling veteran Jack Concannon for the starting spot. Additionally, the team spent its second-round draft pick on rocket-armed passer Bobby Douglass from Kansas State, who was expected to begin his career as a backup and progress as the years went on.

Piccolo, in particular, was eager for his career to continue to blossom. After sitting out 1965 with a hamstring injury, the small-framed running back was a member of the taxi squad in 1966, and carried the ball just a few times in 1967. Pure heart, determination and a positive attitude kept him on the team. After Sayers' injury in 1968, "Pic" (as his teammates called him) became a starter and responded by rushing for 450 yards, catching 28 passes and scoring two touchdowns in six games. At his annual postseason meeting with Halas, Piccolo made it known that his dream was to line up in the same backfield with Gale Sayers, and hoped that 1969 would be the season in which it would finally happen.

According to Bear linebacker Doug Buffone, 1969's training camp in Rensselaer was like any other. Players practiced hard by day, and at night either tried to avoid or openly taunted the local security guard Halas hired to watch player's actions off the practice field. "Super Bolts," as the spy was called by players of Buffone's time, would make sure he knew everything that happened with players off the field.

"One evening, some of us went up to the Indiana dunes, and we were getting back to camp around one or two, which actually wasn't that late compared to some nights," Buffone said. "We pulled in to the parking lot, and we saw Super Bolts coming, so we all ran in the back door of the dorms to our rooms and thought we got away with it. Little did we know, Super Bolts went around to every car in the lot and felt their hoods, and when mine was hot he knew I was involved. Even after Halas retired, he would still come down to camp and had a corner room in the dorms. He knew what everyone did."

Another seemingly innocuous development that summer would later prove to be a haunting memory. "I never missed practice," Buffone said, "And neither did Pic, but one day, for some odd reason we were both sick and stayed in the dorms all day together. Then he seemed to get better. But one other day, and I'll never forget this, I was by his locker, and he was coughing, coughing, coughing. I said 'Pic, you better get that checked out; get some cough medicine or something.' He said, 'aw, Doug, I've got cancer.' He was screwing around, like he always did. He had no idea what was really happening."

Despite the cough, Piccolo continued to play hard for the 1969 Bears, although the team's results on the field were not reflective of the running back's performance. Chicago lost their first seven games of the season, by far the worst start in the history of the franchise. Jack Concannon had won the starting quarterback job during the preseason. After four losses, however, Dooley benched him and started Douglass, the rookie, instead of 1968 savior Virgil Carter.

In game six of that season, a humbling 9-7 loss to the Los Angeles Rams, starting fullback Ronnie Bull was injured. The chance Piccolo had been waiting for had arrived, and he was inserted as the top fullback. He started three games and it looked as if he had finally proven that he deserved a place in the starting lineup. Against Minnesota on November 2nd, Piccolo rushed seven times with a 5.3 average per run. The following week against Pittsburgh, the Bears won their first game of the season. In that game, Piccolo handled the ball 14 times and scored a touchdown.

Throughout the 1969 season, the cough that had alarmed Buffone earlier continued to worsen. On November 16th at Atlanta, Piccolo played before members of his wife's family, and he scored the Bears' last touchdown of the day in a 48-31 loss. After the touchdown, Piccolo returned to the bench and took himself out of the game for the first time in his life. He continued to cough, couldn't breathe, and had chest pains.

The following Tuesday, Piccolo practiced with the team, and then went to see the Bears' team doctor for a checkup. Following a chest x-ray and tests, the 26-year-old father of three was diagnosed with an extremely rare form of cancer. The running back had a clean chest x-ray taken in July before training camp, and over the next four months had developed a grapefruit-sized tumor in his chest cavity. The form of cancer he was diagnosed with was embryonal cell carcinoma, and in 1969, according to Piccolo, only 400 operations had been performed on it throughout the world.

Following his diagnosis on November 21, 1969, Piccolo would travel to Memorial Sloan-Kettering Cancer Center in New York City for further tests and surgery to remove the tumor. The Saturday before making the trip, players visited Piccolo in his hospital room, throwing an impromptu party of sorts. They left early, as they readied for a game against the Baltimore Colts at Wrigley Field the following day.

Ed McCaskey, son-in-law of George Halas and new Vice President of the Bears, was asked by the owner to spend as much time as he could making sure Piccolo and his wife Joy's needs were met. That evening, McCaskey wrote a speech for Gale Sayers to deliver to the team prior to the Colts game. By reading the speech, Sayers would ask the team to dedicate the game to Piccolo so he could be presented with the game ball in his honor.

Many tears were shed in the locker room, a scene that is eternalized in the movie *Brian's Song*. The saddened team took to the field determined to defeat the Colts, even though their record stood at 1-8. Late in the fourth quarter, the Bears were accomplishing their goal, beating Baltimore 21-14. But with rookie quarterback Bobby Douglass still at the helm, and a tired defense cracking, the Colts game back to defeat the Bears 28-24.

The players' traditional post-game dinner was held that night not at a usual upscale Chicago restaurant, but in room 524 of Illinois Masonic Hospital. Sayers apologized for not being able to present the game ball to his backfield mate and friend, and Piccolo replied, "For Christ sake, if you couldn't get me the ball, just get me cash." Not being able to win a game even for their sick teammate could only have happened to the 1969 Bears.

Piccolo underwent a $4^1/_2$ hour operation on November 28, one day after Thanksgiving. Doctors were confident that the tumor had been removed in its entirety, although they did remove a lymph node that was cancerous, indicating a slight spread outside the chest cavity. Piccolo was discharged home on December 10, 1969. He would undergo chemotherapy in Chicago and was asked to return to New York in June 1970, to evaluate his football career.

Despite owner George Halas' reputation for keeping his coins in his pocket, he instructed Piccolo to seek the best treatment he could find in the world and assured him the Bears would cover the expenses, which they did—in addition to paying the running back his full salary, including incentives, for that season.

On the football field, the Bears continued to lose. Gale Sayers was on his way to rushing for 1,032 yards and eight touchdowns to complete the greatest comeback from knee surgery anyone had seen to that time. But without a passing game, wins were difficult to come by. Between their three quarterbacks, Chicago averaged only 106 yards passing per game and threw 21 interceptions on the year, almost two per game. Bobby Douglass had started seven straight games, losing six, before Dooley finally turned the offense over once again to Virgil Carter. But it is alleged in Cooper Rollow's *Bears Football Book* that Dooley did not give Carter a game plan.

Despite not knowing the plays, Carter passed for almost 300 yards in the contest, but the Bears still lost 42-21.On December 14th, Carter completed just two of 17 passes and was benched at halftime. Following the game, a livid Carter claimed that Dooley had promised the second-year player that he would not be taken out of the game under any circumstance. "The Bears have screwed me for the last time," he told the *Chicago Tribune*. Later, he was quoted by the Tribune as saying he hoped Halas "wouldn't be chicken sh— enough" to force him to stay in Chicago. Halas fined Carter $1,000, suspended him for the final game of the season, and traded him the following year.

The Bears did lose that final game of the 1970 season to Detroit, 20-3, ending the

campaign with a 1-13 record, worst in the history of the franchise. Ironically, even worse, the Bears only victory happened to come against the Pittsburgh Steelers, the only other 1-13 team in the league. Since both teams finished with identical records, a coin would be flipped between the two to decide who had the first overall pick in the 1970 draft. The stakes were high, as everyone knew the first pick in that draft would be Louisiana Tech quarterback Terry Bradshaw.

According to a 1989 *Chicago Tribune* article, the flip was conducted in a posh New Orleans hotel prior to Super Bowl IV. At the toss, Ed McCaskey called heads, and the 1921 silver dollar fell from the air to land with tails up. According to the article, a Chicago sportswriter in the back of the room yelled, "McCaskey you bum, you can't even win a coin flip!" Consequently, the Bears wound up with the number two selection, which they would trade away.

Meanwhile, things looked positive for Brian Piccolo and his family in January 1970. Brian and his wife Joy had been invited to Phoenix that month for a celebrity golf outing sponsored by American Airlines. Brian was eager to leave, but not until he wrote a heartfelt letter to a University of Texas college football player that had been diagnosed with bone cancer around the same time. The player's name was Fred Steinmark, who turned out to be a Bears fan. Piccolo shared his faith in God with the younger gridiron star, whose leg had been amputated at the hip, ending his sports career. Piccolo stated that he knew both of the athletes were living out the plan God had for them. Steinmark would die in 1971.

The Piccolos enjoyed their trip to Phoenix, where Brian played several rounds of golf with Chicago Cubs star Ernie Banks. Doug Buffone remembers what happened shortly after Piccolo's return. "We had a basketball team that played during the offseason, and we made Brian our coach, since he couldn't compete. We were walking out of the gym, and Brian was rubbing his chest. I said 'what's the matter, Pic?' He said, 'I think this thing's coming back.'"

Piccolo had discovered a lump on his chest, indicating a radical spread of his cancer. He returned to New York on February 15th. After being given a regimen of "intensive quadruple chemotherapy," it was recommended that Piccolo undergo a mastectomy to remove this latest tumor. His second surgery was performed on March 24th. Following further chemotherapy and radiation treatment, Piccolo's left lung had to be removed on April 9th. Just prior to his third operation, Piccolo had to finally give up hope that he would play football again, but he never gave up hope that he would live.

In late May of 1970, Piccolo returned home after three weeks of radiation therapy. Around the same time, Gale Sayers flew to New York to accept the George S. Halas Award, given to the most courageous football player of the preceding season. Sayers was receiving the award for the miraculous comeback from his devastating knee injury. As Sayers stepped to the podium to receive the award, he told the audience: "He has the heart of a giant and that rare form of courage that allows him to kid himself and his enemy: cancer. He has the mental attitude that makes me proud to have a friend that spells out the word courage 24 hours a day, every day of his life. You flatter me by giving me this award, but I tell you I accept it for Brian Piccolo. It is mine tonight, it is Brian Piccolo's tomorrow. I love Brian Piccolo, and I'd like all of you to love him, too. Tonight, when you hit your knees, please ask God to love him."

During his final days, although Piccolo surely knew he would perish, he refused to admit it publicly. While on duty with his National Guard unit, Buffone called Piccolo during the running back's last week. While struggling to breathe, Piccolo informed his friend not to worry about him, as he was "too tough" to succumb to the disease. When McCaskey visited and burst into tears at first site, Piccolo said "don't worry about me, big Ed, I'm not afraid of anything. Only [Packer linebacker Ray] Nitchke." Piccolo died on June 16, 1970, just over seven months after his diagnosis. He was 26, and left a wife and three daughters.

"Sheer sadness, that's for damn sure," teammate Ed O'Bradovich told ESPN classic in 2001. "Forget about being a football player. When you're 26 with a wife and three children, and the good Lord takes you, I don't find too much happiness in that."

The Chicago Bears organization carried on through that 1970 season, but were "in shock"

over Piccolo's death, according to Buffone. "The accident with Galimore and Farrington was one thing, but for this illness to happen to such a healthy young man was another," he said. The Bears scheduled a scrimmage with the St. Louis Cardinals in Rensselaer that summer to benefit the Piccolo family, and set their sights on the 1970 campaign.

Desperate for an influx of veteran talent to turn the tide from the disappointing '69 season, Dooley and Halas elected to trade their first round pick, the second selection overall, to Green Bay for linebacker Lee Roy Caffey, running back Elijah Pitts, and center Bob Hyland. With the pick, the Packers drafted defensive tackle Mike McCoy, who would play with them for the next seven seasons. For the Bears, Pitts didn't last the 1970 season, and the other two were shipped off after just one year.

Chicago's second-round pick was traded to Dallas for running back Craig Baynham and defensive back Phil Clark. Likewise, both of those players only lasted a season with the team. The Bears also acquired quarterback Kent Nix, and in the draft took receiver George Farmer and linebacker Ross Brupbacher in the third and fourth rounds.

Though the draft and trades may not have produced long-term results, they seemed to pay immediate dividends in the first two weeks of 1970. In that fortnight, Chicago doubled its win total of the previous season by starting 2-0 on the year. Kick returner Cecil Turner ran back a kickoff for a touchdown in each of these two games.

The home opener on September 27th was notable, when the Bears started a home season outside of Wrigley Field for the first time in their history, except for 1920 in Decatur. With the Cubs still playing their home schedule, the Bears packed Northwestern University's Dyche Stadium with a sellout crowd. Also new that year were player's names on the back of every jersey, which was a new NFL rule.

Following the first two wins over the New York Giants and Philadelphia, the 1970 Bears lost four straight. They won at Atlanta, then lost two more. In the fourth game of the season, a particularly troubling 24-0 shutout at the hands of Minnesota, Sayers again suffered a knee injury and was lost for the rest of the season. The accident didn't even happen while he was carrying the ball; he stretched a ligament while he was chasing Viking Alan Page on an interception return. The injury would require surgery.

After a 2-0 start, the Bears found themselves with a 3-6 record in mid-November. The week before Chicago hosted Buffalo in the season's ninth week, Dooley switched starting quarterbacks once again, this time benching Jack Concannon for Bobby Douglass. The strong-armed lefty proceeded to fire four touchdown passes on the day, but broke his wrist in the process, ending his season after just one game. Interestingly, three of the touchdown passes came after the injury. The Bears won 31-13 and seemed to be discovering an offense.

On November 29th, the Bears traveled to Baltimore to face the eventual Super Bowl champion Colts. Although they jumped out to a 17-0 lead, Chicago lost 21-20 in a game similar to the "Piccolo tribute" the year before. They lost again at Minnesota a week later.

Chicago started the season 2-0, and would finish 2-0 when they defeated Green Bay and New Orleans in consecutive weeks to end the year. Against Green Bay, Jack Concannon reprised Douglass' earlier performance and threw four touchdowns. The resurgence was too late for that season, however, and the Bears finished 6-8 on the 1970 season.

This mark, two games below .500, was clearly better than the previous year. Primary wide receiver Dick Gordon led the NFL with 1,026 yards on 71 catches and 13 touchdowns, a Bear receiving mark that would stand for over two decades. Opposite Gordon, rookie George Farmer showed that his hands would be counted on for years, and linebacker Ross Brupbacher looked to be a fourth-round gem.

During the off-season prior to the 1971 campaign, the Bears learned the NFL would now require teams to play in stadiums that seated at least 50,000 spectators. With this new rule Wrigley Field, with a capacity of around 45,000 for football, would no longer meet the minimum. The Bears organization first considered Dyche Stadium in Evanston, but officials from that city balked at allowing a professional team to play in their municipality. The only other logical

choice was venerable Solider Field on Chicago's lakefront, southeast of the Chicago loop. The decision was made, and the Bears would begin their 1971 season in a new den.

Municipal Grant Park Stadium was built in 1924 as a municipal multi-use stadium with grand roman colonnades on the east and west sides of the structure. Shortly after its construction, it was renamed in honor of soldiers who had served in World War I. Due to its design to host a multitude of events, nearly two football fields could be located in the area between the north and south ends of the structure. True to its nature, over the years automobile races, boxing matches, religious festivals and even a ski-jump competition were hosted there. But despite the Chicago Cardinals making it their home for several years, it was not designed primarily for viewing football games.

To make it suitable, the Bears moved their temporary Wrigley Field seats, the structure that was moved in ahead of the bleachers in the baseball stadium, to Soldier Field and placed them in what became the north end zone. That well-traveled seating structure would remain at the Bears' new home until renovations on the stadium took place prior to the 1980 season. On Wrigley Field, Halas commented that "the fans were at our elbow." Many opposing NFL players lamented the fact that fans almost sat on their bench, they were so close to the visiting team. For that reason, Halas felt Wrigley was "worth almost a touchdown to us" during every game. Soldier Field's configuration was so different that almost immediately, Halas began thinking of ways to build a new stadium for the team. He was envious of new stadiums being built for other NFL teams, but was quoted in his autobiography as saying, "If I had to choose between loving fans and a luxurious stadium I would stay with the fans."

Jim Dooley entered the 1971 season with a 14-28 overall record in his three years, not exactly a record in which to feel confident. Perhaps sensing that Gale Sayers' career was in jeopardy, the Bears drafted running backs in the first two rounds of that year's draft, coincidentally both from Missouri, in Joe Moore and Jim Harrison. This draft would only continue a dubious personnel trend, however, as the pair of top rookies would only rush for a combined 103 yards on the season.

During training camp in 1971, film crews from Columbia Pictures were on hand to film *Brian's Song*, a movie detailing Brian Piccolo's life and death. Many Bears players had roles in the film, including assistant coach Abe Gibron, linebackers Butkus and Buffone, quarterback Concannon, and others. The film would be released as a made-for-TV movie that fall. Prior to its release, Bears players attended a first screening of the movie with Piccolo's widow Joy, and according to Buffone, "there wasn't a dry eye in the house." The film remains a legendary story of courage and racial harmony to this day.

The Bears organization had also started an annual Brian Piccolo award, given to the team's rookie that best exemplified the strength, courage and determination of the late running back, and founded an annual golf outing to raise money and awareness of the disease that took his life. His foundation raised millions of dollars for cancer research over the years, and as a result the cure rate for embryonal cell carcinoma has improved dramatically.

Because they had shared Wrigley Field with the baseball Cubs for 50 years, on September 19, 1971, the Bears were able to open the regular season at home for just the seventh time in their history. On that day, they hosted the Pittsburgh Steelers, who deployed a quarterback the Bears might have had in Terry Bradshaw.

Pittsburgh looked as if they would spoil the Bears' christening of their new stadium, as they led Chicago 15-3 late in the game's final period. Behind key defensive plays from Ed O'Bradovich, Dick Butkus, and Ross Brupbacher, the Bears rallied to score 14 points in the final four minutes to win 17-15. In the next game at Minnesota more of the same magic was present, and Chicago, like the year before, began the season 2-0.

But there would be no midseason collapse during this campaign. After the first nine games, the Bears had a 6-3 record. During their sixth victory, over the Washington Redskins, it seemed that even when something went wrong, it worked out in Chicago's favor. The Bears had tied the game at 15-15 late in the fourth quarter, but the extra point snap was high. Holder Bobby Douglass rifled a desperation pass into the end zone, and it fell into the hands of Dick Butkus.

The linebacker playfully handed the ball to a nearby Redskin defender, as to say "how 'bout that," only to have the Redskin slap the ball away.

Winning three of the remaining games might have given the Bears a fighting chance of making the playoffs, but it was not to be. The Bears lost each and every one of the remaining five games, and again finished 6-8 on the season. This finish was due in part again to massive shuffling at the quarterback position. Concannon began the season as the starter, as he had over the past four seasons, but was pulled by Dooley for Kent Nix several times in the first two games. Nix and Concannon would both be injured, and Douglass stepped back in. In a telling statistic, the Bears finished the season with a 41.9 combined completion percentage, their opponents 52 percent.

After carrying the ball only 13 times during the season, Gale Sayers retired due to his repeated knee injuries. Over a shortened seven-year career, the enigmatic running back became Chicago's second all-time leading rusher with 4,956 yards and a 5.0 average per attempt. After the deaths of Galimore and Piccolo, Sayers' battle with injuries would be another chapter in the book of troubles at the position in Chicago. No other team would have so many stars, yet so many sad stories at running back.

Halas had had enough by that point, and announced in late December that Dooley was fired as head coach of the Bears. It was the first time the Bears relieved a coach and did not replace him with Halas.

Players that talk about the Dooley era give the coach his due, but do not seem convinced that he was truly "running the show." According to running back Ronnie Bull, "Dooley was a marvelous football man. He helped install the zone defense for the first time, and really did a good job of figuring out how to attack that Green Bay defense from an offensive perspective. But at the same time, we never really knew if it wasn't Halas that was really pulling the strings."

According to Buffone, during the 1970 home opener at Dyche Stadium, Halas was still hanging on to a coaching role from his spot in the press box: "I came running off the field after a series, and the ballboy comes running up to me. I couldn't imagine what he wanted, but he had a note in his hand. I opened the note, and it said 'Watch out for the sweeps–George Halas.' So we knew Halas was still involved in day-to-day coaching, no question about it."

In Dooley's place, the owner elevated seven-year assistant coach and former player Abe Gibron. During Gibron's tenure from 1972 to 1974, the Bears would be even worse on the field, posting an 11-30-1 record. While the era was clearly depressing from a football standpoint, never again would players on both the Bears and the opposing sidelines be more entertained by sideline antics of a coach.

Gibron played on the offensive line for the Cleveland Browns in the 1950s, before finishing his career at the same position with the Bears in 1958 and 1959. Buffone said, "the rumor about Abe in Cleveland was that despite the fact that he was short, heavy, and round, he could cover the first 10 years off the ball faster than any player in the NFL. He was a hell of a football player." Not only that, but when he took over the lead job for the Bears, he was a player's coach, according to Buffone.

In Mudbaths and Bloodbaths, a book that chronicles the Bear-Packer rivalry, the authors say, "There might not be another head coach in the history of the rivalry that worked himself into more of an emotional lather than Abe Gibron. Not George Halas, Curly Lambeau, Mike Ditka or Forrest Gregg." In that book, former Packer Dave Robinson said, "in those days, the commissioner was worried about players taking 'uppers'. We were convinced that the only person on the field that could be taking uppers was Gibron."

One of the most colorful stories of the Gibron era was how he treated longtime Packer kicker Chester Marcol. Marcol began his Green Bay career in 1972 and faced the Bears each game until 1983. The kicker beat the Bears in the '72 preseason, then in the teams' first regular season meeting that season on late field goals. After those contests, Gibron decided to utilize backup running back Gary Kosins as an "enforcer" against Marcol. "On kickoffs, Abe would say 'Go get him, he's no Polish Prince. Go knock his ass off.' My job was to go

after Marcol and intimidate him, to make him think every time he kicked the ball off he would have someone coming to knock his block off."

According to the rivalry book, this tactic may have worked, as Marcol missed a winning field goal attempt in the Bear-Packer 1973 exhibition. A sportswriter in Milwaukee suggested that NFL Commissioner Pete Rozelle should step in to end Gibron's practice, and the Bear coach responded by saying, "Do you want football to be two-hand touch or something?"

According to various sources, despite his poor record of victories, no coach took more pride in inflicting a physical beating on the opposing team. After the Bears lost to the Packers 23-17 in 1972, Gibron bragged that Packer players "went off the field like flies." Buffone also remembers a Bear loss to the Detroit Lions sometime during Gibron's tenure. "After the game, I'm dejected about the loss, of course, and Abe comes up and says 'what's the matter, Doug?' I said, 'we lost another game, Abe.' Abe says 'don't you worry, we put eleven Lions out of the game today.' And I said 'yeah, Abe, but they don't put parentheses next to the standings listing how many players you put out of the game.' "

In 1972, for once a quarterback started the entire season for the Bears. Bobby Douglass set an NFL record that still stands by rushing for 968 yards from the quarterback position. But his completion percentage was a dismal 37.9, and the team finished the season 4-9-1. An interesting fact about the 1972–73 seasons was how the Bears tinkered with the design of their uniform for the last time. Their home jerseys omitted the stripes on the sleeves, and on the road, their white uniforms featured block numerals for the only time in their history. They returned to their classic road look in 1974. Also in '72, their helmet "C" became burnt orange bordered by white.

In 1973, the team posted a 3-11 record and could only improve to 4-10 in 1974. Douglass was slowly supplanted in the lineup by Gary Huff, a Florida State quarterback selected in the second round of the 1973 draft. Also drafted during the Gibron years were several enduring legends of Bears lore. In 1972, the top picks were offensive tackle Lionel Antoine and defensive back Craig Clemons, along with punter/tight end Bob Parsons and defensive tackle Jim Osborne. One '72 draft pick that didn't make the team was quarterback Jim Fassel, destined to one day become a head coach in the league.

In addition to Huff, in '73 the Bears selected defensive end Wally Chambers, defensive back Alan Ellis, and linebacker Don Rives. The 1974 draft brought linebacker Waymond Bryant, running back Ken Grandberry, and defensive tackle Jeff Sevy. The selection of Bryant was deemed necessary, as in 1973 the Hall of Fame career of Dick Butkus came to an end due to injuries. Butkus had wreaked terror on opposing offenses for nine years, but after playing in 110 of 112 possible games, he could only play in nine his final season.

Major changes were in order for the Bears prior to the 1974 season. George Halas' son, George Jr. ("Mugs") had been serving the team as President since 1963, but twelve years later felt the organization needed to be led by an outside "football man" for the first time. In September of that year, father and son Halas hired former Minnesota Vikings General Manager Jim Finks to lead the club into the latter part of the 1970s. With the hiring of Finks, the players knew that after the current season, major changes would be in order if the team didn't start winning regularly.

At the end of that campaign, rumors flew that Gibron would indeed be fired. "We went in to the last game of that season, against Washington, and Abe wanted his job back, there was no question about that," Buffone remembers. "The players did everything we could in that game, because we wanted Abe to come back, but we got buried by the Redskins. The next day, Finks fired Gibron."

The next year, Finks would move the Bears' training camp from Rennselaer to Lake Forest, Illinois, and a grand Gibron-Rennselaer tradition would die. According to Buffone, Wednesday nights at training camp under Gibron were bonfire and feast nights. "Abe would get a lamb, sweet corn, and kegs of beer. We'd roast the lamb, eat, drink beer, and have a great time. Even Halas would be there," he said.

One night in particular, Buffone stayed with his coach to help extinguish the fire: "Abe says to me, 'did you ever try this,' and pulled out a bottle of Wild Turkey. To make a long story short, we finished the bottle. The next day, I'm feeling sick, we start running, and I finally collapsed and started vomiting. Abe runs over to me and starts kicking me. Abe said, 'don't you know better than to stay up late drinking that stuff.' I said, 'but you were with me, Abe!' And Abe said 'I don't care who you were with, if you can't handle it, don't do it.' "

After his firing, Gibron couldn't hide some disdain for the press, saying, "God gave me the good fortune to be one of the twenty-four head coaches in the NFL, not one of the fifty thousand sportswriters."

Finks Takes Charge: 1975–1981

Having been hired in September 1974, new General Manager Jim Finks had no choice but to watch his team languish through that first regular season. After it was over, wholesale changes would be made on a scale never before seen in Chicago.

Finks was drafted into the NFL by the Pittsburgh Steelers in 1949. After a seven-year career as a quarterback and defensive back, he coached at Notre Dame, then served a stint in the Canadian Football League as a general manager. In 1964, the Minnesota Vikings hired him as their GM, and in a matter of two years he helped turn the Vikings from a losing bunch to the feared "Purple People Eaters."

Finks left the Vikings, and after working on NFL Management Council issues for several years, the forward-thinking Halas' hired Finks as the first non-family member to lead the Bears in its 55-year history. After firing Gibron, Finks "started cleaning house from players all the way down to the equipment manager," according to Buffone. All told, over 70 players that participated in some fashion with the Bears in 1974 would not return for the next season.

Finks made short work of hiring a new head coach. Gibron had been dismissed on December 17th, and on New Year's Eve, the general manager announced the hiring of 38-year-old former NFL linebacker Jack Pardee. Pardee served as an assistant coach for the Washington Redskins, then as a head coach in the short-lived World Football League. The hiring marked the first time a leader of the Bears on the gridiron had not previously played or coached for the organization.

During the spring of 1975, Pardee and Finks invited 28 players from the team to their first minicamp in Orlando, Florida. According to the team's newsletter, the *Bear News*, in Pardee's first speech to the team, he said, "We'll win football games for the greatest organization in the history of pro football. The Chicago Bears *are* pro football, from George Halas to you. You are now the Bears; the new Bears. All things equal," he continued, "with effort and sound special teams play, the Bears will win more games in 1975. Two, three, maybe four games on special teams alone."

Finks was busy after the final game of '74 building virtually a new team of veterans. Players that came over from other teams in the first few months of the Finks era included offensive linemen Dan Neal, Noah Jackson, and Bob Nordquist; tight end Greg Latta; defensive back Nemiah Wilson; wide receiver Steve Schubert; running back Mike Adamle; and kicker Bob Thomas.

In the '75 draft, the Bears struck gold from top to bottom. By virtue of their 4-10 record from the previous season, the Bears owned the fourth overall pick in that year's auction, which was held in late January. Of high priority for the new regime was the running game, of course, since a rotating unit of mediocrity had been manning the backfield since Sayers and Bull retired. Improving the running game would necessitate rebuilding the offensive line as well as the backfield. In 1974, Chicago had yielded 36 quarterback sacks to their opposition, Pardee noticed, even though the league did not count them as a statistic at that time. "We can't have 50 sacks a season and expect to win any games," the new coach said.

On draft day, quarterback Steve Bartkowski was selected first overall by Atlanta. Next, Dallas selected defensive lineman Randy White, followed by Baltimore picking guard Ken Huff. With the fourth selection overall, the Bears were able to select the man they wanted all along— running back Walter Payton from Jackson State in Mississippi. When he first addressed the

press, the soft-spoken yet confident Payton spoke those immortal words: "When I get through with Chicago, they'll be loving me."

Throughout the rest of the draft, the Bears selected eight more eventual starters on both sides of the ball. Defensive end Mike Hartenstine was their second-round pick, followed by corner Virgil Livers in the fourth, guard Revie Sorey in the fifth, quarterback Bob Avellini and linebacker Tom Hicks in the sixth, defensive lineman Roger Stillwell in the ninth, safety Doug Plank in the 12th, and finally running back Roland Harper in the 17th round.

As the regular season began, Gary Huff was again the Bears' starting quarterback, and the rookie Payton was in the lineup from the beginning. In a disappointing 35-7 loss to Baltimore in Soldier Field, Payton attempted to rush the ball eight times, but gained zero net yards. It was an inauspicious start for the future star. Payton showed flashes of brilliance throughout his rookie season, but also suffered the low-point of his career. Against Pittsburgh, Payton's ankle was slightly injured, and a trainer insisted he sit out the game. It was the only game the running back would miss in his career.

The Bears started the season 1-6, then went to 2-9, and then 3-10. In the season finale of the 1975 season, they finally put things together to defeat the New Orleans Saints 42-17 in that team's new home, the Superdome. Payton was brilliant on the day, rushing for 134 yards and ripping off what he called the best touchdown run of his career.

As the 1975 season came to a close, many facets of the Bears' game had improved. At season's end, seven rookies were starting for the team: Avellini, Payton, Harper, Hartenstine, Stillwell, Plank, and Livers. In fact, the Bears were now led by the youngest coach in the NFL, and fielded 17 rookie players, the highest number of in the league.

For Hartenstine, despite the record, the players took a great deal of pride in how they played his rookie season. "We were 4-10, sure, but of the ten teams that beat us, only one of them won their game the following week. We laid it on the line and played some tough football," he said. Despite the improvement and hope for the future, the Bears finished 1975 where they left off the previous year, with a 4-10 record.

In 1976, the rebuilding continued, and this time focused on the offensive line. The Bears' top pick in that draft, eighth overall, was tackle Dennis Lick from Wisconsin. They also added tackles Dan Jiggetts in the draft and Wayne Mattingly in a trade. Also drafted that season was wide receiver/running back Brian Baschnagel and linebacker Jerry Muckensturm. Signed as free agents were safety Gary Fencik, who had been injured and released by the Miami Dolphins, and wide receiver James Scott.

That season, Chicago would finally turn their record around for the first time since Dooley's departure. They finished the season 7-7 despite playing an extremely difficult schedule that featured the playoff-bound teams of Dallas, Minnesota, Oakland, Los Angeles, and Washington. Of those opponents, the Bears defeated Washington and Minnesota (second meeting), and lost by a very small margin to Oakland and Minnesota (in the first game).

Payton made his first NFL Pro Bowl appearance in 1976 after he rushed for 1,390 yards and 13 touchdowns in his sophomore season. Avellini had nailed down the starting quarterback job, although he completed less than 50 percent of his passes and threw for twice as many interceptions as touchdowns. Pardee was named NFC Coach of the Year.

One young player that was making an impact on defense was safety Doug Plank, whose reputation for punishing tackles in the secondary was beginning to grow. "Doug Plank started the Nineteen Seventy-Five season probably fourth-string on the depth chart, but somehow he ended up starting before the season was over," Buffone remembers. "We used to call him 'bullet' because he absolutely loved to hit people. He loved it so much that a lot of times it didn't matter if it was the opponents, or his teammates. My tackling improved so much, because if I saw Plank racing over to the pile, I wanted to make sure I had the opponent down so I could get out of the way before Doug came in."

Buffone remembers one time, specifically, where Plank's subliminal urge to hit reared itself above the circumstance. "It was third down and long, and I called the defense and said 'ok,

Plank, here's your chance for an interception. We're going to blitz, and we've watched these guys and know they're going to throw that pass over the middle.' Just as I said, they threw a pass right over the middle, and I expected Plank to step in front of the ball and get the interception. What happens? Plank takes a clean hit at the guy. 'What were you doing?,' I asked him, and he said 'I just can't help hitting them.' "

Plank was never selected for a Pro Bowl, but he and Fencik teamed to become the most feared safety tandem in the NFL from 1976 through 1981.

Massive personnel improvement continued during the 1977 offseason. Tackle Ted Albrecht was the team's first-round selection, and the Bears hoped to team him with Dennis Lick, Revie Sorey, Noah Jackson, and Dan Neal for years to come. Still not satisfied with the quarterback position, Finks traded 1978's first-round pick to Cleveland for veteran signal-caller Mike Phipps. Also selected in the draft were defensive back Mike Spivey, fullback Robin Earl, and another quarterback, strong-armed Vince Evans from USC. The two new quarterbacks were expected to battle Avellini for the starting job that season.

Another important new addition to the Chicago Bears in 1977 would never step foot on the field, not for a single play. The addition was announced to Chicago in a headline in the *Bears News* that read: "Club Improves Soldier Field Sidelines." This new addition was the Honey Bears, the first group of organized cheerleaders in the team's history.

"Dallas, Denver, and Kansas City had cheerleaders at that time," said Cathy Core, founding coach of the Honey Bears. (Core is currently choreographer for the Chicago Bull's Luvabulls and Matadors.) "Jim Finks called me, because George Halas thought the team needed some dancing girls."

Core had experience coaching junior high girls' cheerleading squads, and was floored when out of the blue she received the call from Finks: "I had a friend from church that knew what I did, and she was acquainted with Ted Haracz, public relations director of the Bears. One day, I received a call, and the man on the other end of the line said 'this is Jim Finks, general manager of the Bears.' And I said, 'yeah right, and I'm Mary Poppins.' I didn't believe him."

Finks had Core's friend from church, who had introduced him to Core, call her and confirm that he was indeed who he said he was. An embarrassed Core received another call from Finks, who asked her to come to the Bears' offices in Chicago to talk about her putting together a cheerleading squad. Core and her husband drove into the city, which incidentally was Core's first trip downtown since moving from New Jersey several years before.

"We went into the office, and told the receptionist that we were there to see Mr. Haracz. Next thing we knew, George Halas came out, which was obviously a mix-up of their names," Core remembers. "He graciously gave us a tour of the offices, and we worked out a plan to create the Honey Bears. Halas definitely wanted cheerleaders for the Bears,"

Core was sent to Texas to speak with representatives from the Dallas Cowboys cheerleaders, and after selecting 80 finalists from 200 applications, Core picked 28 women to form the group's first unit. They made their first appearance at a game in the 1977 opener against Detroit on September 18th. The exercise was a great learning experience for Core and her group. "No one had told me the intricacies of the NFL game, such as not to stand in front of the 30-second clock," she said. "I was walking by the opposing bench, and someone handed me a phone. It was Haracz, from the press box, giving me tips on what to do and what not to do." From that first game, the Honey Bears would be a fixture in Chicago for the next nine years.

On the football field in '77, the Bears started the season 4-5, which included a blowout 26-0 victory over Green Bay, and a devastating 47-0 loss to Houston in the Astrodome in week nine. Finks' team had made so much progress over the previous three seasons that anything short of the playoffs that year would be considered a disappointment. In fact, Pardee had said before the season, "We're not out here trying to build character, we'll go out trying to win every game."

The team faced a fork in the road as they took on the 2-6 Kansas City Chiefs in the tenth game of the season. Another loss and the Bears' playoff hopes would be gone. At halftime of the game, Chicago trailed 17-0. In the second half, it looked as though a completely different

team hit the field. Chicago scored 14 points, then allowed a field goal before Payton scored a 15-yard touchdown to make the score Chicago 21, Kansas City 20. The Chiefs scored another touchdown, pulling ahead 27-21 with just 24 seconds left in the game. Three passes later, tight end Greg Latta caught a touchdown pass from Avellini. With three seconds left, the Bears won 28-27. Payton rushed for 192 yards in the game, but his best was yet to come.

The following week, still needing to win every game, Payton was battling a terrible case of the flu. Remarkably, he rushed for 275 yards in the game, setting a new NFL record that would stand for 23 years. Despite the enormous numbers, the Bears could only muster 10 points against the Vikings. But they won because the defense only allowed seven.

Doug Buffone, still playing for the Bears in his eleventh season, explains that the second half of 1977 "was just one of those years, no one expected us to win but we went on a tear." The team beat Detroit, Tampa, and Green Bay in the following three weeks to set up a must-win situation against the New York Giants on December 18th. If the Bears won the game, they would earn a wild-card berth into the playoffs. If they lost, the most exciting season since 1968 would earn them nothing. Additionally, Payton had a slight chance of breaking O.J. Simpson's single-season rushing record of 2,003 yards.

Upon viewing the condition of the field, Payton must have known from the outset that breaking the record would be impossible. Much as had happened in 1934, for the Bears-Giants championship game, the New York area was in the midst of an ice storm, turning the Astro Turf surface of Giants Stadium into a virtual ice rink. Players slipped and slid, passes from quarterbacks Avellini and Joe Pisarcik were virtually uncatchable, and many turnovers occurred. The Giants almost won the game with less than a minute to play, when a wide-open receiver caught, then dropped, a pass in the end zone.

As a result, the game was tied 9-9 at the end of regulation and headed to overtime. As opposed to the old NFL days, when overtime didn't exist, teams now played a "sudden death" quarter in which the first team to score won the game. The two teams battled back and forth throughout the period with the Bears first missing a field goal, and then botching a snap on another from the Giant ten-yard line. Chicago took over for the final time from the Giant 45 with one minute and 12 seconds to play. The Bears needed score, as a win and not a tie was required for them to reach the postseason.

Three plays later, Payton took an Avellini pass down to the New York ten-yard line, but could not stop the clock. The field goal unit, led by kicker Bob Thomas, rushed onto the field, and the veteran from Notre Dame split the uprights from 27 yards out. The game was Chicago's first overtime win ever, and it put the Bears into the playoffs for the first time since 1963.

It was also the first trip to the playoffs for Buffone, the elder member of the squad. Asked to describe how it felt to have a shot at glory for the first time in a long career, Buffone thinks not of himself but of teammates that never had the chance: "Forget about me, how do you figure that we had guys like Butkus and Sayers that never once went to the playoffs."

It would be a quick trip into the postseason, as the Bears were demolished the next week by Super Bowl-bound Dallas, 37-7. The team was not satisfied with how the 1977 season ended, but took pride in their three-year turnaround. Receiver James Scott became a force in the passing game, catching 50 balls for 809 yards, and Payton had his finest season ever, winning the NFL rushing title with 1,852 yards and 14 touchdowns. The running back was named the NFL's Most Valuable Player for the season. Bob Avellini won the quarterback competition and led the team through the year, completing 52 percent of his passes, but still threw 18 interceptions.

Unexpectedly, Finks was forced to hire a new head coach after the miracle 1977 season. Jack Pardee resigned on January 19, 1978, to become the head coach of the Washington Redskins, for whom he previously served as an assistant. Pardee's departure turned into a controversial matter. It appeared that the departing coach had been eyeing the vacant top job in Washington, even before the Bears' playoff game in Dallas. Once Pardee made his announcement, players were angered that the coach had not taken his players to a warmer

climate to practice for the game. The way it appeared, Pardee chose to stay in Chicago through the brutal cold to ready his house for sale.

After Pardee's abrupt resignation, Finks took just over a month to identify his successor, Neill Armstrong. The hiring of Armstrong was a reach back into Finks' roots, as Armstrong had served under Finks on Bud Grant's Viking staff for the previous nine seasons.

Armstrong hired six assistant coaches from the college ranks, but most significantly brought with him Buddy Ryan to serve as defensive coordinator. Ryan had served as a sergeant in the Army during the Korean War, then coached at Pacific, Vanderbilt, SUNY Buffalo, and for the New York Jets and Vikings in the NFL.

The Bears were short on draft picks in 1978, having sent their first-round selection to Cleveland for Mike Phipps. Their second-round pick was traded to San Francisco for defensive end Tommy Hart, but Chicago added a 1979 first-rounder when they sent defensive lineman Wally Chambers to Tampa. Regarding the lack of picks, Finks said, "We've gone from 4-10 in 1975 to co-champions of the division in two years. To do that, we had to do some mortgaging of future draft choices. But with this draft, that's all behind us. Next draft we have two number ones and our own pick in every other round."

Added in the slim 1978 college selection process were running back John Skibinski and defensive lineman Brad Shearer. Also acquired were legendary defensive tackle Alan Page, from the Vikings, and wide receiver Golden Richards from Dallas.

Outside of Walter Payton rushing for over 1,000 yards for the third straight season, and Doug Buffone setting a Bear record for games played, good times were hard to find in 1978. Chicago won its first three games, then lost eight in a row. By November, they had a 3-8 record. The NFL had expanded the regular season to include 16 games for the first time in '78, cutting two from the preseason, and the Bears finished with a 7-9 record. Noteworthy was the fact that the team won four of their final five games to finish the season strong. Mike Phipps, for whom the Bears had traded their top draft choice, played in some games but threw ten interceptions to two touchdowns. Avellini wasn't much better, tossing five touchdown passes but throwing 16 picks.

In '78, the team gave up 274 points and only scored 253, so in the first round of the 1979 draft they bolstered the defense. Their first selection, received from Tampa in the Wally Chambers deal, was defensive lineman Dan Hampton from Arkansas. Immediately dubbed "Big Rook" by his teammates, Hampton may not have ever played football were it not for the coach of his high school football team. At that time, Hampton played saxophone in the band until the coach saw the massive youngster marching and had him trade in his band uniform for shoulder pads.

The team's second first-round pick was another defensive lineman, Al Harris from Arizona State. Finks went for offense in the second and third rounds, selecting Tulsa wide receiver Rickey Watts and running back Willie McClendon from Georgia. When he took McClendon, Finks proved his satisfaction with Phipps, Evans, and Avellini, as he passed on the opportunity to draft Joe Montana from Notre Dame.

Nineteen Seventy-Nine would be another cardiac season for the team. Phipps began the year as the starter, but after an injury was replaced by 1977 draftee Vince Evans. Evans commanded the team through the fifth week of the season, but lost three of the four games in which he played. Following a loss to Tampa, which dropped the Bears' record to 2-3, Evans was lost for the season with an aggressive staph infection.

Phipps again took over the quarterbacking on October 7th, when the Bears beat Buffalo 7-0 on a single end-zone leap for a touchdown by Payton, a trademark play for number 34. In the next two weeks the Bears lost again, first to New England, then at Minnesota. The team was led at times by Avellini during those two weeks, with mixed results. With a 3-5 record, the Bears faced another do-or-die finish in 1979. Against San Francisco in the season's ninth game, Chicago trailed 27-21 in the fourth quarter. Thanks to heroics by Phipps and James Scott, who hooked up on a 48-yard touchdown pass, the Bears went ahead 28-27 with under a minute remaining. The game was not over, however, until Plank intercepted Steve DeBerg with 41 seconds left.

After nine games the Bears were 4-5, and knew they would need to finish with at least a 10-6 record to have a realistic chance at the postseason. They won three more games, then lost 20-0 at Detroit on Thanksgiving Day. With six losses, they would now have to win three in a row to finish the season.

The team responded by blanking Green Bay 14-0, then won a squeaker at Tampa, 15-14. After that victory, playoff scenarios were set. The Tampa Bay Buccaneers, steady doormats of the NFL since their inception in 1976, would win the NFL Central Division with a 10-6 record if they defeated Kansas City in their season finale. If Tampa lost and the Bears won, Chicago would take the division. If both the Bears and Buccaneers won, the division would go to Tampa, but the Bears could squeak in as a wild-card if Dallas beat Washington and the combined difference in scoring between the Redskins defeat and the Bears' win was more than 33 points.

This circumstance was due to a complicated tie-breaking formula. If the Bears and Redskins both finished with a 10-6 record, the wildcard would go to the team that had a better difference in points scored to points allowed. After week fifteen, the Redskins had scored 54 more points than their opponents; the Bears exceeded their opponent's total by 21. Therefore, the Redskins would have to lose, and the Bears would have to make up this 33-point difference. An unlikely scenario at best, but the team set out to do just that.

On the morning of December 16, 1979, Bears players awoke to a fresh coating of snow on the ground, negative 12-degree wind chills, and devastating news. Overnight, team president "Mugs" Halas had died of a heart attack at the age of 54. The sad news added to the surreal feeling of that day.

"We were shocked at hearing of Mugs' death," said Buffone, "and we knew that the only way we were going to win that football game is if we pulled out all the stops." The team did just that. The Bears scored three touchdowns in the first half and led St. Louis 21-0. St. Louis then scored to make it 21-6. At one point, as the fullback on the punt team, Buffone had the option to audible to a fake, and figuring "what do we have to lose," he did so. In his final game in Chicago, the linebacker caught a pass on the fake from punter Bob Parsons and rumbled 22 yards for a first down. Chicago would score 21 more points in the second half, and the team held up their end of the bargain, winning by a score of 42-6.

A side note to the game was Walter Payton battling Cardinal rookie Ottis Anderson for the NFC rushing title. Payton trailed the rookie going into the game, but out-rushed Anderson 157 to 39. Payton took the title with 1,610 yards on the year.

After the win, players gathered underneath Soldier Field to listen to the end of the Redskins-Cowboys game. Dallas would win 35-34 on the contest's final drive. With that, the margin of victory between the two games was 37 points in the Bears' favor, and Chicago was in the playoffs for the second time in three years.

With their astonishing finish, the Bears earned a trip to 11-5 Philadelphia, the NFC's other wildcard team. Chicago led 17-10 at halftime, and in the third quarter, Walter Payton appeared to break an 84-yard run for a touchdown. The score was called back on an illegal motion penalty on wide receiver Brian Baschnagel, a call on which officials would later admit they were wrong. The game went downhill from there, and the Bears eventually lost 27-17.

"We had beaten the Los Angeles Rams that season," Buffone said. (The Rams would squeak by Tampa in the NFC Championship, 9-0.) "If things would have worked out in Philadelphia, I really think we could have gone on to do some damage in the postseason, but it didn't work out," he added. The loss was especially painful for Buffone, as it would be his last game in a Bear uniform. Buffone retired that year after starting at Bears linebacker for 14 seasons.

As Buffone replaced Joe Fortunato a decade-and-a-half before, the Bears drafted another number 55 in 1980, linebacker Otis Wilson, with their first pick in the draft. Ironically, Wilson played college football at Buffone's *alma mater*, Louisville. Also selected that year, in the second round, was fullback Matt Suhey from Penn State. The pieces were beginning to fall into place.

The new decade got off to a whimsical start in Green Bay. The previous season's matchup in Wisconsin had ended in the low score of 6-3, and points were hard to come by in 1980, as well.

At the end of regulation the score was locked at 6-6, forcing overtime. In the extra period, the Bears looked to have dodged a bullet when Chester Marcol's short field goal attempt was blocked by Alan Page. Remarkably, the blocked kick bounced directly back into the kicker's hands, and he awkwardly ran into the end zone for a touchdown. Green Bay won 12-6.

The Bears began the 1980 season with a 2-4 record. They were quarterbacked mostly by Vince Evans, who was a solid runner but seemed to lack touch on many of his passes. Interestingly, the Bears dominated some opponents, such as their 23-0 victory over Tampa, while they looked outmatched to others, as in a 38-3 loss to world champion Pittsburgh. They scored 35 first-half points against ex-coach Pardee and the Redskins on November 9th, then couldn't stop Earl Campbell and the Oilers in a 10-6 loss the following week.

On November 23rd, in a 23-17 loss at Atlanta, the unthinkable happened when Walter Payton was ejected from the game. Payton had placed the ball on the ground after he was tackled, and the officials ruled that it was a fumble. As he jumped up to protest, Payton was pushed from behind and he lightly grabbed onto an official to stop from knocking him over. The referee ruled Payton had forcefully pushed him, and ejected the running back from further play that day.

The next week, 4-8 Chicago traveled to Detroit to play the Lions on Thanksgiving, clinging to slim hopes that an 8-8 record would get them in to the playoffs. Vince Evans had to rally the team to tie the score at 17-17, sending the game into overtime. The Bears won the toss, and running back David Williams returned the opening kickoff of the period for a touchdown, clinching what was then the shortest overtime in NFL history.

On December 7th, the Bears and Packers met in Soldier Field on the 39th anniversary of the attack on Pearl Harbor. By the end of that game, the Packers may have felt as if they had been bombed themselves. The Bears won 61-7, tying their team record for most points scored in a regular season game. A host of other records were set or broken in the game, including most first downs and highest completion percentage. Evans became the first Bear quarterback to pass for 300 yards in a game since Jack Concannon had done so, and Payton rushed for 130 yards. After the game, Green Bay accused Bear defensive coaches of stealing offensive signals during the game, which was never proven.

Despite the flashy finish, the Bears learned they had been eliminated from postseason competition after the game. They split their final two contests and finished the season 7-9.

Finks was either becoming dissatisfied with the play of his offensive line, or looking to add quality depth when he selected massive offensive tackle Keith Van Horne from USC with his first selection in the 1981 draft. The Bears then traded up with San Francisco to select linebacker Mike Singletary from Baylor in the second round. Bill Walsh, San Francisco's head coach, would later admit the mistake in allowing Chicago to take Singletary.

Further quality depth was added throughout the draft with the selections of wide receiver Ken Margerum and defensive backs Todd Bell, Ruben Henderson, and Jeff Fisher. Several free agents were added in 1981 that would play a huge part in the Bears future in center Jay Hilgenberg, defensive tackle Steve McMichael, and cornerback Leslie Frazier.

The Bears opened the '81 season for the third year in a row at Green Bay, but this year there was no surprise finish when Chicago lost 16-7. Things looked glum throughout the first part of that season as the team bumbled to a 1-6 start. In a Monday Night Football matchup against Detroit on October 19th, the Bears looked to turn the tide against the Lions, led by rookie quarterback Eric Hipple. Instead, the Bears were pounded 48-17. It was during that game that some players began to question their leadership. One player, it was said, left the field early during that loss to make a phone call in the locker room, but was not disciplined by the coaching staff. Occurrences such as that would take their toll on team morale through the remainder of the season.

Not much good happened in 1981, although Buddy Ryan's new defense—the "46" which was named after Plank's uniform number—began to take shape and terrorize opposing offenses. Against powerful San Diego, Ryan lined his unit up for much of the game in an unorthodox formation to

neutralize the Charger attack, known as "Air Coryall." Five defensive lineman, one linebacker, and five defensive backs teamed to shut down their opponents' offense, and the Bears pulled one of the biggest upsets of the year, 20-17. In fact, in 1981 the Bears faced the top four teams in the NFC West, the most balanced division in the NFL, and beat all four largely due to Chicago defenders.

The Bears won their final three games of the season to finish a disappointing 6-10 in 1981. Many in the city, including Finks, lobbied to retain Neill Armstrong as coach, largely based on the team's promising finish. But too many lapses in discipline had occurred, and Armstrong had lost the confidence of many of his better players. Buffone remembers that even in the two years for which he played for Armstrong, many players called him "Nice Neill." "Armstrong was a nice guy, and some players took advantage of that," Buffone said. "Sometimes when you have that happen, you just need a change."

In John Mullin's book, *Tales from the Chicago Bears Sidelines*, Dan Hampton illustrated how bad the discipline problem had gotten to that point. Hampton said that a wide receiver was seen drinking alcohol in the locker room prior to the season finale, and his teammates approached Hampton to deal with the situation. Hampton told the players to tell the coaches, who came full circle to Hampton, asking him to instruct the player to stop drinking. Simply put, "the inmates were running the asylum," according to the defensive standout.

Though he had retired from coaching in 1967 and agreed to turn full control of football operations over to Finks in 1975, George Halas would make his final mark on the Bears in late 1981. Despite Finks' protests, Halas dismissed Neill Armstrong on January 4, 1982. There was much speculation in the media as to whom Halas would recruit as Chicago's tenth coach in franchise history, but it seems that Halas knew from the beginning.

In 1964, the Bears entered training camp on the heels of a world championship. They pushed through the ensuing thirteen seasons without a playoff appearance until an entirely rebuilt franchise took them there once again in 1977. After the tragic deaths of several running backs and an injury-shortened career of another, the Bears found perhaps their greatest player of all time in 1975 in running back Walter Payton. Still, the era of 1964–1981 closed with the team in as dire straits as they had ever been. Thanks to the leadership of Jim Finks, however, the team was poised for a breakout in the mid-1980s.

Doug Buffone tackles a Redskin ballcarrier. Buffone was drafted by the Bears on the fourth round of the 1966 draft from the University of Louisville and replaced the retired Joe Fortunato the following season. He would go on to play for the Bears for 14 years, retiring after the 1979 season, compiling 24 interceptions along the way. (Author's collection.)

Brian Piccolo scores one of his five career touchdowns. Piccolo was signed as a free agent in 1965, and despite being too small and slow by NFL standards, had worked his way into the starting lineup by 1969. Tragically, the 26 year old was diagnosed with cancer in November of that year and would die seven months later. (Author's collection.)

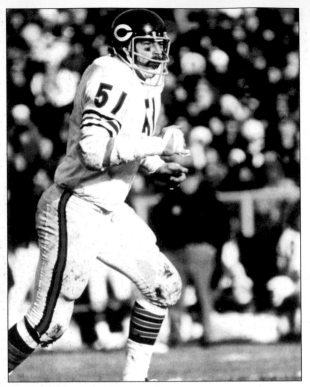

Dick Butkus, drafted by the Bears in 1965 from the University of Illinois, pursues a ballcarrier in the early 1970s. Butkus grew up in Chicago and became the most dominating player in the NFL at his position during his playing career. Unfortunately, Butkus had to retire after the 1973 season following several debilitating injuries. He was inducted into the Pro Football Hall of Fame in 1979, and his number 51 was retired in 1994. (Author's collection.)

Gale Sayers, running back from the University of Kansas, was nicknamed "The Kansas Comet" and "Magic" after his magical running style. Sayers was arguably the quickest, most elusive runner and kick returner in NFL history. In 1968, he suffered a devastating knee injury in a game against the San Francisco 49ers, but returned to form the following season. After two more injuries in 1970 and '71, Sayers was forced to retire. He became the youngest player ever inducted into the Pro Football Hall of Fame in 1977, at the age of 34. (Author's collection.)

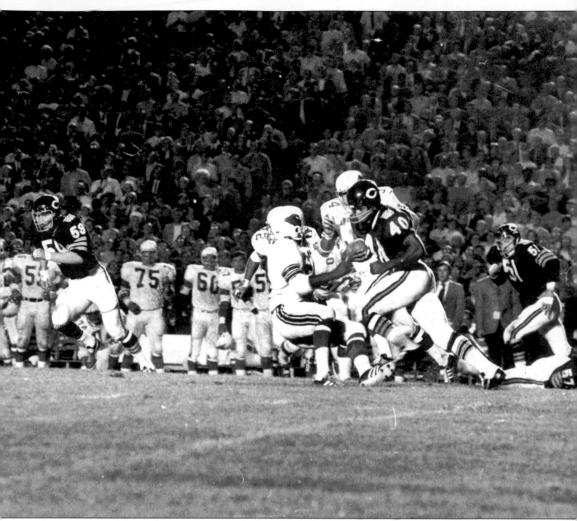

Gale Sayers returns a kick against the St. Louis Cardinals during a preseason game in 1969. Linebacker Dick Butkus (No. 51) chases the pile while linebacker Rudy Kuechenberg (No. 59) runs ahead. Butkus and Sayers were both selected in the first round of the 1965 draft. They both had Hall of Fame careers that were cut dramatically short by injuries. Paralleling their dual existence, they both had their uniform numbers retired by the team in a halftime ceremony on Halloween night, 1994. Twenty-Six Bears have been inducted to the Pro Football Hall of Fame: George Halas (end/coach), Harold "Red" Grange (running back/defensive back), and Bronko Nagurski (running back/tackle) in 1963; George Trafton (center), Roy "Link" Lyman (tackle), and Ed Healey (tackle) in 1964; John "Paddy" Driscoll (running back), Danny Fortmann (guard), and Sid Luckman (quarterback) in 1965; Clyde "Bulldog" Turner (center/linebacker) and George McAfee (running back/defensive back) in 1966; Joe Stydahar (tackle) in 1967; Bill Hewitt (end) in 1971; Bill George (linebacker) in 1974; George Connor (tackle/linebacker) in 1975; Gale Sayers (running back) in 1977; Dick Butkus (linebacker) in 1979; George Blanda (quarterback/kicker) in 1981; Doug Atkins (defensive end) and George Musso (tackle) in 1982; Mike Ditka (tight end/coach) in 1988; Stan Jones (tackle/guard) in 1991; Walter Payton (running back) in 1993; Jim Finks (general manager) in 1995; Mike Singletary (linebacker) in 1998; Dan Hampton (defensive end/defensive tackle) in 2002. (Photo courtesy the Nicole Black Photo Collection.)

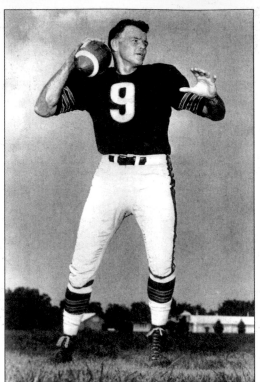

Quarterback Bill Wade led the Bears to the 1963 NFL Championship and played with the team through the 1966 season. Wade was acquired by the Bears prior to the 1961 season in a trade with the Los Angeles Rams. In his six seasons with the Bears, Wade passed for over 9,900 yards and 68 touchdowns. (Author's collection.)

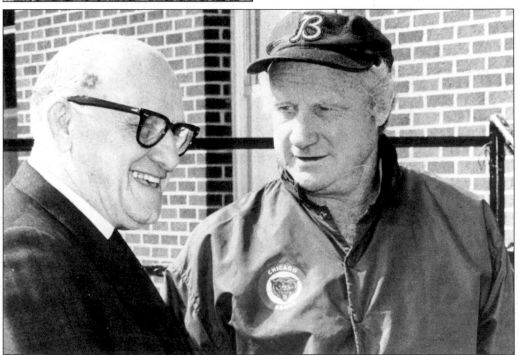

George Halas chats with Jack Warden, who portrayed the coach in the 1971 movie *Brian's Song*, which was partially filmed at the Bears' 1971 training camp in Rensselaer, Indiana. (Author's collection.)

George Halas looks onto the field intensely during a 1960s game. Halas founded the Chicago Bears and was instrumental in organizing the National Football League. He served as head coach of the Bears (1920–29, 1933–42, 1946–1955, and 1958–1967) before finally stepping down. Halas was the winningest coach in league history until the Miami Dolphins' Don Shula surpassed him in the 1990s. (Author's collection.)

Brian Piccolo's jersey number 41 was retired by the team after the running back's death from cancer. The Chicago Bears have retired 13 numbers: Bronko Nagurski (No. 3), George McAfee (No. 5), George Halas (No. 7), Willie Galimore (No. 28), Walter Payton (No. 34), Gale Sayers (No. 40), Brian Piccolo (No. 41), Sid Luckman (No. 42), Dick Butkus (No. 51), Bill Hewitt (No. 56), Bill George (No. 61), Clyde "Bulldog" Turner (No. 66), and Harold "Red" Grange (No. 77). (Author's collection.)

Hard-hitting safety Doug Plank played for the Bears from 1975 to 1982 and remains a fan-favorite for his punishing play. Plank joined the Bears as a 12th-round draft pick in 1975. By 1976, he teamed with Gary Fencik to form a punishing safety tandem in Chicago's secondary. Plank played briefly in the USFL after his Bear career ended, and moved to Phoenix, Arizona, where he became defensive coordinator for the Arizona Rattlers of the Arena Football League. (Author's collection.)

FOUR
Chicago Football Renaissance
1982–1992

106-62 Record
One World Championship, seven playoff appearances

At the end of Neill Armstrong's coaching reign, Bears players and fans alike clamored for a return to "Bears Football." For the fans, that meant a no-nonsense approach to each game, with the players making sure if the Bears lost a game, the opponent should not win the following week, as Hartenstine had described. For the team, it meant that the discipline lacking under Armstrong should be doled out by their leaders, not the players. Chicago started this era with many questions, but at its end had dominated the NFL for a decade like not many teams had before.

Certainly the Bears' success in this era was thanks mainly to Jim Finks, who had revamped the entire organization and brought in players that would be the catalyst for winning. Finks would leave the club before his work came to fruition, to be replaced by a loyal Bears' employee who would serve as a buffer between their volatile coach and the owners of the organization. Pro football would lose its founder during this era, when the years finally caught up with George Halas.

Two years after his death, players, fans, and the city of Chicago could only imagine the pleasure Halas would take in watching his life's work take over the world for one short season.

Ditka Arrives: 1982–1984
Shortly after Christmas of 1981, George Halas called a press conference at the Bears' downtown offices. Speculation ran rampant in the press as to what would be announced at the conference. When defensive coordinator Buddy Ryan appeared with Halas, the immediate thought was that Ryan would be named head coach to succeed Armstrong. It didn't turn out that way.

Shortly before this occurrence, the Bears' defensive players, led by defensive lineman Alan Page, had written a passionate letter to Halas, pleading for the owner to retain Ryan as defensive coordinator. Halas visited the defensive players while they were practicing at Great Lakes Naval Training Center, and told them "Buddy Parker is a fine coach; you have nothing to worry about." (Buddy Parker was a longtime head coach in the NFL from 1949 to 1964, Halas obviously meant to say Buddy "Ryan".) In Ryan's typical biting humor, when told of the letter, he said, "I can't believe those players would write a letter on my behalf after all the times I've chewed them out."

So at that press conference, prior to announcing the fate of his head coach, Halas told the press that he was retaining Ryan as defensive coordinator. General Manager Jim Finks could not have been happy to have his authority usurped in this manner, but Halas was almost 87 years old and tired of losing. In fact, according to Armen Keteyian's 1992 book, *Ditka: Monster of the Midway*, it seemed that several factions were developing within the Bears front office. Finks was becoming aligned with the "McCaskey faction," led by Halas' son-in-law Ed, while Halas himself was leaning more and more on the decisions of team accountant Jerry Vainisi. The problems associated with these various in-house alliances would come to a head in due time, but for now, Halas was firmly in charge.

On January 4, 1982, Neill Armstrong was dismissed as Head Coach of the Bears. The media focused on several men as the most likely candidates to replace Armstrong. USC coach John

Robinson, former Bears assistant coach George Allen, CFL coach Hugh Campbell and a dark horse. The dark horse, a long shot candidate, was former Bears player Mike Ditka.

After Halas and Ditka had some very public disputes in 1965 and 1966, Ditka was traded to the Philadelphia Eagles. The tight end spent two tumultuous seasons with the Eagles, after which "Iron Mike," as he was known, was picked up for four more years by the Dallas Cowboys. When his playing career ended in 1972, Ditka was offered a job on Tom Landry's staff as tight ends and special teams coach, a position he held from 1973 to 1981.

Several local football writers argued that hiring Ditka would be a mistake. In Dallas, Ditka held the same position without advancement his entire tenure, and few football followers could imagine a special teams coach being given the keys to a team without advancing in the assistant ranks first. And less still could believe that the bridges burned between the owner and former player would have been mended, even after 15 years. The group of people that could not comprehend this logic did not include Halas.

Buffone remembers that he "got a call from [former Bear assistant] George Allen in late Nineteen Eighty-One. Allen asked me to call and talk to the Bears because he was interested in becoming their new coach. So I called George Halas." Buffone placed a call to the owner and repeated what Allen had told him: "The old man said 'let me tell you something, kid. I've got my guy. I'm bringing Mike Ditka back to Chicago.' And that's what he did. I had no idea Mike Ditka was even being considered. Halas knew in his mind what he wanted to do, and that was to bring back the Monsters of the Midway."

It was indeed a strange time for the Bears' organization. After general manager Jim Finks had done so much to turn the team around from 1975 to '81, Halas was letting him twist in the wind. It seems to have started in 1979, soon after his son's sudden death. The elder team executive elevated himself to the title of team president to replace his son. When asked why he didn't promote Finks or Ed McCaskey to the position, Halas responded by saying, "why would I consider anyone but myself." In his book, Keteyian likened Halas' running of the organization to a Greek coffee shop. "No one outside of the immediate family touches the cash register," as Keteyian put it.

After returning to an official executive role, it was said that Halas urged the replacement of offensive coordinator Ken Meyer with Ted Marchibroda prior to the 1981 season. He had looked at Meyer's playbook and judged "there was no game plan at all." It was also reported that Halas had to personally approve Marchibroda's strategy before he would bless it.

Signs were clear just prior to the 1981 season that doom was impending for Armstrong, his offensive staff, and Finks. In training camp, Halas was heard saying, "this season better finish better than .500." In October 1981, Halas forced Armstrong to add former head coach Jim Dooley as a special offensive consultant. This appointment came to the absolute chagrin of Armstrong and Finks.

Halas then rehired Ryan and fired Armstrong without so much as speaking to Finks. The general manager and the owner/president were at an absolute impasse from late December 1981 on. Finks was interviewed countless times by reporters and could only say that he knew nothing. In fact, on January 17th, Halas issued a press release stating that he and Finks "came to a meeting of minds," even though the owner never spoke with general manager. The easy thing for Finks, and perhaps what Halas wanted, would have been to resign. But with a contract that ran through 1984 and a five percent ownership stake in the club, Finks proved to be as tough a nut to crack as Halas.

Speaking of nuts, the situation was so bad at an official press conference to present Ryan to the media that a reporter asked Halas if senility may be setting in. Halas responded by saying, "nuts to you! There's no goddamn senility in this carcass."

On January 20, 1982, Halas gathered the Chicago media around a table in the Bears' business offices to announce the hiring of Michael Keller Ditka as the tenth head coach in the team's history. In Ditka's words, told to WTTW reporter Bob Sirott in a 2004 interview: "In Nineteen Seventy-Five or Seventy-Six, I was with the Cowboys, and used to go in and get my work done real

early in the morning. One day, I decided I was going to write a letter. I wrote to George Halas and told him I thought there would be a time when I would be ready to become a head coach in the National Football League. It wasn't then. And I [told him] I wondered if I would have the opportunity to come back to Chicago and finish the job I never finished. In Nineteen Eighty-Two, he hired me. I went into his apartment, sat at the kitchen table, and he told me to tell him my philosophy on football. I told him, 'coach, don't kid me. My philosophy is the same as yours, to win.' 'And we'll find ways to win,' he said. 'OK, we're going to pay you X amount of dollars.' And I said, 'boy, I'm happy to have the job.' This was a lifetime ambition for me."

Thus, in a simple manner, one of the grandest eras of Chicago Bears football began. Finks' role was clearly defined, not to the GM's liking. The head coach would report directly to Halas. On personnel matters, Finks would make recommendations and present them for decisions to be made by the owner and coach.

Ditka didn't waste any time informing the players that the easy days of the Armstrong regime were over. His first chance to address the team as a group came during an April 1982 minicamp in Arizona. He began his very first meeting by demanding that players remove their hats. Shortly after, he made the statement that would become prophetic: "The good news is our goal to win the division and then get to the championship game and then win the most important game of our lives, the Super Bowl. The bad news is that as I look out at you half of you won't be there when we get there."

"That's something I hadn't heard in the six years I've been here," safety Gary Fencik told the *Bear Report* in August 1982. "We're always talking about being competitive. I'm glad somebody's got a different frame of mind. I'm tired of being competitive. Obviously, that attitude hasn't pushed us to our limits."

Wide receiver Rickey Watts, a 1979 second-round draft pick and the most productive receiver on the roster, learned quickly that Ditka meant business. After leaving the minicamp, Ditka ordered his locker to be cleaned out by the trainer and fully intended to cut him. After Watts explained himself to Ditka and apologized to the team, he was retained (the receiver would play through the 1983 season).

Second-year tackle Keith Van Horne, a 1981 all-rookie selection, added, "Neill was a great guy. But we needed a coach. That's what we have in Mike. I just think it was a little too loose here last year. Guys would do what they wanted. No one likes to be disciplined or pushed, but that's how it's been for most of us all the time we played. In the long run, you do like it once you see how it helps you win."

On April 27, 1982, the NFL draft was held, and the cards fell exactly as the Bears wanted them. Ditka, Finks, and director of scouting Bill Tobin agreed that the top priority in the draft would be the quarterback position. Veteran Mike Phipps would not be returning after he had relinquished the starting role to Vince Evans in 1980 and 1981. Evans and Avellini would return, but their play over the past seven years did not satisfy the new leader. It was predicted that one of two quarterbacks would fall to the Bears at their fifth pick, either Ohio State's Art Schlichter or BYU's Jim McMahon.

Schlichter was generally regarded as the better pro prospect of the two. He stood 6 feet 2 inches and had a track record for durability. McMahon, on the other hand, battled through a variety of injuries in college and was hampered by a vision problem caused by a childhood injury. Based on moxie alone, McMahon was the preference of all parties. And after the Baltimore Colts selected Schlichter with their fourth pick, McMahon was property of the Bears. The day after being picked, McMahon arrived at Halas Hall and stepped out of his limo with a beer in his hand.

Also picked in the 1982 draft were tight end Tim Wrightman, running back Dennis Gentry, and offensive lineman Kurt Becker, a Chicago-area native. The Bears traded their second-round pick to Tampa for the Buccaneers' first-round selection in the 1983 draft, and for the second time in five years, the Bears would benefit greatly from Tampa's draft generosity.

Ditka hired Ed Hughes, another Dallas assistant, to serve as his offensive coordinator. Ditka

and Hughes would install portions of the Dallas offense, which featured multiple offensive formations and a variety of shifts and motion. Explaining the differences between the previous Bears offense, which many felt had become "Payton left, middle, right, punt," Hughes said, "I don't' think the terminology or play calling will be a shock. I think the thing that's going to be a little bit different is the discipline in the multiple-offensive formations we will be featuring."

While the offensive staff would work together flawlessly, co-existing with the defensive staff would prove difficult. This could be expected in any situation in which the boss has his assistants hired for him, which was the case with Ryan and his staff. *Chicago Tribune* pro football writer Don Pierson said recently, "George Halas used to encourage dissention among his staff as a way of making the team stronger." Ditka and Ryan would co-exist, but not happily.

As Ditka favored installing a bulk of the Dallas offense, he also preferred to implement the Cowboy's "flex" defense in the 3-4 alignment, drastically different than Ryan's attacking 46 schemes. Fencik explained to ESPN in 2004 that "Buddy said Ditka could run any defense he wanted, but if he was going to run it, Ryan would be back on his ranch in Kentucky."

After a tough training camp, the Bears went 1-3 in the preseason, and opened the regular season at Detroit, where they lost 17-10. In what had to be a difficult circumstance for any rookie coach, a player's strike was also looming. Prior to week two at Solider Field, every player from both teams ran to the middle of the field before to the game and shook hands in a show of labor solidarity, a scene which was met by a chorus of boos from the crowd. The Bears stumbled through the game, looking disorganized and demoralized, and lost 10-0.

The Chicago offense looked as if they didn't have any grasp of the multiple-formation with motion scheme. Particularly comical was a little wrinkle Ditka brought in directly from the Cowboys. The great Dallas offensive lines of the 1970s would always stand up in unison just before they set before their play, and Ditka even emulated this portion of the package. The Bears, however, led by guard Noah Jackson, couldn't even stand and set synchronously.

After the shutout loss to the Saints, the players went on strike for eight weeks, canceling all games during that stretch of the schedule. According to Keteyian, Ditka matured during those eight weeks and softened his approach when the season resumed. Among changes instituted when the players returned was the elevation of rookie McMahon to starting quarterback. The positive results were immediate; in McMahon's first start, the Bears beat Detroit 20-17.

Chicago would finish Ditka's rookie campaign 3-6, but surprisingly just missed the playoffs in an overtime loss at Tampa Bay in the season finale. Notable about 1982 is that due to the strike, for the first time in their history, the Bears did not play Green Bay that season. The defense continued its uphill climb, finishing fifth against the rush and 16th overall in the NFL. Dan Hampton was named Defensive Player of the Year, and McMahon was named Offensive Rookie of the Year.

During the winter and spring of 1983, all eyes looked forward to the April college draft. The Bears were primed to address needs on the offensive line, add a speedy receiver, and bulk up their improving defense. With the sixth and 18th picks in the first round, the triumvirate of Finks, scouting director Bill Tobin, and Ditka were enthusiastic. Despite his displeasure with his situation since the hiring of Ditka, Finks was obviously still doing his job well. Although they were optimistic, the men may not have been able to realize that they were about to pull off the greatest draft in their history.

With their first selection, they took offensive tackle Jim Covert of Pittsburgh. The lineman only allowed three quarterback sacks in his first three years in college, none his senior year. Bears scout Jim Parmer stated that "Covert is so strong, he just stops defenders cold." With their second first-rounder, they selected wide receiver Willie Gault from Tennessee. Gault was a member of the 1980 U.S. Olympic sprinting team, and according to Finks, "he'll get deep." In the second round, they selected cornerback Mike Richardson, and in the third landed safety Dave Duerson from Notre Dame.

In an obvious miscommunication, the Bears' fourth-round pick was guard Tom Thayer, also from Notre Dame. Shortly before the NFL draft, Thayer had signed a contract with the Chicago

Blitz of the upstart USFL. The Joliet, Illinois native was eager to play in Chicago, and was "completely shocked" that he was selected by the Bears after signing the commitment to play for the Blitz. On Thayer, Finks said, "who knows, maybe he'll be playing in our stable some day."

Perhaps even more impressive than the future stars they landed in rounds one through four were a pair of eighth-round picks: defensive tackle Mark Bortz and defensive end Richard Dent. Ditka called Bortz a "battler, a hard-nosed son of a gun," and according to Tobin, Dent was the best pure pass rusher he saw in the draft. At 240 pounds, Dent's knock was his size, but the Bears felt he had the potential to add weight to his frame. They were correct.

The team also added wide receiver Dennis McKinnon as an undrafted free agent. McKinnon would end up starting across from Gault before the season was over.

Finks, however, wouldn't be around to watch the development of his young stars, as on August 24th he tendered his resignation as general manager. After his authority had been taken away in function, if not in title, Finks' role had steadily diminished to the point where the proud man couldn't take it. Halas named Vainisi to replace the departing GM.

If the 1983 Bears were improved with the influx of talent and ready to turn a corner, they for the most part didn't show it in the first ten weeks of the season. During that stretch they went 3-7, beating only Tampa, Denver, and Philadelphia. Two of those losses, however, were close overtime contests in back-to-back weeks. After the second loss, 22-19 at Baltimore, Ditka punched a locker in the dressing room and broke his hand. In that game, Ditka had pulled quarterback Jim McMahon and rookie tackle Covert, and the Bears lost on an overtime Colt field goal.

Regarding the broken hand that was in a cast the next week, Ditka said, "I got excited about a number of things." Foreshadowing the future, he added, "I wish I could say I'm not going to get excited anymore, but it's just not my nature, and I don't apologize for it. I wish I could stand there like Bud Grant or Tom Landry, but I can't do it."

Inspired, the team soundly defeated Denver 31-14, but would win only one more game before November 14th. On that day, the Bears beat the Philadelphia Eagles for the second time on the season, and would finish the final six weeks of the 1983 campaign by winning five of the last six. In the season finale, one of the coldest games in Chicago history, the Bears defeated Green Bay in dramatic fashion, 23-21, on a last-second Bob Thomas field goal. The winning points were made possible by a long Jim McMahon scoring drive in the game's final minute. The loss knocked Green Bay out of the playoffs and cost Packer head coach Bart Starr his job.

The Bears finished 8-8 and would miss the playoffs for the fourth season in a row, but by far the saddest event of the season occurred on October 31, when 88-year old George Halas passed away, having lost a long battle with pancreatic cancer. Not only the Bears, but the entire NFL mourned for one of its founders. Halas had served as President of the National Football Conference since the league merger in 1970, and his daughter Virginia would carry on in that role ceremonially each year to come.

In Keteyian's book, he states that Ditka kept a vigil at Halas' bedside during the week leading up to his death. During that time, Halas presented his coach with a bottle of champagne with a note attached that read "Don't open until you win the Super Bowl."

Following Halas' death, the Bears organization announced that his grandson Michael McCaskey, son of Ed and Virginia, would take over as President and CEO of the organization. McCaskey was a graduate of Yale University, taught at Harvard Business School, and authored a book titled *The Executive Challenge: Managing Change and Ambiguity.*

After the 1983 season, there definitely was a sense that the team was headed in the right direction. Thanks to a sit-down Ditka's good friend and boss Vainisi had with him mid-season, the coach was beginning to pay attention to his temper and tone he used with the players. Defensively, the Bears rose to be ranked eighth overall in the NFL. More surprisingly, the Bears offense made a huge jump, ranking fourth overall, first in rushing, and 17th in passing.

Walter Payton continued his dominating play, rushing for 1421 yards with a 4.5 average and six touchdowns. He added 53 receptions, leading the team in catches, while rookie Willie Gault caught passes for 836 yards and eight scores. It was the most receiving yards for a Bear receiver

since Dick Gordon's Pro Bowl year in 1970. Gault and Covert were named to the NFL's All-Rookie Team, and McMahon was solidly entrenched as the starting quarterback. In addition to Covert and Gault, rookies Richardson, Dent, and McKinnon entered the starting lineup by season's end. Infused with a wealth of young talent, the Bears were eager to prove themselves to the other teams in the 1984 season.

In the 1984 draft, the Bears further bolstered their defense, which was already starting to dominate opponents, by selecting linebackers Wilbur Marshall and Ron Rivera with their first two picks. Also added for depth were offensive linemen Tom Andrews and Stefan Humphries, as since Ditka arrived Dennis Lick, Ted Albrecht, and Revie Sorey had been lost to injuries. Defensive back Shaun Gayle was added in the later rounds, and quarterback Steve Fuller was acquired via trade from the LA Rams. Fuller would be injured in the preseason and not be able to play until at least the sixth week of 1984.

That season started in a different place than it had for the previous ten years, when Ditka and Vainisi moved their team's training camp 200 miles to the northwest at Platteville, Wisconsin. The town welcomed the Bears and enjoyed the buzz the players brought, as well as the tens of thousands of dollars that came with the visitors. Ditka's main reason for moving the camp was to improve the camaraderie of the players, as they would live together in a dorm, away from their families for 3 1/2 weeks each summer.

The team opened the season with a new look, wearing navy pants instead of white on the road for the first time since the 1940s. Another new, permanent addition to the uniform were the initials "GSH" on their left sleeves, in tribute to George S. Halas. And the team had changed the color of their facemasks from gray to navy blue after the 1981 season.

There was one main goal for the 1984 season, and anticipation of a record being set early on. The team's goal, outside of obviously winning the division, conference championship, and Super Bowl, was to start the season strong. In each of the past five seasons, including the 1979 playoff run, the team had started the campaign with a losing record in the season's first eight games. The 1983 team had won five of its last six, meaning if they had started stronger instead of faltering, they may have made the playoffs.

The milestone that was approaching was Walter Payton closing in on Jim Brown's all-time NFL record for rushing yards. As the season began, Payton had rushed for 11,625 yards, and Brown's mark was 12,312. It was assumed that Chicago's star would break the record sometime in the first half of the year.

The Bears seemed to be accomplishing their first goal. They won the first three games of the season in impressive form, beating Tampa, Denver, and Green Bay by a combined 70-21 score. In the fourth and fifth weeks, however, the Bears lost at Seattle, then to Dallas at home. Having let veteran quarterback Vince Evans leave for the USFL, and with Fuller injured, the Bears had to rely on veteran Bob Avellini when McMahon was injured. Avellini started and played on September 23rd, a 38-9 loss at Seattle, and was unimpressive. On October 1st, with Fuller scheduled to come off injured reserve, Ditka cut Avellini, ending the quarterback's ten-year Bear career. With the veteran's departure and McMahon's history of getting hurt, the team would rely on Fuller and unproven Rusty Lisch to back up the starter.

On October 7th, the 3-2 Bears faced New Orleans at Soldier Field, and everyone in the city assumed this would be the day for Walter Payton, although the runner cautioned that "running for 66 yards isn't like falling off a log." In the season's first five weeks, Payton had rushed for 621 yards, putting him 66 yards short of Brown. "Sweetness," the nickname by which Payton was well known, had been on an absolute tear in '84, rushing for 61, 179, 110, 116, and 155 yards.

In the third quarter of the Saints game, Payton took a pitch from McMahon and swept left. Defensive back Todd Bell, who always met Payton immediately after pregame introductions for a towering "high-five," made his way close to the sideline so he'd be near his friend at the end of the run. At the conclusion of the six-yard rushing attempt, the 2,794th of Payton's career, the running back owned the record. The game momentarily stopped for Payton to receive hugs from several teammates and the aforementioned high-five from Bell. Not more than a minute

later, Payton was seen urging everyone off the field so the game could continue.

The Bears won the contest 20-7 to improve their record to 4-2, and afterwards the media flocked to Payton. The legend dedicated his ten-year effort to previous athletes that were unable to pursue their dreams, such as Brian Piccolo. He also received a congratulatory call from President Ronald Regan, who was onboard Air Force One. Payton thanked the President and said, "Give my regards to Nancy."

With Payton's record on the books, all eyes became focused on the Bears providing hope for a city shocked by the baseball Cubs' exit from the 1984 National League Championship Series. Since the Bears' 1963 title, the city had grown accustomed to teams losing just when they appeared to have a chance. The Bears lost their following game at St. Louis, then won two in a row.

On November 4th, the team saw their chance to prove themselves in a matchup with the defending world champion Los Angeles Raiders. In a 17-6 victory, the Chicago defense dominated the game, sacking Raider quarterbacks nine times while recovering two fumbles and forcing three interceptions. Despite the sheer dominance, disaster struck when in the third quarter, McMahon had to leave the game with a severely lacerated kidney.

The starting quarterback's season was finished. The Bears had a record of 7-3 but would be forced to rely on Fuller, then unexpectedly on others. Fuller led the team to a win over Detroit, and then in Minnesota on November 25th, quarterbacked them to a 34-3 victory. With a 9-4 record, the Bears clinched the NFC Central championship for the first time since the division was created. It was the Bears' first championship of any kind since 1963, and the team was elated.

The following week, Fuller was injured on the Bears' second series. "We'll never use that play again," Ditka said, since Fuller injured the same shoulder on the same play he had in the preseason. Backup Rusty Lisch had to enter the game, and finished with no touchdowns, an interception, and was sacked four times. The Bears lost that game 20-7 at San Diego.

The following week against Green Bay, the quarterback situation became downright whimsical. An ineffective Lisch was pulled from his first start close to halftime and replaced at the position by Payton. The running back-turned-quarterback actually ran most of the time from shotgun formation, and threw only two passes; one was intercepted. Lisch returned in the second half, but was no more effective. The Bears lost 20-14. Especially frustrating was the fact the Bears were down 14-13 with two minutes left and had the ball in Green Bay territory, but fumbled.

In the 1984 season finale at Detroit, the team started gray-haired, 38-year old Greg Landry at quarterback, acquired on December 5th after he had been out of the NFL for over two years. Landry's steady if unspectacular play got the Bears their final victory at Detroit, and the team finished 10-6.

The Bears were slated to play their first non-wildcard playoff game since 1963 at Washington, who had never lost a playoff game at RFK Stadium. The Redskins were the defending NFC Champions and were heavily favored.

Led, as always, by a dominating defense and a rejuvenated and healthy Steve Fuller, the Bears shocked football prognosticators by upsetting Washington 23-19. Late in the fourth quarter, the Bears were backed up to punt out of their own end zone as they clung to a slim 23-17 lead. Ditka instructed punter Dave Finzer to step out of the endzone, giving Washington two points but gaining the Bears valuable field position. The defense clung to the lead, and Chicago had won its first playoff game in 22 years.

The Bears' stunning upset of Washington took them to an NFC Championship matchup in San Francisco against the powerful 49ers, who were favored by more than ten points. As oddsmakers started to respect the young Bears, the line came down through the week, but San Francisco was still roundly expected to win.

And win they did, shutting out the Bears 23-0. Payton never stopped fighting, even struggling for more yards as the final gun sounded. After the game, television showed the great running back sitting alone on the bench, head down, pondering the prospect of coming so close but not getting over the top. There was an anger brewing, however, within the team at losing to San Francisco. They made it their goal to not be stopped short the following season. He may

not have known how he would retaliate at the time, but Ditka was personally steamed at 49er head coach Bill Walsh. The San Francisco offensive genius had inserted guard Guy McIntyre at fullback after the game was out of reach, and the move didn't sit well with Ditka.

Despite the demoralizing loss in the championship game, the Bears had improved solidly in 1984. First and foremost their defense, effectively running Ryan's 46 blitz schemes, had dominated the NFL. They ranked first overall, first against the run, and second versus the pass. They had set an NFL record with 72 quarterback sacks that season, and second-year pro Richard Dent led the NFL with 17.5 takedowns. Top picks Wilbur Marshall and Ron Rivera hardly cracked the lineup, so the prospect of their development made the unit further confident.

Offensively, the Bears did slip to be ranked 26th in passing, thanks in part to McMahon's injuries. But the offensive line came together with starters Jim Covert, Mark Bortz (who had been converted from defense in 1983), Jay Hilgenberg, Kurt Becker, and Keith Van Horne. The unit would play together with few injuries for years to come.

With more competent quarterbacking, the continuing stellar play of the NFL's leading rusher, and what looked to be the most dominating defense in NFL history, the Bears felt primed to win the Super Bowl in 1985.

1985: The Bears Conquer the World

Chicago is a city of contrasts. It is cosmopolitan enough to be considered a world-class city with Michigan Avenue, the north shore, and a thriving financial district. Yet most outsiders would probably refer to Chicago's rough side, its history as a blue-collar mecca with stockyards and steel mills, when asked to describe its populace.

The 1985 Bears team unified rich and poor, old and young, and in fact became a cultural icon of America. They tore through the NFL that year with just a single blemish, and dominated teams in such a way that they were recently voted the best team in the history of professional football by ESPN.com.

With underdogs like William Perry, class acts such as Walter Payton, and "characters" led by Jim McMahon, the team sported a combined personality that pleased every portion of society. A few teams in the history of the NFL may have outdone the '85 Bears in one portion of the game, but none have transcended their sport to capture the hearts of the nation as this club collectively did. They brutalized their opponents with their defense. They ran the opposition into the ground with the greatest running back of all-time. Their coach turned a little-known rookie into a pop icon and used him to humiliate the enemy while he openly feuded with his top assistant.

The '85 Chicago Bears season capped off a promise head coach Mike Ditka made to his new team in 1982: that he would take them to a Super Bowl and win it. It justified the last major organizational change Bears' and NFL founder George Halas would make before his death. And it created millions of new Chicago Bears fans around the world, while it brought ecstasy to those lifelong fans who had endured 22 years of losing.

Motivation for a world championship season in 1985 was given a kick-start on January 6th. After finishing 10-6 and winning their first postseason game since 1963, the Bears were dominated and humiliated 23-0 by the San Francisco 49ers in the '83 NFC Championship. Starting quarterback Steve Fuller was sacked nine times and threw for only 37 total yards. During that contest, pretentious San Francisco coach Bill Walsh had inserted guard Guy McIntyre at fullback, and Ditka took it as an affront. That very act would spawn yet another side story among many during the '85 campaign. Though disappointed after the 49er loss, to a man the Bears sensed the best was yet to come.

Thanks to the 1983 draft, the Bears had supercharged their offense, although two receivers, Kenny Margerum and Brian Baschnagel, were battling injuries that put their careers in question. For that reason, it was thought that another receiver would be high on the team's draft list. Adding a competent third-string quarterback was also a necessity. Defensively, the team was thin at tackle and Buddy Ryan was still searching for a top cornerback to pair with pro-bowler Leslie

Frazier. Thankfully the team was deep at linebacker and safety, as top starters Al Harris and Todd Bell gave every indication they'd sit the entire season in order to get new contracts.

In 1985's edition of the draft, the Bears surprised the NFL by selecting William Perry, a defensive tackle from Clemson, whose playing weight ranged anywhere from 320 to 360 pounds. Personnel boss Bill Tobin explained that the weight had ballooned the previous year due to a poor performance by his college team, resulting in Perry "eating every chicken he could see." "Maybe he didn't de-feather all of them," Tobin added. In addition to adding depth on the defensive line, Ditka figured Perry would draw double-teams in the middle, freeing up Dent and Hampton to rush the passer. Perry was given the nickname, "Refrigerator," in college, after a teammate observed that he was bigger than the appliance. Overall, the selection of Perry was considered a risk with potential.

In the second round, they reached for SMU cornerback Reggie Phillips, due to their strong desire to improve that position. In the third, they drafted fast wide receiver James Manness from TCU, and in the fourth, took placekicker Kevin Butler of Georgia. The Butler selection surprised many, given trusted veteran Bob Thomas' fine 1984 season. On the selection of Butler and competition for the respected Thomas, Tobin said, "You can't let your heart make choices in the draft; personalities can't enter in to your decisions."

Later picks were running back Thomas Sanders of Texas A&M, and linebacker Jim Morrissey of Michigan State. Ohio State's second-best quarterback in history, Mike Tomczak, went undrafted, and the Bears snapped him up to compete with Lisch for the number three quarterback spot. Also signed was cornerback Ken Taylor.

Despite the happy feeling entering training camp off their NFC Championship appearance, finance issues looked to cloud the future. Among players holding out in camp were Perry, Van Horne, Singletary, Harris, Bell, and McMichael. Due to the holdouts, a foot injury to Leslie Frazier and questionable play in 1984 from Mike Richardson, defensive coordinator Buddy Ryan tinkered with the idea of starting his two rookie corners (Phillips and Taylor) over the veterans. Also discussed was the possibility of inserting second-year pro Rivera in Singletary's place if the veteran starter did not return from his holdout.

Eventually all the holdouts would return, except for Bell and Harris, who would sit the entire season. All the starter's jobs remained intact, and it didn't take long for Ditka to choose Tomczak as his third quarterback, as Lisch was cut prior to the first preseason game.

McMahon returned to the Bears this training camp with his injured kidney healed, but his head looked to be injured after he had butchered his own haircut. The mohawk-looking hairdo earned him the name "Punky QB" for the first time, even though he insists he had nothing to do with punk rock music. The Bears lost their first three preseason games before defeating Buffalo in the finale. Fans were disappointed throughout August, yelling at Ditka from the stands. "It's a little early to be burying us and writing our names on the tombstone," the coach said.

On September 8th, the 1985 season opened at home against Tampa Bay for the second straight year. Due to the holdouts of Bell and Harris, the Bears were forced to start two new players at their positions: Wilbur Marshall at outside linebacker and Dave Duerson at strong safety. Perhaps the duo was missed more than had been predicted, as at halftime Chicago trailed the Buccaneers 28-17. Twenty-eight seconds into the second half, however, Leslie Frazier intercepted a Steve DeBerg pass and took it back for a touchdown, bringing the score to a four-point deficit. Behind the rushing of Payton, who would run for 120 yards on the day, and the arm of McMahon, the Bears pulled out a 38-28 victory. It was the first time they had rallied from a 14-point deficit to win since 1980. After allowing 166 yards rushing to Tampa's James Wilder, however, there were defensive concerns.

Those concerns were allayed the following week when the Bears held New England's runners to 27 yards, one week after the Patriots rushed for 206. In all, the Bear defense racked up six sacks and three interceptions against third-year quarterback Tony Eason. "Wherever I looked, they had a person there," he said. The Patriots only spent 17 seconds in Bear territory all day, and Chicago won 20-7. The previous week it had been questioned as to whether Marshall and

Duerson would fill in adequately for Harris and Bell, but Marshall in particular had a dominating game against New England. Concerning, however, was a flaring upper back/neck injury to Jim McMahon, and Walter Payton left the game with bruised ribs after rushing for only 39 yards. McMahon had developed a habit of exchanging "head butts" with offensive linemen after scores, and it was wondered if those had anything to do with his neck injury. The quarterback would spend part of the following week in traction in the hospital, and it was questionable if he would be ready for the next game, a Thursday night showdown at Minnesota.

The evening of the game, Ditka decided to start Steve Fuller for McMahon, as the latter player had not practiced all week. Behind Fuller, the offense struggled into the third quarter, and the Bears trailed the Vikings 17-9. McMahon paced the sideline, and each time he passed Ditka he suggested that the coach should put him in before the game slipped away. Finally, with 7:32 remaining in the third period, Ditka told McMahon to "get his ass in there." On McMahon's first snap, he threw a 70-yard touchdown pass to Gault. The play call was for a screen pass, but upon a furious blitz from a Minnesota linebacker, picked up soundly by Payton, the quarterback saw Gault streaking in the clear. Ditka later said, "If Walter didn't make that block, McMahon would have been murdered." On the first play of the Bears' following possession, McMahon tossed a 25-yard touchdown pass to McKinnon, and the Bears led 23-17. On the eighth play in which McMahon participated, the quarterback threw a 43-yard touchdown, again to McKinnon. The Bears won 33-24, and opened the season with a 3-0 record.

They were just getting warmed up.

The next week featured a rematch of the 1984 divisional playoff when Washington came to Soldier Field. Observers saw this as a true test for the Bears against a powerful team, and the Bears won 45-10. The rout actually started with a 10-0 Redskin lead before the Bears scored 31 in the second quarter to set a team record. Included in the spectacular day was a 99-yard kickoff return for a touchdown by Gault, and a touchdown pass from Walter Payton to none other than his quarterback, McMahon.

In week five, the Bears traveled to Tampa, where they defeated the Bucs for the second time on the season, 27-19. Notable during this game was a run that Ditka called the finest of Payton's career. From the nine-yard line, Payton stopped on a dime to make a Tampa tackler miss, then scampered in for a touchdown. With a 5-0 record, the Bears traveled west to San Francisco to attempt to avenge the blowout loss in the NFC Championship game the year before.

On October 13th, Bear players entered the locker room to find the walls plastered with newspaper articles from the previous 23-0 loss. "Next time, bring an offense," a national magazine proclaimed. Ditka did plan to do just that, and called 15 passes on the first 20 plays of the game. "We're not going to just run, run, run and punt again," he said. After jumping out to a 16-0 lead, the Bears won handily, 26-10. In the game's final minutes, Ditka returned insult after injury when he inserted a backfield formation of Thomas Sanders at halfback and William Perry at fullback. The move was payback for Walsh's stunt the year before. Perry carried two times for four yards, and a star was born. The week after the game, the Bears were featured on the cover of *Sports Illustrated*. Payton had made the cover three times himself since entering the league, but it was the first time the Bears as a team had made the cover since the 1960s. The team was 6-0.

On Monday night, October 21, 1985, the Chicago Bears and William "Refrigerator" Perry took their first steps toward winning over the world. Perry lined up at fullback and blocked for two Payton touchdowns, pushing Packer linebacker George Cumby into the Stone Age. Then Perry took the ball himself and crashed in from the one, scoring a touchdown himself, and the Soldier Field crowd went wild. After adding a late safety, the Bears won their seventh straight by a score of 23-7. Ditka's usage of Perry was not simply a novelty, the coach said, at least publicly. "I saw him cover ten yards as fast as anyone, and thought what would he look like blocking for Walter, or running with the ball." If he didn't know it before, the coach had created the biggest sensation in Chicago since Payton himself joined the team eleven years earlier.

In the eighth week of the season the Bears beat Minnesota 27-9, nabbing six interceptions, while Perry registered his first sack on defense. The following week they traveled to Green Bay

for a rematch with the angry Packers. Bad blood between the two teams was at its peak before this game. After Chicago knocked Green Bay out of playoff contention in 1983, coach Bart Starr was fired and replaced by Packer legend Forrest Gregg. Gregg and Ditka had played against each other in countless games during the 1960s, games in which the Packers usually came out on top. The tables were turned now, and Green Bay's collective ego didn't like it. As they arrived in the locker room, the Bears were met with a bag of fertilizer, planted there compliments of a Milwaukee radio station.

On the field, play resembled a pro wrestling match more than a football game. "They played like damn animals," Otis Wilson said. "It was evident when they came out they didn't want to play football. They wanted to fight." Fight they did. On the ninth play of the game, Packer defensive back Mark Lee pushed Payton out of bounds and didn't stop until he had knocked the running back clear over the Bears' bench, five yards away from the sideline. Lee was ejected from the game, but teammate Ken Stills continued the madness by flattening running back Matt Suhey well after a play was over. In addition to the fighting, the contest was as close as they come. Perry's legend grew just prior to halftime, as he was sent in motion and scored on a touchdown reception. Into the fourth quarter, the Bears trailed 10-9, but the game was saved on a 27-yard, game-winning Payton touchdown run. Payton finished with his best performance since 1977, rushing for 192 yards.

The Bears legend and following was growing as they defeated the Detroit Lions 24-3 in the season's tenth week. Jim McMahon sat out the game with shoulder problems, leading some to fear a reprise of the team's 1984 issues at the quarterback position. This time, however, Steve Fuller directed a run-heavy offense as both Payton and Suhey rushed for over 100 yards. The defense dominated the game as usual. Perry led the charge with two sacks, and the unit held the Detroit offense to a paltry 106 total yards of offense. Even with McMahon now not expected back for several weeks, the Bears were primed to unleash a fury unseen to that point in the NFL.

On November 17th, Ditka returned to Dallas to face his mentor Tom Landry for the first time in his old home. The Bears had lost to the Cowboys in the preseason in a game filled with fights, and Ditka had to stop himself throughout the season from looking forward to the rematch. Despite the fact the team was led by Fuller, and later rookie Mike Tomczak, the game was in the Bears' control very early. Dallas had advanced to the Chicago 38-yard line on their first possession, but that was the closest the Cowboys would get to the Bears end zone all day. The Bears scored their first 14 points on interception returns by Richard Dent and Mike Richardson. The score was 24-0 at halftime, 27-0 in the third, and ended up 44-0. The final 17 points had been scored while Chicago's backups were on the field, and included touchdown runs by running backs Dennis Gentry and Calvin Thomas. The win was satisfying to Ditka, and Otis Wilson added, "Who made the Cowboys 'America's Team'? We want to be America's Team." It indeed looked like they were on their way.

Again led by Fuller, the Bears pasted the Atlanta Falcons the following week 36-0, and as a result had outscored their opponents 104-3 in three games. The American Broadcasting Corporation could not have been more thrilled, when the following week's matchup featured the 12-0 Bears against the only team in NFL history to finish a 14-game season unbeaten, the Miami Dolphins. But week 13 would prove to be very unlucky for the Bears, Fuller, and their defense. Miami quarterback Dan Marino and his receivers Mark Clayton and Mark Duper made mincemeat of the Chicago defense in the first half, as they led 31-10 at the break. It has been reported that a fistfight almost broke out between Ditka and Ryan in the locker room, because Ditka had been insisting that Ryan play a nickel defense against Marino and his receivers. In the second half, Ditka finally did replace Fuller with McMahon, but there would be no reprise of the earlier heroics in Minnesota, and the Bears lost 38-24.

The following morning, several players from the Bears met at a downtown Chicago recording studio to record the "Super Bowl Shuffle," a bold song and video that predicted the team would win the title that year. Some players, including Dan Hampton, thought it was ridiculous for the

team to make this claim with six more games to go, but the record was cut and became a best seller, just in time for the title run.

In the next game it was back to business, as the Bears beat Indianapolis 17-10. They then traveled to New York to play the Jets and won 19-6. In the regular season finale at Detroit, they won 37-17. Chicago knocked out several Lion quarterbacks, including veteran Joe Ferguson on a vicious hit by Marshall. The Bears had equaled the 49ers' 1984 record for victories in a season with 15, won the NFC Central Division for the second straight year, and clinched home field advantage throughout the NFC playoffs. Nine Bears players were voted to the 1985 Pro Bowl, a team record. Those pro bowlers included Dave Duerson, who had replaced Todd Bell satisfactorily. Despite an outstanding six-sack, four-interception season, Wilbur Marshall did not make the ' 85 NFL Pro Bowl game, perhaps because the other two Bears linebackers, Singletary and Wilson, did.

Ironically, in Chicago's first home playoff game since 1963, they were scheduled to face the same team they had beaten 22 years earlier—the New York Giants. Things were even in the first quarter in icy Soldier Field, until Giant punter Sean Landeta whiffed on a punt attempt from his own 5-yard line. Shaun Gayle grabbed up the ball and scored the shortest punt return for a touchdown in NFL history, and the Bears led 7-0. After two scoring strikes from McMahon to McKinnon, the Bears easily shut out New York 21-0. Ryan's 46 defense had looked impenetrable; on one second-half sack in particular Gary Fencik simply waltzed through the Giant line to knock quarterback Phil Simms down immediately. The play led Fencik to later say, "we could literally see where they couldn't block us, it was simply one, two, three, BOOM."

The NFC Championship game, to which Ditka had pointed back in 1982, stood before the Bears on January 12, 1986. In town were the Los Angeles Rams, who in his weekly press conference Ditka had nicknamed the "Smiths." In this famous statement, Ditka said, "Some teams are Smiths, and some are Grabowskis. We're Grabowskis." Ditka emphasized his desire for his team to be known as a collection of blue-collar, working-class men.

Prior to the game, the CBS pregame show was set up in the north end zone of Soldier Field, where legendary prognosticator Jimmy "The Greek" Snyder predicted the Rams would win a close game. Perhaps some of the players were aware of this, because 60 minutes of football later, they proved Snyder dead wrong by winning the NFC title 24-0. They were the first team to post back-to-back shutouts in the playoffs in NFL history. The Bears led 17-0 in the game's final minutes, when a light snow began to fall. Richard Dent sacked Ram quarterback Dieter Brock, Marshall scooped up the ball and ran 52 yards for a final touchdown. Punctuating the scene, William Perry ran interference for Marshall the whole way despite no Ram defenders being in the vicinity.

The streets of Chicago were filled with pandemonium following the win. Cars honked, people screamed, Rush Street was jammed with revelers. The Chicago Bears had exorcised the demons of failed Chicago sports teams, and headed for Super Bowl XX in New Orleans two weeks later. The team they faced would be the surprising wild-card New England Patriots, who had shocked the Miami Dolphins in the AFC Championship.

Nothing surrounding the 1985 Chicago Bears could happen without controversy, and the weeks leading up to the Super Bowl were no exception. McMahon was angry with the team for refusing to fly his Japanese acupuncturist on the team charter to New Orleans. He later dropped his pants to "moon" a television news helicopter that monitored their practice. While staying at the team hotel the week before the game, New Orleans sports anchor Buddy Dilberto misquoted McMahon, claiming he called "all the people of New Orleans stupid and the women sluts." The quarterback received death threats and was scared he would be shot before Dilberto issued a correction.

Another side story before the big game was news that the beloved Honey Bears were being terminated after this final trip with the team. "The whole experience of the Super Bowl was fantastic, but no one to this day can explain why we were released," founder Cathy Core said. In mid-November, GM Jerry Vainisi had told Core and the talent agency that managed the

group that their contract would not be renewed for the 1986 season. While not directly answering the question as to why the cheerleaders were dismissed, Vainisi told the *Chicago Tribune*, "Do we feel that cheerleaders have become passé, or do they have a place in professional football?" After working with the current general manager as well as his predecessor Jim Finks for years, Core knows the decision came from a level higher than Vainisi. "George Halas said that as long as he was alive, there would be 'dancing girls' on the sidelines." After his death, however, the organization decided cheerleaders had no place in professional football, and a fond chapter in the memory of Chicago Bears fans closed.

The most consequential distraction of the weeks leading up to the game happened on the eve of the event. Defensive coordinator Buddy Ryan addressed his unit, acknowledging that the rumors they had heard were true. The grizzled veteran admitted that he would be leaving the Bears to become head coach of the Philadelphia Eagles for the 1986 season. Players were stunned and saddened, but after Ryan left the room and Steve McMichael impaled the chalkboard with a chair, the defense was primed to win the last game they could for Buddy.

After a week of hard-partying and hijinks, the teams settled in to play the Super Bowl on January 26, 1986. Chicago was a double-digit favorite for the game, and many preferred to wager on whether New England would score a point, let alone cover the spread. On the Bears' first offensive series, quarterback Jim McMahon called an incorrect formation for the offense. Payton took a handoff but was hit by a wall of Patriot defenders and fumbled. New England was in prime position to take an early 7-0 lead, but two sure touchdown passes were dropped by their receivers on consecutive plays. They did end up kicking a field goal to jump to a 3-0 lead. New England had at least proved they could score on the Bear defense, albeit assisted by a Chicago offensive mistake.

After scoring the early points, New England must have felt as if they were being shelled incessantly by an enemy that had them outgunned in numbers and caliber of weapons. The Patriots were successful in shutting down the Bears greatest weapon, Walter Payton, but Chicago then successfully unleashed the passing game and the running of fullback Matt Suhey. In the first quarter the Bears first kicked two field goals, then scored a touchdown on a Suhey outside run. At the end of the first quarter, the Bears led 13-3. They would score ten more points in the second period and lead 23-3 at halftime.

As if the 20-point halftime lead wasn't enough, in the third quarter the Bears scored 21 more on runs by Perry and McMahon, and a 28-yard interception return by rookie Reggie Phillips. While many of Chicago's backups were already playing in the game, Philips was there due to a massive knee injury suffered in the first half by top cornerback Leslie Frazier. Though it didn't affect the outcome of this game, Frazier's absence would be felt into the future.

After backup defensive lineman Henry Waechter sacked quarterback Steve Grogan for a safety, the score was finalized at Chicago 46, New England 10. After the game, despite protests from Ditka, the team carried him off the field on their shoulders, as they did for Ryan. The exiting coordinator's defense had been indomitable. The Bears as a whole set a Super Bowl record for greatest margin of victory, but by far the defense swept the record book as no team had before. At halftime, the Patriots had only converted a single first down, and were held to negative 5 yards rushing, negative 14 yards passing, for a total of negative 19 yards offense. These were all records. New England could only muster 123 yards on the entire game, 37 against the Bears' second-stringers. They almost set another Super Bowl record for least yards allowed, but missed by just four.

Richard Dent was voted the game's Most Valuable Player, a rarity for a defender. The Bears surely won the game on defense, but couldn't have done it without solid play from the offense. Jim McMahon passed for 256 yards on just 12 completions, ran for two scores himself, and picked up the slack from the shut-down Payton, whom the Patriots had keyed to stop. Payton voiced one displeasure in the post-game locker room, that with 37 points scored by the offense he didn't have the opportunity to take it in once. The legendary running back eventually forgave his coach and reveled in the glow of finally winning the big game.

Defensive lineman Steve McMichael summed up the game in a recent interview with ESPN. According to McMichael, prior to taking his first snap, Patriot quarterback Tony Eason stepped to the line with eyes as big as saucers when he gazed out at the Chicago defense. "At that very moment, we knew we had the game won," the defender said.

The Bears partied hard into the night after the game, and returned to Chicago to be met by hundreds of thousands of fans that gathered for a ticker-tape parade in Chicago's downtown "loop." It was not much of a parade, because the crowds that filled the avenues and hung from streetlights would not allow the team's buses to pass. It was, however, quite a celebration. At a lectern in Daley Plaza, team President Michael McCaskey presented the Super Bowl trophy to Chicago Mayor Harold Washington.

The sight of McCaskey presenting the trophy, not Ditka or Vainisi, the architects of the dominating path to glory, was a troubling sign of things to come.

Dynasty Unfulfilled: 1986–1989

In August 1986 the question for most followers of the Chicago Bears was just how many Super Bowls in a row they would win, not if they would win another.

It was hard to find arguments against the Bears winning multiple championships. The team had dominated every opponent except Miami in 1985, and since the Dolphins didn't win their conference, that could be chalked up as a one-time occurrence. Walter Payton and his stalwart offensive line returned intact. The defensive line and linebackers returned deep and solid, and even 1985 holdouts Al Harris and Todd Bell came into camp and signed contracts.

However, cracks were developing in the team's façade. It seemed like every "name" player on the team was appearing in commercials, owned their own restaurant, had their own television show or all of the above in media-crazy Chicago. Ditka, Payton, and McMahon fit into the "all" category. The coach would warn his players to not let outside interests distract them from football while he appeared in many commercials himself. Rivalries and jealousy developed based on certain players getting a bigger piece of the pie, according to several sources.

It was during the 1986 training camp that differences between the star quarterback and his head coach began to surface. McMahon had reported to training camp out of shape and overweight, a product of enjoying an offseason after a world championship. In a 1997 Associated Press article, McMahon said, "I did report to camp a little puffy that summer, two hundred seventeen pounds. They couldn't figure out my body fat because they didn't have a calipers that big." Ditka was not pleased with the shape his quarterback was in, and when McMahon wouldn't talk to his coach, Ditka accused him of "pouting," to which McMahon responded, "He thinks I'm pouting just because I don't kiss his ass?"

The clock counting down the outspoken quarterback's days in Chicago may have started to tick that offseason, when McMahon released an autobiography that was critical in particular of team president McCaskey. According to kicker Kevin Butler, after he read the book he approached McMahon and said, "It's been nice playing with you," meaning he thought the quarterback's days in Chicago were numbered.

During camp, McMahon's shoulder started to flare up, and he watched most of the preseason from the sidelines. Also missing from the offense was receiver Dennis McKinnon, lost for the season to knee surgery. Defensively, Leslie Frazier would also be out for '86 as a result of the knee injury suffered in the Super Bowl. A team that had been trying to solidify their number two cornerback position now was forced into drafting to replace their number one, pro bowl corner.

In place of departed defensive coordinator Ryan, the Bears hired Vince Tobin, former college and USFL defensive coach. Tobin was pro personnel director Bill Tobin's brother.

In that year's college lottery, the team drafted running back Neal Anderson with their first pick, obviously with the intention to groom him to replace Walter Payton. In the second round they selected another cornerback out of necessity, Vestee Jackson from Washington. Also taken were wide receivers Lew Barnes and Glen Kozlowski, and defensive back Maurice Douglass.

Quarterbacks Steve Fuller and Mike Tomczak took the bulk of the snaps during the

preseason, as Ditka perhaps figured he would depend on them most throughout the season. The Bears opened the season at Solider Field against the Cleveland Browns, and solidly defeated them 41-31. Due to McMahon's shoulder and shaky preseason play by primary backup Fuller, Tomczak came in to finish opening day, and would start the following week.

That week would feature no run-of-the-mill opponent; headed to Soldier Field was Buddy Ryan and his Philadelphia Eagle team. Ditka downplayed his former coach's return while the media looked for every opportunity to create a story about the rivalry. Ryan didn't see fit to muzzle himself. He told one publication that the Bears "didn't have a chance" to repeat as world champions. To this, McMichael, never a huge Ryan fan, responded, "The old fat man has been talking a little stuff in Philly, ain't he?" The game, tied at 10-10, went to overtime before the Bears forced an Eagle fumble deep in their own territory. Butler kicked a field goal, giving Ditka and the Bears their first win over Ryan.

In the next four games, led at times by Fuller and others by McMahon, the Bears dominated their opponents, winning by a combined margin of 102-26. After his team's September 28 victory in Cincinnati, 44-7, Ditka addressed the media in an area accessible to fans, and a Bengal heckler yelled at Ditka, mispronouncing his name by repeatedly yelling an emphatic "Ditkus" at the coach. During this strange moment, Ditka broke from his speech with the media by flashing the "ok" sign at the heckler, yelling, "See that, that's your I.Q., buddy, zero!" As the media's questions continued, the coach stopped and said, "I'd rather talk to him," pointing at the abrasive spectator.

The Bears had won twelve in a row in 1985 before losing to Miami, and had won twelve more before they lost at Minnesota on October 19, 1986. Fuller had started for McMahon and looked lost, confused and hurried in the 23-7 defeat.

After one more win over Detroit, the Bears lost again, this time on Monday Night Football, 20-17 to the Los Angeles Rams. The two losses in three games had coaches, players and fans concerned.

Despite those concerns, the 1986 Bears won their final seven regular season games, mostly because of their still-stifling defense. Even absent Ryan as the defensive coordinator and playing traditional non-attacking schemes more often, the unit set a new NFL record by allowing just 187 points on the season.

Offense was a different matter. Due to his shoulder problems, McMahon missed three of the first eight games, and the quarterback's coach and GM were finally finished with wondering week-to-week whether the starter would be ready to play. For this reason, in mid-October the Bears traded a sixth-round draft pick and swapped a third for a fourth with the Rams to acquire the rights to quarterback Doug Flutie. Flutie stood just 5 feet 9 inches tall, but was best remembered for a last-second touchdown pass he threw that beat the Miami Hurricanes in a college bowl game.

The acquisition gave Ditka another option at quarterback. Fuller's 1986 play had been questionable at times, and Ditka elevated Tomczak to start in McMahon's place, but Tomczak wasn't too impressive either. In the four late-season games in which he played, the Bears averaged only slightly more than 13 points per contest.

Strategically, the Flutie acquisition seemed to be a no-brainer, while tactically it turned out to be a disaster. The Bear offense quickly divided; the players on one side solidly backing McMahon, Fuller, and Tomczak, and the head coach and his GM behind Flutie. It was reported that the coach entertained Flutie and his fiancée at Thanksgiving dinner, and said that yelling at the diminutive player was like screaming at "Bambi." The players were not amused. At the same time, defensive lineman Dan Hampton called McMahon out for his inability to play, causing further rifts among teammates.

McMahon did start one more contest that season, the November 23rd contest with Green Bay at Soldier Field. In no game in history did the heated Bear-Packer rivalry become more contemptuous. Packer defensive lineman Charles Martin left the locker room wearing a white towel from his belt that was emblazoned with several numbers. Included on the towel were 9,

34, 29, and 83, ostensibly announcing that Martin intended to knock McMahon, Payton, Gentry, Gault, and others from the game.

Starting his first game in over a month, McMahon had a poor outing, throwing for just 95 yards on 12 completions in 32 attempts. He also threw three interceptions and no touchdowns. In the second quarter, after throwing his third interception, McMahon was body-slammed to the turf by Martin, who had crept up on the unsuspecting quarterback from behind several seconds after the ball was thrown. Martin was immediately ejected from the game, which the Bears won 12-10, but the damage was done. McMahon had landed directly on his injured right shoulder and was lost for the remainder of the year.

Tomczak continued to start for the Bears until the season finale at Dallas, which became Flutie's first NFL start. The Bears won that game 24-10 against a 7-9 Dallas team and finished the season with a 14-2 record. The team's 29-3 two-year record was the best in NFL history. They would have a week off, then host the Washington Redskins, a team that had finished the season 12-4.

With both Fuller and Tomczak available to start the playoff game, Ditka chose his newest acquisition in Flutie to command the offense. The players were incensed at the decision—and concerned. In Keteyian's book, safety Fencik recalled that Flutie would throw countless interceptions into the secondary at practice. Offensive coordinator Hughes said the coaches would stand behind him and see blind spots over which the short quarterback could not see.

During the Redskin playoff game, Flutie strapped a card to his wrist listing over 30 offensive plays, but by the end of the game was confused nonetheless. After leading 13-7 at halftime, a third quarter Flutie interception set up a Washington touchdown that put the visitors on top 14-13. They would never look back, eventually defeating the Bears 27-13. For the game, Flutie completed just 11 of 31 passes for 134 yards.

According to Hughes, Flutie as the starting quarterback wasn't the only reason the offense sputtered in the playoff game. In 1986, Ditka had directed the offense to start using more motion prior to the snap, either from wide receivers motioning or tight ends and running backs shifting prior to the play. Ditka intended for this motion to confuse the defense, limiting their ability to focus on the formation. An adverse affect, according to the offensive coordinator, is that it limited the quarterback's ability to audible to a better playcall. Perhaps this was Ditka's intent, as McMahon's improvisation had become an annoyance to the coach over their five seasons together. This annoyance, however, was one of McMahon's strong points. According to Hughes, McMahon was the best in-game quarterback he had ever coached.

Following the playoff loss on January 3, 1987, the month did not prove to get any better for Ditka. The coach learned less than a week after the bitter loss that his best friend and biggest ally in the Bears organization, GM Jerry Vainisi, would soon be fired.

Michael McCaskey announced to the press on January 15th that the parting of ways was a "mutual decision" between the two men. Ditka's comment was that he was "taken totally by surprise and very, very hurt" over his "best friend" losing his job. According to Keteyian's book, Ditka asked McCaskey, before the decision was made public, to keep Vainisi for one more season, after which he could release both the GM and the coach at the same time. McCaskey was unwilling to accept Ditka's plan. The Bears would move on without a GM but retain Ditka. However, the coach's contract was up after one season and the length of his tenure with the team was very much in question.

Ditka, Vainisi, and personnel boss Bill Tobin had been a three-headed team that made football decisions for the club, and Ditka would soon find out that the trio would now include McCaskey instead of Vainisi. Vainisi had served as the coach's buffer with management, and now the new trio would need to learn how to settle their differences in a productive manner.

The coach found out first hand how this would work during the 1987 draft. With the 26th pick in the first round, Ditka favored selecting linebacker Alex Gordon of Cincinnati. Still feeling the quarterback situation was unsettled, Tobin and McCaskey overruled the coach and

picked quarterback Jim Harbaugh from Michigan. McMahon and his agent were horrified, and it took a personal phone call from Ditka to get the starting quarterback to back off his demands to be traded. The team selected wide receiver Ron Morris from Southern Methodist with its second-round choice; the teams' other ten picks would not make an impact with the team through their careers.

The selection of Harbaugh further muddled the Bears' situation behind center. It was not known if McMahon's ailing shoulder would be healed sufficiently to allow him to play at all in 1987. In fact, the August 24th issue of *Sports Illustrated* featured a photo of McMahon and asked "Will Jim McMahon Play in '87?" Inside was a telling photo of the Bears' signal-callers: McMahon as the ringleader, surrounded by Flutie, Tomczak, Fuller, and Harbaugh—a group of players that would eventually combine to play 75 seasons in the NFL. For the '87 season, however, Fuller was injured and released and the Flutie experiment ended when he was traded to the New England Patriots. On the roster at the start of the season were McMahon, Tomczak, and Harbaugh.

1987 would be the end of an era, as Walter Payton and Gary Fencik, two Bear legends, announced they would retire following the campaign. Both veterans' roles would diminish that season, as Payton yielded carries to heir-apparent Neal Anderson, and Fencik relinquished his starting position part-time to Todd Bell.

McMahon's shoulder injury did indeed sideline him for Chicago's 1987 opener-a Monday Night Football showdown at Soldier Field against the reigning world champion New York Giants. Behind third-year pro Mike Tomczak, now the unquestioned starter while McMahon was sidelined, the Bears beat the world champs 34-19. The game featured another triumphant comeback, as Dennis McKinnon, sidelined in '86 with a knee injury, scored a touchdown on an amazing 94-yard punt return.

The following week the Bears defeated Tampa 20-3, and after that second game, the NFL player's union announced its second strike in the previous five seasons. Games were cancelled the following week, but this time the owners would not allow the NFL to shut down while the players union stayed away. The league fell back on a contingency plan, and each club recruited an entirely new team to play in place of union players.

Some NFL coaches, such as Buddy Ryan, played along but did not give full support to their new teams. Mike Ditka on the other hand called his replacement players the "Real Bears" and called the striking union players "crybabies" and "primadonnas." The replacement Bears won two of three games before some NFL players started crossing picket lines on October 14th. That week, the players ended their grievance after 24 days and returned to play the weekend of October 25th. Ditka's comments were not to be forgotten by some of his men, further dividing the team and thwarting yet another Super Bowl run.

One positive aspect of the player's strike was that it allowed McMahon some rest to heal his ailing shoulder, and upon the union players' return the team won three in a row in spectacular fashion. In their first game at Tampa, the Bears trailed the Buccaneers 20-0 in the first quarter and 26-14 in the fourth. A last minute touchdown pass from McMahon to Anderson, who outleapt three Bucs for the winning points, allowed the Bears to pull out a 27-26 victory. Against Kansas City the following week, Chicago trailed 14-0, then 28-17 in the fourth. Two touchdown passes from McMahon to Gault sealed another come-from-behind shocker, 31-28. Finally, on November 8th, it took a last-second 52-yard field goal from Kevin Butler to beat the Packers in Green Bay, 26-24. After nailing his kick, Butler turned to the Green Bay sideline and gave a one-finger salute to coach Forrest Gregg, underscoring his teammate's feelings for the Packer coach. Gregg would resign his position with the Packers after the season.

On November 16th, under the Monday night lights, the Bears had the chance to remain undefeated as a "regular" unit. Overall they were 7-1 and their only loss had come during the strike. Despite McMahon's best performance of the season, in which he threw for 311 yards and three touchdowns against the Broncos, the Bears lost 31-29, blowing an 8-point fourth quarter lead. A streak ended that night, as the team had won the previous 25 games with McMahon as the starting quarterback.

Following the loss, the Bears won three more until McMahon injured a hamstring. On another Monday night, December 14th, the Bears were annihilated 41-0 by the 49ers in San Francisco. During the carnage, Tomczak threw four interceptions before he was replaced by the rookie Harbaugh. The defense began to weaken, allowing 199 yards rushing and four touchdown passes by Steve Young. Following the game, Ditka allegedly threw gum into the stands, striking a female 49er fan in the head. The woman threatened to press charges before dropping the matter. Ditka refused to admit guilt.

The Bears limped through the final two weeks of the season, losing to the Seattle Seahawks 34-21 and barely beating the Los Angeles Rams 6-3. More amusing during the latter part of the '87 season were Ditka's always colorful quotes than the team's play on the field. Prior to the December 6th game at Minnesota, the coach called the Viking's stadium the "rollerdome," as to him, he thought only roller derbies should be hosted indoors. In response to his comments, Minnesota's GM sent Ditka a pair of skates, which he donned to take for a spin around Halas Hall to the delight of the media. Several weeks later, the coach would remark that Washington's Dexter Manley had the "I.Q. of a grapefruit."

With a win in the season finale, the Bears finished 11-4 on the season, good enough to host a divisional playoff game for the second year in a row against the Washington Redskins. This time, the Bears had a healthy McMahon, and the Bears were playing in perhaps Walter Payton's final home game. Chicago jumped out to a 14-0 lead on a Calvin Thomas run and a touchdown pass from McMahon to rookie receiver Ron Morris. Washington, led by rejuvenated veteran quarterback Doug Williams, quickly tied the score at 14-14. The game remained tight in the third quarter, until Redskin Darrell Green snaked through a pack of Bears to return a punt 52 yards for the decisive touchdown. The Bears had several opportunities to reach the end zone from there, but McMahon was intercepted three times, and Chicago lost Payton's final game 21-17.

After the loss, a frustrated Ditka said, "Our guys played hard. It wasn't a matter of wanting to. It wasn't a matter of being ready. It wasn't a matter of being stale. It was a matter of not being able to make plays when we had to."

The Bears had been knocked from the playoffs two straight years at home by the same team. Legendary running back Walter Payton retired after setting 28 team and 7 NFL records. Safety Gary Fencik retired as well. Payton led the team in rushing in the playoff game, while Fencik was called upon to start the final three games after Ditka shook up the defense late in the season.

Despite three straight division championships, a 40-7 three-year record and continuing solid personnel, all was not entirely well with the Bears. Before the last game of the season, linebacker Otis Wilson and Ditka engaged in a heated argument, during which Wilson said Ditka told him "you'll never play again." A public settlement of the dispute was announced, but Wilson would not last another year with the team. Wide receiver Willie Gault, the fastest member of the team and the offense's only deep threat, wanted to be traded, preferably to Los Angeles to further his acting career.

Perhaps most troubling, linebacker Wilbur Marshall was entertaining a serious offer from the Washington Redskins as a free agent. In the 1980s, becoming a free agent meant that a player could be pursued by another team, but the new club was required to give up multiple draft picks as compensation if they signed the player. As if ending the Bears' season two years in a row was not enough, the Bears chose not to match the Redskins' five-year, $6 million offer to Marshall. The linebacker accepted and became the first free agent to switch teams in the NFL since 1979. Washington would compensate Chicago with two first-round picks. In July, Gault was traded to the Los Angeles Raiders for a 1989 first-round pick and a 1990 third-rounder.

For the 1988 season, the Bears would go without two of their fastest and most productive stars. In the draft, they selected running back Brad Muster and receiver Wendell Davis in the first round, linebacker Dante Jones in the second, tight end James Thornton in the fourth and defensive backs Lemuel Stinson and David Tate in later rounds.

The '88 season would prove to be the Bears' final year of dominance in the NFC. They finished the campaign with a 12-4 record, winning home field advantage throughout the

playoffs, losing only to the Los Angeles Rams, Minnesota (twice) and New England, who, led by Doug Flutie, trounced the Bears in Massachusetts.

The season was memorable in that the Bears finished strong despite losing several offensive and defensive starters to injury. Ditka himself suffered a health crisis when he had a heart attack in November. The coach would miss one game before returning to the sidelines; Vince Tobin coached the team on an interim basis. Neal Anderson had a breakout first season as the starter at running back, rushing for 1,106 yards. Anderson was the first Chicago running back other than Walter Payton to rush for over 1,000 in a season since 1967.

McMahon started the season looking strong, and played in every game until week ten, when Tomczak relieved him due to an injured knee. Tomczak was then himself injured, and Jim Harbaugh received his first starting assignments in weeks 14 and 15.

By the opening round of the 1988 playoffs, McMahon's knee was healed, but Ditka started Tomczak against Ryan's Eagles. The quarterback threw a quick touchdown bomb to McKinnon, and Anderson rushed for a score, putting the Bears on top 17-9. After halftime in a surreal environment, a fog descended over the stadium, obscuring visibility on the field as well as in the stands. In what came to be known as the "Fog Bowl," the Bears beat Ryan's Eagles for the third time, 20-12, despite Philadelphia penetrating the Bears' red zone nine times.

The win set up an NFC Championship matchup in Chicago against San Francisco, who the Bears had beaten 10-9 during the regular season. McMahon was named the starting quarterback, but couldn't get the offense going. The Bears lost 28-3 in the ice-cold stadium, forever reducing the perceived advantage of "Bear weather" over warm-climate teams.

While the '88 Bears won a playoff game for the first time since 1985, they were unable to win when it counted in the NFC Championship game. According to offensive coordinator Hughes, as quoted in Keteyian's book, McMahon was finally fed up with the constraints placed on him by the Bears' offense after the 49er loss. He met with his agent after the game and asked him to look for a trade.

In the 1989 draft, Chicago went defense and finally selected the lock-down cornerback they had coveted throughout the 1980s. The corner, Clemson's Donnell Woolford, was selected with the eleventh pick in the draft, obtained from the Raiders for Gault. With their next pick, obtained from Washington for Marshall, they selected defensive end Trace Armstrong from Florida. Later in the draft they would select linebacker John Roper, offensive lineman Jerry Fontenot, defensive back Markus Paul and running back Mark Green.

During the preseason, the Jim McMahon era ended in Chicago when the Bears traded the disgruntled seven-year veteran to the San Diego Chargers for a conditional first, second or third-round pick, depending on McMahon and his new team's performance. The quarterback's departure opened the door for Tomczak to become the unquestioned leader of the offense, with Harbaugh waiting in the wings.

In the spring of 1989, longtime offensive coordinator Ed Hughes was "promoted" to the title of assistant head coach, moving former player and quarterback coach Greg Landry into the top offensive job. Hughes, a huge supporter of McMahon, resigned his position shortly after the McMahon trade, although he denied the trade had anything to do with his departure. He did, however elaborate with the media on his reasons for leaving, and primarily it was over growing philosophical differences with Ditka and Landry.

The Bears opened the 1989 season with a 4-0 record, beating defending AFC Champion Cincinnati, then Detroit, Minnesota, and Philadelphia. At that point, the Bears had compiled a 70-17 record since the beginning of the 1984 season, an NFL record for winning percentage in that span. Just as remarkable, the Bears had not been out of first place in the NFC Central since 1983, six years earlier.

At that point, the team's fortunes changed. Chicago's 1989 demise would coincide with the loss of defensive lineman Dan Hampton for the season with a knee injury. After the 4-0 start, the team lost ten of its last twelve, finishing 6-10 on the season and fourth place in the division. Several losses that year were particularly devastating. After the 4-0 start, the team blew big

leads to lose late in the game to Houston and Tampa Bay. On November 5th at Green Bay, the Packers won on the last play in what came to be known as the "instant replay game." Packer quarterback Don Majkowski threw the winning touchdown pass to Sterling Sharpe, but was ruled to have crossed the line for scrimmage. The penalty was very questionably overruled on instant replay, and the Packers won, plunging the Bears' record to 5-4.

On November 19th, Jim Harbaugh started the rematch against Tampa but was pulled for Tomczak in the fourth quarter. The older veteran threw three touchdown passes in the final period, putting the Bears ahead, until the defense allowed the Buccaneers to win the game on a field goal. After the team lost to Washington on November 26th, Ditka proclaimed that rookie cornerback Woolford "couldn't cover anyone," and predicted his team wouldn't win another game on the season. He was correct.

Despite the poor finish, Neal Anderson continued to improve with a Pro Bowl season, rushing for 1,275 yards. Defensive rookies Armstrong, Woolford, Roper and Paul gained valuable experience, and by the end of the season Lemuel Stinson had gained a starting role opposite Woolford. This defensive backfield gave the team a shut-down corner on one side and a gambling playmaker on the other.

In 1989, the offense ranked tenth overall, while the defense slipped mightily from second in 1988 to 25th.

The team ended the decade of the 1980s with a record of 84-60. They had risen from a team with one star player to the darlings of the league and world. But by the end of the decade, the once-unstoppable group could not get over the hump. As the 1990s began, many wondered if the wounded Bears of 1989 had any gas left in the tank before the inevitable mass retirements of players from the championship teams of the '80s.

Ditka's Last Stand: 1990–1992

As the 1990 NFL draft approached, Bears management had grown tired of continual holdouts by rookies and veterans alike long into training camp. While there wasn't much the team could do about the veterans, they decided to take matters into their own hands with the rookies. The team contacted USC safety Mark Carrier prior to the draft. Carrier, a probable top-20 pick, was told the Bears would select him with their sixth pick in the draft if the player would agree to contract terms before the selection was announced. Carrier was assured of being picked higher than most thought, and at the same time the team did not have to worry about a holdout. The parties agreed, and Carrier was the Bear's man.

Also selected to bolster the team's slipping defense were linemen Fred Washington and Tim Ryan, linebacker Ron Cox, and safety John Mangum. Offensively, the Bears selected quarterback Peter Tom Willis and running back Johnny Bailey.

This influx of new talent was a requirement, as the dominating Bears' unit from the previous decade was aging. The offensive backfield was young, led by what many considered was the best backfield tandem in the NFL in Neal Anderson and Brad Muster. Matt Suhey had retired following the '89 season. The receivers were young and steady with Ron Morris, Wendell Davis, and Dennis Gentry the primaries. Tomczak and Harbaugh would battle in camp for the starting job, while Willis would be groomed for the future.

The offensive line, the rock of the unit for a decade, was wearing down. Jim Covert, Mark Bortz, Jay Hilgenberg, Tom Thayer, and Keith Van Horne had played as a unit since the 1985 season, but age and injuries were starting to take their toll. Center/guard Jerry Fontenot, a 1989 draftee, looked to be solid for the future, but numerous other draft picks through the late 1980s did not pan out to provide depth. Sooner or later the team knew they would need to rebuild their line, but for one or two more years it would be depended on to stay together and continue to perform at a high level.

On defense, the secondary had youth and talent with Woolford and Stinson at the corners, and veteran Shaun Gayle and the rookie Carrier at the safety positions. Veteran Dave Duerson would be released prior to the season. Starting at linebacker that year would be the ageless Mike

Singletary in the middle, flanked by veterans Ron Rivera and Jim Morrissey. Youngsters John Roper and Ron Cox would alternate. The defensive line, much like the offensive line, was aging but still playing at a high level. This proved to be a quandary; the unit still was one of the best in the NFL with Richard Dent, William Perry, Steve McMichael, and Trace Armstrong, but outside of the latter player would need an influx of new talent in the coming seasons. Legendary lineman Dan Hampton announced that 1990 would be his final season. Fortunately that year's draft had provided players with potential in Ryan and Washington.

What was assured for the team as the new decade began was fan support. The Bears had sold out every game at Soldier Field since 1983, and the aura surrounding the team had only grown since the Super Bowl season. The team was now even being featured in a regular skit on Saturday Night Live called the "Superfans." George Wendt, Mike Meyers, Chris Farley, Joe Montagna, and others played a group of beer-swilling Ditka disciples that loved nothing more than "Da Bears." This nationwide attention on the team kept the organization in the limelight and undoubtedly spawned legions of new fans of the team and their blue-collar, no-nonsense reputation.

At the end of training camp, Ditka announced that his 1987 first-round pick, Jim Harbaugh, had won the right to be the Bears' unquestioned starting quarterback over Mike Tomczak. Harbaugh would direct a new offense in 1990, designed and installed by coordinator Greg Landry, who almost lost his life that summer to an intense viral infection. The new scheme featured quick passes to running backs Anderson and Muster, as well as heavy shifts and motion packages, as Ditka had always preferred.

The 1990 Bears looked like they had indeed bounced back from the horrible '89 season, when they won their first three games in dominating fashion. In week four, they did lose at the powerful Los Angeles Raiders, but then went on to win six straight behind a rejuvenated defense and the running of Muster and Anderson. Harbaugh's passing was proficient as well, as he set a new team record by throwing just one interception in 243 attempts.

The defense was not only winning, but having fun. While cornerback Donnell Woolford was more dependable on a play-for-play basis, his partner Stinson made headlines by boldly predicting the number of interceptions he would make in games. On November 11th, he bolstered his dynamic image by making good on his promise to intercept two passes against the high-flying Atlanta Falcons, in a game the Bears won 30-24. The following week at Denver, Stinson suffered a devastating knee injury and was lost for the season, which he finished with six takeaways.

While Stinson bragged of his exploits, rookie free safety Carrier simply delivered. Carrier was named the NFL's Defensive Rookie of the Year after he intercepted ten passes, including three in a single game at Washington. The defensive backfield's success was due undoubtedly to the play of the team's pass rush, which generated 43 sacks on the season, led by ends Dent, with 12, and Armstrong, who posted ten.

After the team's 10-2 start, they faltered, losing three of their last four games. Harbaugh suffered a separated shoulder in the season's 14th week, and was replaced as the starter by Tomczak. The Bears won the NFC Central division in 1990 for the sixth time in seven years with an 11-5 record, then beat the upstart New Orleans Saints 20-6 at Soldier Field in the playoffs' wild card week. The following Sunday, Chicago was blown out 30-3 by the eventual Super Bowl champion Giants in New York. The Bears' offense, led by Tomczak, was ineffective. The Giants were led by veteran running back Ottis Anderson, the same runner Walter Payton had out-rushed for the NFC crown in 1979, and deposed Bear safety Dave Duerson.

In December of 1990, the team suffered a blow when promising rookie defensive tackle Fred Washington was killed in a single-car accident near his home in Chicago's north suburbs. Not only was the loss a tragedy in human terms, it further clouded the future along the defensive line.

In the 1991 draft, Ditka favored selecting Notre Dame defensive tackle Chris Zorich, the nation's top lineman, in the first round, but was overruled by personnel boss Tobin and team president McCaskey. Desperate for young prospects at offensive tackle, the Bears selected lineman Stan Thomas from Texas. This draft scene may have been one of the final straws to Ditka's patience.

The coach told the *Chicago Sun Times'* Dan Pompeii in a 1995 article that, "the situation that made me the maddest was the drafting of Thomas, because it was an out-and-out mistake. I told them [McCaskey and Tobin] that on draft day. I told them the guy was a bum and not a good football player. He wasn't a good character kid, and that bothered me. If I'm not a judge of character, I don't know who is." Ditka later said that McCaskey called Thomas the "last of the big guys," but Ditka still didn't want any part of him.

If there was any consolation to the draft, the undersized Zorich was still available to the Bears in the second round, where the team selected him. Zorich grew up on Chicago's south side, and would now get to play with his childhood hero, Mike Singletary. The team also selected punter Chris Gardocki and fast wide receiver Anthony Morgan in the third and fifth rounds. In the sixth, the Bears took a gamble on running back Darren Lewis of Texas A&M. Lewis was a top performer in college, but his stock fell after he had tested positive for cocaine.

The Bears began the 1991 preseason overseas for the third time in six years. In 1986, as the world champions, the Bears traveled to London to play the Dallas Cowboys. In '88, they played the Minnesota Vikings in Goteborg, Sweden, and in '91 would face the San Francisco 49ers in Berlin, Germany. The team's worldwide appeal was obvious as they traveled to serve as ambassadors of American football, just as a previous Bears team had toured the states.

Just as Jim McMahon's persona had worn thin on Ditka through the 1980s, icon William Perry spent much time in the head coach's doghouse, and in no year was this friction more obvious than 1991. The defensive tackle's weight had changed each season as he came into camp, and this year it neared 380 pounds. Ditka was determined to use any of his young tackles to try to motivate the oversized "Fridge" to perform at a weight that was acceptable.

Terrible football news came to the team that training camp, when left tackle Jim Covert suffered a serious back injury in the summer's first week. Although the team immediately traded with the New York Jets for veteran lineman Ron Mattes, it looked likely that Ditka's least favorite draftee, Thomas, would be the starter on the left side that season. Quarterback Mike Tomczak was left unprotected in free agency that summer, and would eventually sign with Green Bay, leaving the Bears to be led by Harbaugh, Willis, and rookie Paul Justin.

On opening day against Minnesota, to whom the Bears had lost four of their last six games, Thomas would face all-pro defensive end Chris Doleman. Despite being plagued by false start and holding penalties, Thomas performed respectably, and the Bears won the opener 10-6. Another unlikely hero was born that day. Although rookie wide receiver Anthony Morgan would start for the injured Ron Morris, first-year active player Tom Waddle would be called upon to replace Morgan when he was injured. Waddle was the antithesis of Morgan, a "slow white guy" as he was called by some. Just prior to halftime, Waddle caught a diving 37-yard touchdown pass from Harbaugh, helping the Bears to eek out the victory.

The Bears won the following week, then their fans enjoyed two of the most exciting games in history. They first beat the defending world champion Giants 20-17 after the resurgent William Perry helped block a last-second field goal attempt. The following week the game vs. New York's other team, the Jets, had to be witnessed to be believed. The Bears trailed 13-6 with less than a minute to play and the Jets were running out the clock. Defensive tackle McMichael stripped the ball from running back Blair Thomas, and Harbaugh drove the field to throw the tying touchdown pass to Neal Anderson with one second on the clock. In overtime, the Jets missed a chip-shot field goal, and with less than five minutes remaining, Harbaugh threw what looked like the winning touchdown pass to tight end Cap Boso. After Boso jumped to his feet with a wad of Soldier Field turf stuck in his facemask, players ran to the locker room, only to be retrieved when it was ruled Boso was down on the one yard line. Harbaugh snuck in for the touchdown, and the Bears finally won 19-13 very late on a Monday night.

Like 1990, the team won five games in a row to start 9-2, but finished the campaign by losing three of their last four. In the season finale at San Francisco, where the Bears had been blown out 41-0 and 26-0 in 1987 and 1989, the Bears would need a victory to win the NFC Central for the seventh time in eight years. If the Bears lost, Detroit would take the title. The drama unfolded on

Monday Night Football, as Lions coach Wayne Fontes was shown watching the game in front of a television at Detroit's Silverdome. The Bears were taken over by a cascade of errors, and eventually lost 52-14, again being splattered on national television by the 49ers. Fontes and his cohorts smoked cigars and relished the Bears' defeat in front of the national audience.

After the huge loss by the California Bay, the Bears stumbled into the 1991 NFC Wild Card game, but were still favored over the surprising Dallas Cowboys. Dallas had finished 1-15 just two seasons earlier, but had made the playoffs in head coach Jimmy Johnson's third year. Johnson's defensive coordinator, Dave Wannstedt, called plays for a unit that kept the Bears out of the end zone for much of the day even though the Bears operated in the Cowboy red zone several times.

Chicago trailed Dallas 17-6 in the third quarter and were able to pull as close as 17-13, but an interception thrown by Harbaugh on the Bears' final drive thwarted any hopes of a Chicago comeback. Dallas would advance to Detroit for the divisional playoffs, and a frustrated, demoralized and beaten Bears team went home after a magical 1991 season.

Harbaugh became the first Bear quarterback to start 16 games in a season since Vince Evans in 1981. Wendell Davis caught passes for 945 yards, the best season by a Bear receiver since Dick Gordon's 1970 Pro Bowl performance. Opposite Davis, Tom Waddle earned a starting role despite possessing neither the size nor the speed demanded of wide receivers in the NFL. Waddle set a Bears' playoff record with nine catches in the loss to Dallas. So battered was he after absorbing hit after hit over the middle, several times Waddle was carried off the field to chants of his name from 67,000 Soldier Field fans.

Those were the positives from the 1991 season, but at the same time the passing game flourished, the vaunted Bears running game took a step backwards. Anderson was limited to under 1,000 yards rushing for the first time since he became a starter, and he and Muster were hampered with hamstring injuries through much of the year. And the offensive line's problems were not addressed with the addition of Thomas. After a strong early-season showing, Thomas' tendency to be called for holding and false starts landed him as a backup to veteran John Wojciechowski, and both lines would again need to be addressed in the following draft.

After the Dallas loss, a defeated Ditka conceded to the press that he fielded a group of "overachievers," and the team did the best it could with the personnel hand it had been dealt. Perhaps this was a delayed jab at Tobin and McCaskey for forcing the selection of Thomas in the '91 draft, but yet another comment from the coach rubbed players the wrong way.

In 1992, Mike Ditka prepared to coach his eleventh season for the Chicago Bears. He was now the second-winningest coach in Bears history behind Halas, and had won his 100th game the previous year. In the '92 draft, the coach, personnel boss and owner agreed to pass over perhaps a more solid pick at defensive end in Robert Porcher for one with a bigger downside but more potential, 20-year old Alonzo Spellman from Ohio State. The defensive end was built like a freak of nature, 6 feet 4 inches, 280 pounds of muscle with just 5.6 percent body fat. Because the team hoped they had several years left in Richard Dent, it wasn't felt that Spellman would need to contribute immediately. In the second round, the team drafted left tackle Troy Auzenne, who became the Bears' starter in place of Thomas, who backed up the aging Van Horne on the right side.

An ugly contract situation brewed at training camp in August 1992, as 12-year veteran and perennial Pro Bowl center Jay Hilgenberg held out for a fair contract. When terms could not be reached, Hilgenberg was traded to the Cleveland Browns for a 1993 fourth-round draft choice. The popular "Hilgy" would be replaced in the lineup by 1989 draftee Fontenot.

Prior to the preseason finale against Dallas, coach Mike Ditka told the broadcast announcers that he felt better about his 1992 club's chances than he did about his '85 team. Whether the coach really meant it or was attempting to inflate egos, he would get a tough test in week one of the season when the Bears hosted the defending division champion Lions. Taking a page directly out of the 1991 Bears' book, Chicago won the game with one second left on the clock on a Harbaugh-to-Waddle pass over the middle. After the Lion game, the team felt they hadn't missed

a step from the teams of 1990 and 1991, and expected to dominate the division once again.

What had changed that season was that three NFC Central rivals were now led by new coaches, with influxes of talent and new "west coast" offensive styles. Bill Walsh disciples Mike Holmgren (in Green Bay) and Dennis Green (in Minnesota) got their teams out to quick starts, while the Bears struggled to a 2-3 record after five weeks. If Ditka's Bears teams were known to finish weakly in every season since 1987, they were also known for lightning starts in September and October. This had changed in 1992.

The unraveling of the season, and Ditka's coaching career, came in week five at Minnesota. The Bears had a 2-2 record and were leading the Vikings 20-0 in the third quarter. According to Mullin's book, the Bears had an absolutely hard rule against calling any audibles at the line of scrimmage in the noisy Metrodome. Facing second down deep in his own territory, Harbaugh called an audible out to Anderson split wide to the left. The quarterback called to change his pass route from a fly pattern to a quick hitch. The running back failed to hear the quarterback's instructions, and Harbaugh's ill-advised pass was intercepted and returned for a touchdown by Viking cornerback Todd Scott. Less than 15 minutes of play later, the Bears collapsed and lost 21-20.

After the Harbaugh audible, Ditka went ballistic on the sidelines, cursing and storming at the quarterback multiple times. The entire escapade was captured on television and replayed countless times throughout the year. In his defense, Ditka explained the no-audible edict to the press, stating he wasn't angry at the mistake but at the direct challenge of his orders. He followed up by asking the press "if you think this is a goddamn soap opera, you're full of sh—. 299 plays I've been calm and one I got excited, yet you sonofabitches focus on just one."

The 1992 Bears would win three additional games that season, but lost eight more, finishing with a 5-11 record. In an effort to spark his players, Ditka shuffled his offensive and defensive lineups several times, benching Mark Carrier, Lemuel Stinson, and John Roper on defense, and Neal Anderson and Harbaugh on offense in favor of Darren Lewis and Peter Tom Willis. Nothing resulted in victories. Nothing, with the exception of Mike Singeltary's final game at Soldier Field on December 13th, when the motivated defense helped shut down the playoff-bound Pittsburgh Steelers 30-13.

When the season ended, speculation on Ditka's future ran rampant, but real news was limited. Michael McCaskey took a few days off after the season, during which time Ditka's public views on the future wavered greatly. The legendary coach first stated that he would not want to return to fulfill the final season of this contract unless he was given greater personnel control of the team, then waffled to sound as if he wished to keep his job at any cost.

January 5, 1993, turned out to be a day of mourning for all of Chicago, when McCaskey announced to the press that the eleven-year coach of the franchise was being terminated. The team CEO ordered extra security around the Bears' Lake Forest, Illinois offices, as dozens of Bears fans showed up to support their beloved coach. "In life, all things pass," Ditka said as he met the media. "This too, shall pass," were his final words.

McCaskey and Ditka never had been on quite the same page since the dismissal of the coach's ally in Vainisi after the 1986 season. In a 2004 interview, Ditka conceded that indeed the sting of the firing still may not have passed. Summing up his feelings that what happened was destined to happen, Ditka said, "I wasn't a McCaskey kind of guy. I was a Halas kind of guy."

Whatever coach would be named to succeed Ditka, everyone knew that it would be an unenviable task to follow the legendary "Iron Mike." Ditka was hired in 1982 to return the fire to a team that had suffered through almost two decades without winning a playoff game. One of George Halas' final actions before his death in 1983 was to elevate his confidant and friend Jerry Vainisi to the role of general manager, and according to Ditka it was indeed "Halas' last wish for me to coach the team and for Jerry to run it."

Under Vainisi and Ditka, the team won its first NFC Central crown in 1984, and took the world by storm the following season. Club President Michael McCaskey exerted his control over the team following the 1986 season by dismissing the GM, thus eliminating a critical

buffer between the controlling owner and outspoken coach. The team continued to win from 1986 through 1988, but could not succeed in critical playoff games. After faltering in 1989, Ditka's Bears returned to form and the playoffs in 1990 and '91, before eventually burning out like a spent missile in 1992.

For all the heartbreaking losses in crunch time, the Bears of the Mike Ditka era will forever be remembered for dominating their opponents on the football field, running up the best record in NFL history over a five-season span. What may be remembered even more, though, are the personalities Ditka wielded, interjected with a few zany episodes of his own.

In January 1993, the Bears left the nostalgic Ditka era and blazed into the mid-1990s, led by an aspiring CEO looking to leave his mark on his Grandfather's club.

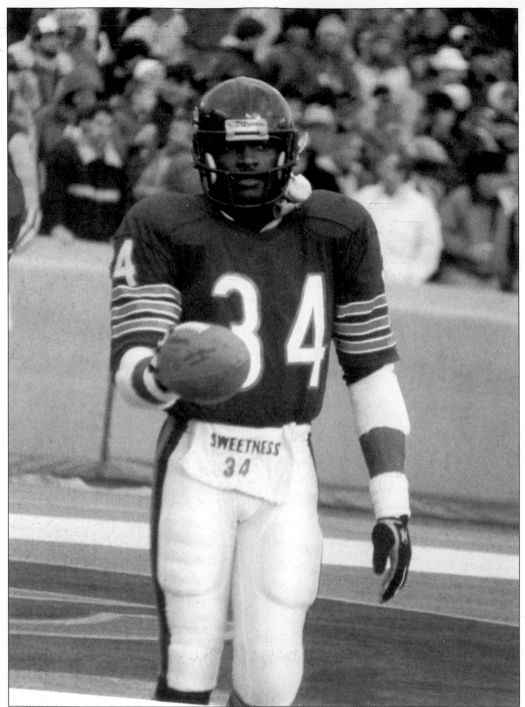

The legendary Walter Payton hands the ball back to the ref at Soldier Field after one of his trademark dives into the end zone. Sweetness was arguably the greatest all-around football player to ever set foot on Soldier Field. He could run the ball, of course, but he was also a threat in the passing game and a devastating blocker as well. He even tossed eight touchdown passes in his career. (Photo courtesy Bob Baer.)

Matt Suhey sweeps right with Walter Payton blocking vs. Indianapolis in 1985. Under Mike Ditka, the Bears were always a "two-back" team that delivered a running threat from both the halfback and fullback positions. After Payton and Suhey retired, Neal Anderson and Brad Muster took their places. (Photo courtesy Bob Baer.)

Dan Hampton sacks Ram quarterback Dieter Brock in the 1985 NFC Championship Game at Soldier Field. The 1985 Bears made playoff history by shutting out both of their opponents. (Photo courtesy Bob Baer.)

95

Bears fans will forever remember this Super Bowl Shuffle publicity shot. Pictured from left to right are cornerback Mike Richardson, free safety Gary Fencik, wide receiver Willie Gault, defensive tackle William Perry, running back Walter Payton, defensive end Richard Dent, quarterback Jim McMahon, linebakers Otis Wilson and Mike Singletary, and quarterback Steve Fuller. To the dismay of some of their teammates, the "shufflin' crew" cut this record and video the day after the Bears lost their only game of the season at Miami. While the Jacksonville Jaguars would later try to record their own presumptuous claim to a Super Bowl victory, the Bears actually made good on their promise. (Author's Collection.)

Jim McMahon huddles up his offense in 1985. McMahon's offensive coordinator Ed Hughes called the quarterback the best field general he ever coached. (Photo courtesy Bob Baer.)

Fans celebrate the NFC Championship win at Soldier Field on January 12, 1986. (Photo courtesy Bob Baer.)

Head Coach Mike Ditka talks to Jim McMahon in this 1988 game. Offensive assistant Greg Landry stands to their side. Landry would take over as offensive coordinator after McMahon was traded to San Diego in 1989. (Photo courtesy Bob Baer.)

Kevin Butler kicks off in 1986. Butler was the Bears' fourth-round draft choice in 1985 and led the NFL in scoring that season with 144 points. He played for the team until he was cut by Dave Wannstedt in 1996. (Photo courtesy Bob Baer.)

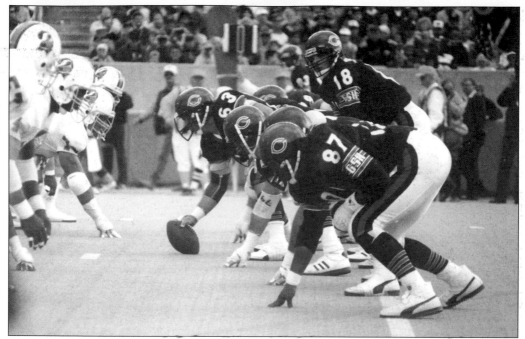

Mike Tomczak barks out signals against Tampa in 1986. Tomczak was acquired as a free agent in 1985 and played for the team until 1990. There have been many quarterback controversies in Bears history, and Tomczak was a part of a rotating lineup with Jim McMahon, Steve Fuller, Doug Flutie, and Jim Harbaugh. (Photo courtesy Bob Baer.)

Walter Payton, guard Tom Thayer (No. 57), and Neal Anderson huddle up in a 1987 game. During the 1987 season, Anderson played fullback instead of Matt Suhey to gain experience, as he would replace Payton the following year. (Photo courtesy Bob Baer.)

Chicago Bears union players picket outside Soldier Field during a "replacement" game in 1987. Shown most clearly in the photo are Doug Flutie, Jay Hilgenberg, Dave Duerson, and Jim McMahon. (Photo courtesy Bob Baer.)

Mike Ditka addresses the Soldier Field crowd after receiving his Hall of Fame ring prior to a game in 1988. Ditka was picked by the Bears in the first round of the 1961 draft from the University of Pittsburgh, and played six seasons in Chicago. Following an acrimonious dispute with owner/coach George Halas, he was traded to the Philadelphia Eagles prior to the 1967 season. He later played and coached for the Dallas Cowboys, and Halas brought Ditka back to Chicago as the tenth head coach in Bears history in 1982. Ditka's play revolutionized the tight end position. (Photo courtesy Bob Baer.)

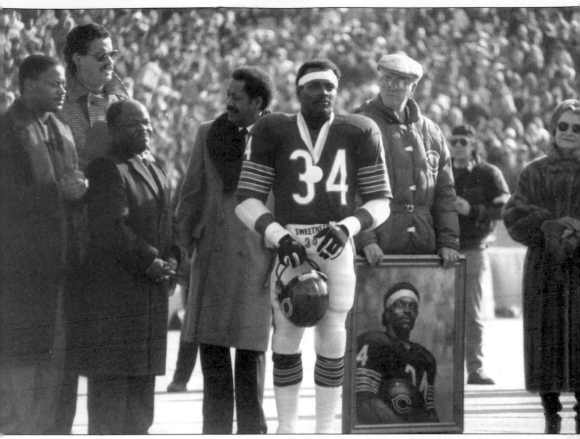

Walter Payton is honored before his final home game in 1987. Payton, from tiny Jackson State in Jackson, Mississippi, was drafted by the Bears with their first-round pick in 1975. Shortly after he was drafted, he proclaimed, "When I get through with Chicago, they'll be loving me." The running back became the NFL's all-time leading rusher in 1984, and was the workhorse behind every Bears' team on which he played. After retiring following the 1987 season, he sat on the Bears board of directors, opened several restaurants and co-owned an auto racing team. Tragically, Payton was diagnosed with a rare liver disease in late 1998. Following a yearlong battle, Payton passed away on November 1, 1999, at the age of 45. Chicago, the NFL and the nation mourned his passing that week, and the Bears beat the Green Bay Packers for the first time in five seasons five days later. (Photo courtesy Bob Baer.)

The 1989 Bear defense, before Dan Hampton was lost for the season. Pictured are Hampton, William Perry, Richard Dent, Trace Armstrong, Ron Rivera, Dave Duerson, and Lemuel Stinson. (Photo courtesy Bob Baer.)

Dan Hampton watches his teammates take on the Houston Oilers from the sidelines in 1989. Hampton missed the final 12 games of that campaign. With him, the team was 4-0. Without, they finished 2-10. Hampton was drafted by Chicago in the first round of the 1979 draft, but may never have played football if his high school coach didn't discover the mammoth teenager as he played saxophone in the marching band. After the 1989 season, Hampton played one more year. He was inducted into the Pro Football Hall of Fame in 2002. (Photo courtesy Bob Baer.)

Jim McMahon visits old buddy Kevin Butler prior to the Bears-Chargers preseason matchup in 1989. McMahon had been traded just days prior to this game. (Photo courtesy Bob Baer.)

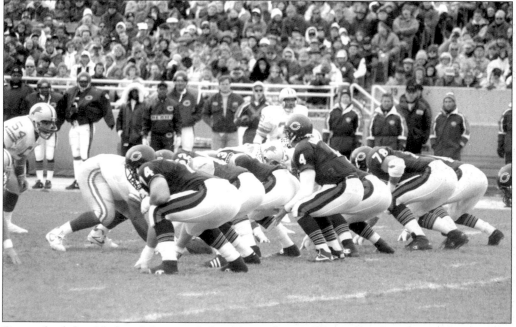

Quarterback Jim Harbaugh lines up behind his stalwart offensive line: Jim Covert, Mark Bortz, Jay Hilgenberg, Tom Thayer, and Keith Van Horne. Harbaugh beat out Mike Tomczak for the starting position in 1990. This was also the first season the Bears wore black shoes since the 1960s. (Photo courtesy Bob Baer.)

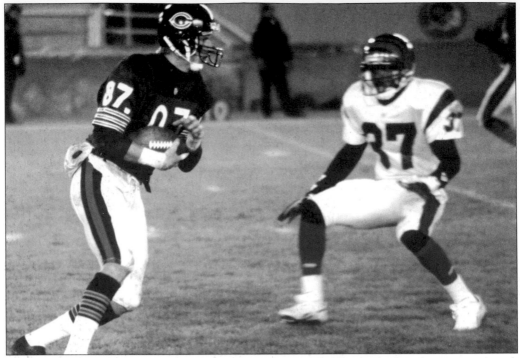

Tom Waddle catches a pass against Cincinnati in 1992. Waddle climbed up the practice squad, after being cut several times, and became a fan favorite in Chicago. (Photo courtesy Bob Baer.)

Center Jay Hilgenberg came to the Bears as a free agent in 1981 and anchored the offensive line from 1983 to 1992. He was voted to the Pro Bowl seven times as a Bear. Prior to the 1992 season, despite being a solid, dependable player for the Bears for eleven seasons, he was traded to the Cleveland Browns after a contract dispute. Venerable left tackle Jim Covert had retired the previous season, and with Hilgenberg's departure the rock-solid line of the 1980s finally needed retooling the following year. (Photo courtesy Bob Baer.)

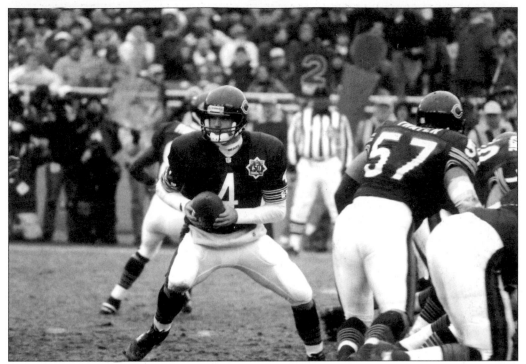

Jim Harbaugh started 16 games for the Bears in 1991, the first time a Bear quarterback had done so since Vince Evans in 1981. Harbaugh played for Chicago from 1987 to 1993. (Photo courtesy Bob Baer.)

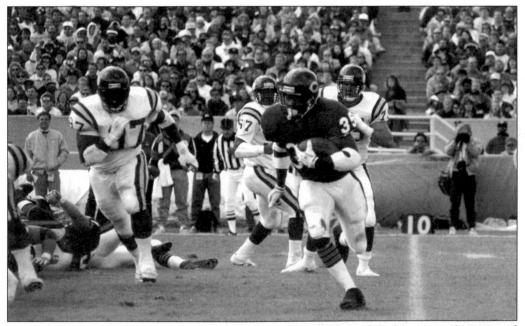

Neal Anderson played running back for the Bears from 1986 to 1993, becoming their second all-time leading rusher. Anderson possessed world-class speed and moves, but after eight seasons he retired from the Bears and the NFL. (Photo courtesy Bob Baer.)

Mike Singletary directs the Bears defense in his final game at Soldier Field in 1992. Singletary was selected by the Bears in the second round of the 1981 draft and served as the "quarterback" of Buddy Ryan's dominating 46 defenses of the 1980s. The middle linebacker was voted NFL Defensive Player of the Year in 1985 and 1988. Singletary was inducted into the Pro Football Hall of Fame in 1998, and now serves as a linebackers coach for the Baltimore Ravens. Although Singletary's uniform number 50 is not retired, no Bear has worn it since he left the game. (Photo courtesy Bob Baer)

Mike Singletary addresses the Soldier Field crowd, and a throng of reporters, prior to his final home game. (Photo courtesy Bob Baer.)

FIVE

Stumbling into a New Century
1993–2004

75-101 Record
Two Playoff Appearances

Michael McCaskey embarked on a mission in January 1993 to hire the best prospect available to replace Mike Ditka as the Bears' head coach. Despite a strong push from the New York Giants, McCaskey was able to land Dallas Cowboy defensive coordinator Dave Wannstedt to become the eleventh head coach in Chicago Bears history. Cowboy owner Jerry Jones had fashioned himself as a hands-on owner, participating in football operations while many owners left those decisions to seasoned football men. Jones' club won its first Super Bowl since the 1970s with this approach, so perhaps McCaskey was emulating Jones when he appeared on the cover of the Bears 1993 media guide with Wannstedt.

Wannstedt's first team finished 7-9 with an again-powerful defense. The following season, the club replaced aging defensive linemen with young players, and the team would end up searching for a pass rush well into the 21st century. The 1994 Bears finished 9-7 and won a playoff game, and even fervent Ditkaphiles believed in the young new coach.

After the 1994 season, the Bears' slim personnel department, with decisions made mainly by Wannstedt, began to erode the level of talent in Chicago and the wins that came along with it. In 1997, the Bears traded their first-round pick for erratic quarterback Rick Mirer, who never stood out in a game. Shortly after the trade, McCaskey hired VP of Player Personnel Mark Hatley to make talent decisions, and beefed up the college and pro scouting departments. Personnel improvement, moderately but not spectacularly better under Hatley, was too late to save Wannstedt's job, as he was fired after the 1998 season.

Hiring Wannstedt's replacement turned in to a fiasco, but eventually Jacksonville defensive coordinator Dick Jauron was hired as the teams' 12th coach. The team drafted highly-touted quarterback Cade McNown in Jauron's first season, and went on to suffer through two agonizing losing seasons.

No one in the world expected the 2001 Bears to post a winning record, let alone their best since 1986 when they finished 13-3 and played in a home playoff game. The team was exposed in that playoff defeat, however, and would not recover. The magical 2001 season seemed like a mirage, as the club missed the playoffs the next two years.

Jauron himself was dismissed following four losing seasons out of five, and the Bears will enter yet another new period in their history in 2004.

Wannstedt's Dallas North: 1993–1995

McCaskey began the new year mulling over coaching candidates, rumored in the media to be Cowboys defensive coordinator Dave Wannstedt, Redskins defensive coordinator and former Bear Richie Pettibon, and in-house coordinators Vince Tobin and Greg Landry. Taking the opportunity to further bash McCaskey, many fans and the media expected the owner to spend wisely and not pursue the league's top candidate in Wannstedt.

After what McCaskey called a "thorough and intense search," the CEO announced the hiring of Wannstedt on January 19th, exactly 14 days after the firing of Ditka. The pursuit of

the year's top candidate impressed McCaskey's harshest critics.

The new coach was a Pittsburgh-area native, went to the same college (Pitt) as Ditka, and to Chicagoans, even sounded like the deposed legend when he spoke. Wannstedt possessed a tireless work ethic, and after Dallas' Super Bowl victory in late January he moved to Chicago to begin his work.

Wannstedt, like his predecessor, had plans to bring Dallas influences to Chicago. One of his first announcements was that the team would no longer wear black shoes as a part of their uniform, which they had done from 1990 to 1992 as a "throwback" look. He hired Ron Turner, brother of Cowboys offensive coordinator Norv, as his top offensive coach, and Bob Slowik to oversee his defense. Wannstedt intended to introduce a Dallas/San Francisco hybrid offensive philosophy, concentrating on the 49ers' west coast offensive style while featuring the running game, as Dallas did. On defense, he planned to install the attacking, gap-control defense used effectively by the Cowboys.

Wannstedt's rallying cry became that the Bears would "increase the speed" on both sides of the ball as well as special teams. To that end, in the 1993 draft, the Bears selected Curtis Conway, a receiver for only two years at the University of Southern California, with the Bears' number 6 overall pick in the draft. In later rounds, Wannstedt took defensive tackle Carl Simpson, tight end Chris Gedney, guard Todd Perry, and defensive end Al Fontenot. With the 1993 draft class, the new coach hoped he was at least on his way to finding an Alvin Harper, Russell Maryland and Jay Novacek for his team in Chicago.

What would be drastically different in the 1993 NFL was the first season of true unrestricted free agency. All players with four years of NFL experience that were not under contract were free agents, able to negotiate with any team. In addition to the concept of true player movement being new to the league, a salary cap was also instituted. This limited the amount of money any team could spend in total on their players. With the cap, new rules were put in place regarding the structuring of contracts. Most players now received a signing bonus along with a non-guaranteed salary for the length of the contract. The bonus could be spread across all years of the deal to only count a prorated amount against each year's cap. However, if a player were released, whatever amount of the bonus was spread across future years would be charged to the cap during the year the release took place.

Sixteen Bears became free agents before the 1993 season. Notable resignees were Jim Harbaugh, who signed the richest deal in team history at four years for $13 million, along with Steve McMichael, Maurice Douglass, Jerry Fontenot, John Mangum, P.T. Willis, and utility lineman John Wojciechowski. Lost to free agency were tight end James "Robocop" Thornton, safety David Tate, and corner Lemuel Stinson. Running back Brad Muster, dependable for his blocking, running and receiving, stated that he wanted to be considered as the featured back in the new coach's offense. Wannstedt's philosophy depended on a primary tailback teamed with a bruising fullback, but the team made a last offer to Muster to stay. When he balked, the Bears signed marauding fullback Craig "Ironhead" Heyward, and ironically Muster accepted an offer from New Orleans to replace Heyward. The Bears added other teams' free agents in cornerback Tony Blaylock, from San Diego, and linebacker Joe Cain from Seattle.

After the draft, longtime personnel boss Bill Tobin was removed from the picture, elevated to a "Special Projects Consultant" by McCaskey, effectively leaving all personnel decisions in the hands of the coach and the owner. *Chicago Tribune* football reporter Don Pierson wrote in a June 1993 article that the balance of power was quickly shifting away from football minds and into the hands of businessmen. He wrote, "The team that George Halas invented and nurtured as owner, coach and two-way end is now a team of professors, accountants, computer analysts, marketing specialists, one consultant and five McCaskey brothers. McCaskey has a brother in charge of a new stadium, a brother in charge of tickets, a brother in charge of community relations and a brother in charge of player relations. Michael is in charge of football. This lack of pro football experience extends to the coaching staff, where special-teams coach Dan Abramowicz is the only man who has ever played in the NFL. Tight ends coach Mike Shula was

with the Tampa Bay Buccaneers in 1987 as a quarterback but never threw a pass." This was the leadership under which the Bears football organization would progress through the mid-1990s.

In training camp, Wannstedt pulled a trade with his old boss in Dallas, sending linebacker John Roper, tight end Kelly Blackwell, and safety Markus Paul south in return for linebackers Vinson Smith and Barry Minter, the latter player having been selected from Tulsa in the 1993 draft. Roper would soon be cut from the Cowboys.

On September 5, 1993, Wannstedt's new team faced the New York Giants and attempted to extend the Bears' NFL-best record on opening day, on which the team had not lost since 1983. The Bears led the Giants 20-19 late into the fourth quarter, until a breakdown in the defensive secondary caused the Bears to lose 26-20. They lost the following week at Minnesota to Jim McMahon's Vikings. Following the 0-2 start, the Bears won three in a row, lost three, then won four. After 12 games, the Bears were a very respectable 7-5, and talk of playoffs in Wannstedt's first season was not out of the question.

As a rule, the offense was sputtering in every game but the first matchup with Tampa, when the Bears scored 47 points. More importantly the defense was holding the opposition at bay, not allowing 20 points in a game since opening day. Veterans Steve McMichael and Richard Dent were having marvelous seasons, with strong play as well from Trace Armstrong at left end. At linebacker, free agent acquisitions Cain and Smith flanked Dante Jones, who was impressively replacing the retired Mike Singletary.

Sadly, the '93 Bears lost their last four games to finish with a 7-9 record on the season. Offensively the team was in trouble. After Harbaugh had been picked over other free agent quarterbacks to lead the team, the scrambling, improvisational player looked ill-suited to run Turner's west-coast timing offense. At running back, Neal Anderson had been counted on to re-emerge, but by season's end had been replaced as the starter by Tim Worley, a disgruntled player with potential that was acquired in a mid-season trade with Pittsburgh.

The defense, however, had improved from 17th overall in 1992 to fourth in 1993. Richard Dent, Mark Carrier, and Donnell Woolford made the Pro Bowl, and the defensive unit looked to be a force to build on the following season.

Now firmly in charge of personnel and the draft, Wannstedt and finance chief Ted Phillips made a final contract proposal to Richard Dent just prior to the 1994 NFL draft. When Dent refused the Bears' offer, the team let him leave to sign with San Francisco, and the Bears selected linebacker John Thierry from tiny Alcorn State to be Chicago's version of Charles Haley. If Wannstedt were looking to emulate Dallas' offensive line as well, he would have been better served to select guard Larry Allen with the Bears' second-round pick, but he instead passed up Allen and took Marcus Spears from another small school in the South. Allen went on to go to multiple pro bowls with Dallas, while Spears left the Bears following the 1996 season after playing in just one game. Only two other 1994 draft picks made the team, third-round defensive tackle Jim Flanigan and fourth-round running back Raymont Harris.

The Bears made their first serious splash in free agency in the spring of 1994, signing quarterback Erik Kramer from Detroit to a 3-year $12 million contract. After just one season on an enormous contract, former starter Harbaugh was released. Also signed were running backs Lewis Tillman and Merrill Hoge, tight end Marv Cook, and left tackle Andy Heck. The team traded a draft pick to Pittsburgh for receiver Jeff Graham, looking to team the steady possession receiver with blazing Curtis Conway. Quarterback Steve Walsh was signed to replace the departed Peter Tom Willis, who found a home in the arena league, and running back Neal Anderson retired as the second-leading rusher in Bears history.

Also released was defensive tackle Steve McMichael, to save salary cap space. "Mongo," the nickname by which he was known, signed for one more year in Green Bay.

After the defense rose in the rankings in 1993, its soul was cut out with the release of Dent and McMichael. In their place Wannstedt had to hope that Alonzo Spellman and Carl Simpson were ready to step in. The secondary remained intact with Gayle and Carrier at the safety positions. Woolford manned one corner, while Jeremy Lincoln, who had shown

playmaking ability in spot '93 duty, replaced Tony Blaylock.

As they did in 1993, the Bears started the '94 season 1-2, but won their next three. After a disheartening 48-14 loss to Minnesota, Steve Walsh replaced Erik Kramer at quarterback under the guise of an injury the incumbent had suffered. Walsh won the three games with careful, calculated play, then relinquished the job back to Kramer. The Bears lost their next two, first at Detroit, then on Halloween night in a blinding rain/ice storm to the hated Packers. The Packer loss would start a miserable run; the Bears would lose to Green Bay in their next nine meetings.

Following the Green Bay loss, Walsh was again appointed the starter, and his team responded with four wins in a row. With an 8-4 record, the Bears led the NFC Central until they lost a heartbreaker in overtime at Minnesota. They then traveled to Green Bay and were thumped 40-3, beat the Rams at home, and lost the season finale to the Patriots. Despite the season-ending loss, with a 9-7 record the Bears snuck into the playoffs with three other NFC Central teams.

After losing four straight to the Vikings, the Bears traveled to the Minneapolis' Metrodome for a wild-card playoff game on New Year's Day. Unlike the previous meeting in Minnesota, in which the lead changed hands multiple times with the Vikings ending up on top, the Bears dominated the Vikings from start to finish, winning their first playoff game since 1990 with a 35-18 score. The wild-card win sent the Bears to San Francisco to play the odds-on favorites to win the Super Bowl. While some in Chicago may have hoped for a miracle victory, most outside of the city did not expect it, and the Bears were trounced 44-15.

The Bears did end the 1994 season on a sour note, but Wannstedt was named the NFC's Coach of the Year for turning the old, slow Bears into a faster playoff team in just two seasons.

In April 1995, the Bears cut another piece of their improving defense when solid six-year veteran defensive end Trace Armstrong was traded to Miami for the Dolphin's second and third-round draft picks. Wannstedt was eager to get John Thierry, his acquisition, on the field with Alonzo Spellman, and looked to add depth with the extra picks. In the draft, the Bears selected the running back they were looking for when they took Heisman Trophy winner Rashaan Salaam.

In free agency, the Bears signed another fast wide receiver in Michael Timpson from New England, auspiciously to "push" Curtis Conway to work harder. The acquisition of Timpson clouded the future of fan-favorite Tom Waddle. After being cut repeatedly in training camp from 1989 to 1991, a chance injury allowed the spunky receiver to make a play and become a Chicago legend. Waddle performed durably in 1993 and 1994, until against Tampa the receiver took a jarring hit from safety Thomas Everett. Waddle's season was finished with knee and jaw injuries. Prior to 1995's training camp, the unsigned Waddle was told that he would need to play for the league minimum if he wanted the chance to compete with Timpson, Graham, and Conway. Waddle signed instead with the Cincinnati Bengals and retired shortly thereafter.

Despite a strong showing from Walsh to win back his starting job from the previous season, the coaching staff went with Erik Kramer as the top quarterback in 1995. The decision paid immediate dividends as the team opened the season with a 6-2 record. Salaam was being eased into the lineup at running back, a position that was hurt by a broken collarbone suffered by Raymont Harris on the year's opening drive. Kramer's connection to his receivers Conway and Graham was lighting up scoreboards throughout the first half of the year; at one point the quarterback had thrown for 16 touchdowns and just four interceptions.

After the 6-2 start, however, the team struggled through the second half of the campaign with a 3-5 record, hampered by the lack of a pass rush and poor play from corner Jeremy Lincoln. To make matters worse, solid corner Donnell Woolford missed most of the second half of the year with a groin injury, and his replacement Kevin Minifield was often overmatched by opposing receivers.

Nevertheless, the team could still make the playoffs with a 9-7 record if they defeated the Philadelphia Eagles in the season finale, as long as San Francisco beat Atlanta, as they were expected to do. In the game in Chicago, defensive end Alonzo Spellman recorded three sacks and two forced fumbles against Eagle quarterback Rodney Peete. Coincidentally, Spellman was an unrestricted free agent following the season, and the total for that one day represented 1/3 of the sacks he recorded all year. The Bears won the game 20-14, but a few minutes later learned

they would miss the playoffs due to a frenzied comeback victory by the Falcons in Atlanta.

After the team had severed key defensive players since Wannstedt's rookie season, the defense took a giant step backwards for the first time in his career. While they improved their ranking against the run from the prior season, they regressed to rank 27th in the league against the pass. Particularly maddening was the unit's inability to stop opposing teams on third down, especially late in the season.

Offense was a different story. Quarterback Erik Kramer had the best season a Bear quarterback had posted since the era of Sid Luckman. He threw for almost 4,000 yards and 29 touchdowns, both team records. After the offense had not featured a receiver that gained 1,000 yards in a season since 1970, both Curtis Conway and Jeff Graham caught passes for over 1,000. Despite missing parts of early season games due to his holdout, Rashaan Salaam set a new team rookie record by rushing for 1,074 yards. Troubling, though, was that Salaam developed a bad habit of fumbling, after being fairly sure-handed in college.

The team, if not their city, felt that 1995 was just a bump in the road to further greatness, to be resolved the following year.

Death Spiral: 1996–1998

Intent on improving his defense, on the first day of the 1996 free agency period Dave Wannstedt, Mike McCaskey and finance director Ted Phillips put together a five year, $15 million contact for the year's top defender available, Miami Dolphin linebacker Bryan Cox. The three-time pro bowler was expected to solidify the Bears' middle linebacker position, as well as provide a pass rush as a defensive end on passing downs.

Around the same time, the Jacksonville Jaguars signed free agent Alonzo Spellman to a four-year, $12 million dollar offer sheet, which after a week the Bears matched. It is unknown how much Spellman's final game (three sacks) as opposed to the other 15 games (six) had to do with the signing.

The team also knew it had a glaring hole at cornerback opposite Donnell Woolford, so they traded up in the '96 draft to select Walt Harris from Mississippi State. Harris was regarded as the second-best corner available in the draft, and he was immediately penciled in to start. In the second round, the Bears filled the absence of Graham by selecting Penn State receiver Bobby Engram. In the fifth round, they found a gem in offensive lineman Chris Villarrial from Indiana University in Pennsylvania.

Among all position battles that would occur in 1996's training camp, most noteworthy was the competition at placekicker between twelve-year veteran Kevin Butler and newcomer Carlos Huerta. Along with being the Bears' all-time leading scorer, Butler held 18 other Bears' records. His performance certainly did not tail off in 1995 despite his age, when he scored 114 points for the team, was named NFC Special Teams Player of the Week once, and converted a game-winning field goal at New York in December.

Two things conspired against Butler in the competition. First and most obviously, was the fact that cutting Butler in favor of Huerta would save the team close to a million dollars in salary. Second, Butler was disliked by punter Todd Sauerbrun, who felt the veteran kicker had been a driving force in a series of hazing incidents the veterans unleashed on the rookie punter. Sauerbrun was one of Wannstedt's top picks, while Butler was a holdover from the Ditka era. Despite kicking for similar statistics in the preseason, Wannstedt surprised the city by cutting the popular Butler after the team's final preseason game, which ended up being called on account of lightning in the vicinity.

Even before the season began, injuries had started to take their toll on the 1996 Bears. Defensive tackle Chris Zorich was lost for the year in a preseason game at New Orleans, and Rashaan Salaam suffered a knee injury in the finale. So on opening night, in front of Monday Night Football's cameras against the world champion Dallas Cowboys, the Bears would play minus their leading receiver, running back and veteran kicker. Also departed from the solid offensive line was right guard Jay Leeuwenburg, lost to free agency. Backup Todd Burger took his place.

111

Luckily for the Bears, the Cowboys were also reeling, having lost top wide receiver Michael Irvin to a drug suspension. The Bears shocked the world that evening by upsetting the world champs 22-6. In a telling moment, the Bears scored their final touchdown of the night when Bryan Cox recovered a Troy Aikman fumble in the end zone. Prior to the season, Wannstedt had stated that "all the pieces are in place for a run deep into the playoffs," and in the opening week the statement seemed to be prophetic.

But it was not to be. Even during the Dallas victory, the team didn't seem to play as they did in 1995. While the defense looked much improved with the additions of Cox and Harris, the offense didn't have the same spark they possessed the season before. Chicago couldn't get anything going offensively until wide receiver Curtis Conway threw a trick touchdown pass to Raymont Harris, and Sauerbrun hit a streaking Harris over the middle on a fake punt.

The next week at Washington, the Bears lost 10-3, with Kramer failing to hit on three final pass attempts for a touchdown inside the Redskins' red zone. They would lose the next two to start the '96 campaign 1-3, when it was learned that Kramer had a degenerative condition in his neck, and was lost for the season.

Over this same stretch, the new kicker Huerta missed on three of his seven field goal attempts (comparatively, Butler had nailed his first 16 in 1995). After the poor start, Huerta was cut and replaced by veteran Jeff Jaeger, recently released himself by the Oakland Raiders.

Behind veteran quarterback Dave Krieg, who would be the starter for the rest of the season, the Bears finished 7-9, far short of the coach's playoff expectations. The running game was derailed, with Salaam, Harris, and Robert Green rotating when they weren't injured. During one midseason stretch, the team was forced to play with rookie seventh-round pick Michael Hicks as the primary back. Also lost to injuries that year were defensive linemen Jim Flanigan and Alonzo Spellman, linebacker Cox to a broken finger, several tight ends, and backup quarterback Steve Stenstrom.

Cox did seem to be a sensible pickup after the '96 season. He applied consistent pressure to quarterbacks when he rushed, and delayed having surgery on his hand by a week in order to play in one last game against Tampa Bay, a win. His recalcitrant personality did surface, however, especially after a week six loss to Green Bay. After the game, he raged against he teammates that he felt hadn't stepped to the plate, urging them to "go see the wizard and get some heart."

In the final game of the season, the feeling that the teams' fortunes had turned for the worse was almost palpable. In the finale at Tampa, the perennial doormat of the NFL whom the Bears had beaten in nine of the last ten meetings, the Bears took the ball on their opening drive and scored a touchdown. But the resurgent Bucs, led by new coach Tony Dungy, eventually wore down the Bears and won 34-19.

In mid-February 1997, flashbulbs popped and cameras rolled as former Seattle Seahawk Rick Mirer was introduced to the press as the Chicago Bears' newest addition. On February 14th, the Bears traded its first round pick to Seattle for Mirer and the Seahawks' fourth. The Mirer deal was not done without controversy. The former Notre Dame quarterback and Indiana native was named offensive rookie of the year in 1993, but since that time his performance had faded to shaky at best. In fact, the Bears had tried to work out a deal with the Seahawks for a lower-round draft pick after Mirer had been demoted for journeyman John Friesz, but a deal could not be struck. Feeling pressure to field another starting-caliber quarterback if Kramer were not able to return from his neck injury, Wannstedt and the team took a gamble.

The Mirer trade and the 1997 draft would be the last major personnel moves the coach and longtime scout and personnel assistant Rod Graves would make on their own. In January, McCaskey announced that he would be restructuring the personnel department to add additional staff and a new leader. When in May the team president announced the search was ongoing and Graves would need to apply for the lead position like everyone else, Graves departed.

That summer, McCaskey announced the hiring of Mark Hatley in the role of Vice President of Player Personnel, long after the draft had concluded and the Mirer trade had been struck. Hatley had worked in a similar role in Kansas City and was chiefly responsible for putting

together teams that contended throughout the 1990s. While he couldn't undo anything that was done prior to his arrival, he did cut rookie guard Bob Sapp before training camp was over, an obvious waste of a crucial high draft pick. (Incidentally, Sapp left football and is now famous in Japan as Bob "The Beast" Sapp on the K-1 fighting circuit.)

Added in free agency for 1997 were cornerback Tom Carter, signed to replace Donnell Woolford with a $13.5 million contract, kick returner Tyrone Hughes from New Orleans, and wide receiver Ricky Proehl. It has been reported that Redskin coach Norv Turner was happy that old friend Wannstedt took Carter off his hands.

Wide receiver Curtis Conway, one of few dependable pieces left on offense, was lost for the first half of 1997 on a preseason injury. Quarterback Erik Kramer was re-signed and promptly beat Mirer out for the starting job. With Kramer at the helm, the Bears lost their first three games. In order to sense if Mirer gave the team any kind of spark, the newcomer was inserted into the second half of a 32-7 loss to Detroit. Kramer was caught laughing on the sidelines, and was bombarded with questions on his sideline demeanor from Chicago sports talk hosts the following week.

Mirer started the next three games against New England, Dallas, and New Orleans, and was rarely able to complete a pass. The following week, when Chicago played host to New Orleans and new coach Mike Ditka, Mirer was yanked in the second half, and Kramer almost brought the team back for their first victory. But after Carter fell down while defending a deep pass, New Orleans scored to seal the victory for Ditka in his return to Chicago.

The next week the Bears played competitively against the Packers at Soldier Field, and scored a late touchdown to pull within one point, 24-23. Wannstedt made one of the bigger blunders of his coaching career when he ordered his team to go for two points and the win. The Packers thwarted the two-point conversion attempt, and the Bears started the season 0-7.

Chicago won their first game the following week, but finished the 1997 season with an abysmal 4-12 record, their worst win total since 1975. With Kramer having clearly beat out their first-round acquisition Mirer, the future was very much in doubt. Raymont Harris led the team in rushing and Proehl in receiving, but neither player was re-signed.

At this point, the Bears had gaping holes to fill at every position on the football team, outside of placekicker Jeff Jaeger. The hiring of Hatley and a larger pro and college scouting staff had helped to improve the team's depth, but the team's starting talent lacked against the competition in every area. At that time, the Bears held the longest Pro Bowl player drought in the league, having not sent a single representative since the 1993 season.

Hatley hoped to help fix things during his first offseason and draft prior to the 1998 campaign. In free agency, he signed running back Edgar Bennett from Green Bay, defensive tackle Mike Wells from Detroit, and resigned his own players in Jim Flanigan and Barry Minter to long-term deals. The Bears held the fifth overall pick in the 1998 draft, and had the option to draft the top running back in Curtis Enis, the best wideout in Randy Moss, or to trade down with one of several teams for additional picks. Turning down offers for two first-round picks from Jacksonville and New England, Hatley stood firm and took Enis. Solid picks were made in the second and third rounds in safety Tony Parrish and center Olin Kreutz.

In training camp 1998, Hatley released Mirer after the quarterback refused a pay cut to remain as the second-stringer. Immediately the Mirer trade went down as one of the biggest blunders in Bears history. Mirer's final Bear statistics showed he had completed 51.5 percent of his passes for 420 yards on 103 attempts. He threw six interceptions and no touchdowns, giving him a quarterback rating of 37.7. Top pick Enis befuddled team officials with a lengthy holdout prior to the season, at times vowing to sit out the entire season. The rookie was accused of a crime during the offseason, then committed himself to Champions for Christ, an athletic religious organization. His agents that prolonged the holdout were members of the group themselves. The running back finally agreed to a short three-year contract for less than $10 million, after turning down long-term offers well over that figure.

Also released prior to the '98 season were Bryan Cox and Alonzo Spellman. Cox did

contribute positively in 1996, his first year with the team. In 1997, however, the linebacker was caught by television cameras on the sidelines more than once causing a stir with his teammates and coaches. In addition to being vocal off the field, Cox was penalized several times throughout the season for throwing his helmet and making obscene gestures to fans.

Spellman was replaced in the starting lineup by Carl Reeves, a 1995 draft pick, during the second half of the '97 season under the guise of an unspecified injury. As reported in January 1998, Wannstedt told the volatile lineman the Bears were seeking a trade for him. Shortly thereafter Spellman barricaded himself in his publicist's home, to be removed only after police and former Bear Mike Singletary arrived on the scene. Spellman was later diagnosed with bipolar disorder. The releases of Mirer, Cox, and Spellman would cause their signing bonuses to accelerate against the 1998 and 1999 salary caps, limiting the Bears' ability to pursue free agents to improve the team's roster.

Chicago opened the 1998 season better than the previous year with a 3-5 record at the season's halfway point, but went on to lose seven of their last eight games to finish 4-12, as they had the year before. Kramer again went down with injuries after the 3-5 start and was replaced by Steve Stenstrom, who finished the season with a 70.4 quarterback rating, average at best.

It was assumed by most that the Bears organization would retain their coach, as he was signed to a guaranteed contract through 2000. Michael McCaskey only began to waver with several weeks left in the season, when he went on the record to say he had not made a decision on the coach's future. The season finale against Green Bay may have sealed Wannstedt's fate, when clearly half the stadium turned up in green and gold for the game. That scene proved to the ruling family that fan support was waning.

The day after the season finale, Michael McCaskey's first hand-picked head coach was dismissed after compiling a six-year record of 41-57. Wannstedt met the press and expressed disappointment as well as thanks for the family that had employed him. He specifically addressed the Mirer trade as his watershed moment, but deferred blame for the fiasco to other members of the organization, along with himself. He also alluded to the possibility that he kept some of Ditka's players on too long, puzzling because he turned his roster over rather quickly and the team started to lose consistently only after Ditka's players were gone. McCaskey announced that Mark Hatley would lead the search to identify several candidates, then bring them to the CEO so a decision could be made as swiftly as possible.

Third-String Coach: 1999–2000
On Friday January 23, 1999, a press release was issued to Chicago media, announcing that Arizona Cardinal defensive coordinator and former Bear coach Dave McGinnis had been hired as the Chicago's new head coach. Problem was, McGinnis had not been told of the announcement and had yet to agree to a contract.

The search for Dave Wannstedt's successor had taken 27 days while other teams in the NFL had hired new head coaches, and those head coaches found capable assistants. Mark Hatley had traveled the country to interview candidates, eventually bringing Gunther Cunningham, Sherm Lewis, Joe Pendry, Dick Jauron, and McGinnis to Chicago to meet team executives. The search stopped at "Coach Mac," who had served under Ditka and Wannstedt as leader of the linebackers from 1986 to 1994.

Quickly, word spread that there was a "snafu" in the announcement, and Bears officials struggled to deal with the situation. McGinnis spent time at the Bears' Lake Forest, Illinois headquarters trying to square things away with Michael McCaskey and his parents Ed and Virginia, but the damage had been done. According to Mullin's book, the Bears CEO had asked McGinnis to accept a contract with a two-year buyout, without revealing that detail to his assistant coaches. McGinnis left town, sticking to his principles while turning down his dream job. Unknown at the time was that McGinnis had already talked to Washington assistant Mike Martz to become his offensive coordinator. Martz would become recognized for turning the lowly St. Louis Rams into Super Bowl champions in his first year.

After being rebuffed by McGinnis, the team turned to its third choice, Jacksonville defensive coordinator Dick Jauron, to lead the Bears. Mullin reported that Green Bay offensive coordinator Lewis was McCaskey's second choice, but Hatley threatened to resign if McCaskey made that decision.

Just more than a week later, Virginia stepped to the same podium and announced the organization was "promoting" her son Michael to the role of Chairman of the Board, while longtime finance staffer Ted Phillips was promoted to President and CEO. Phillips, it was hoped, would revitalize the decades-long effort to secure a new stadium for the Bears, as they were still playing in decaying, 75-year old Soldier Field.

It was a busy February for Bears news. Shortly after the organizational shakeup, Bears board member and legendary player Walter Payton announced he was suffering from primary sclerosing cholangitis, a cancer of the bile ducts in the liver. The Hall of Famer was hoping to be placed on a transplant waiting list, and the people of the nation watched and worried with him.

While Hatley had privately lobbied for Wannstedt to retain his job, he pushed full out to provide Jauron and his new offensive coordinator Gary Crowton with weapons. In the 1999 draft, the Bears made five different trades to parlay the team's original five draft picks into 13. After trading from the seventh overall slot to the twelfth, the Bears selected the quarterback they coveted, Cade McNown from UCLA. Also selected throughout that draft were a defensive lineman, three wide receivers, three linebackers, two offensive linemen, two defensive backs, and a running back.

Crowton had made a name for himself in the college ranks for employing multiple wide receiver sets much of the time, thus necessitating the selection of the receivers. Two of the linebackers, Warrick Holdman and Roosevelt Colvin, would crack the starting lineup in 1999 and 2000, and the other picks provided depth and hope for the future.

Shane Matthews, who had previously played for the team from 1993 to 1995, was resigned to be the veteran starter, and the Bears unexpectedly cut veteran Erik Kramer in training camp. McNown wouldn't simply back Matthews up, however, as prior to the season Jauron announced a plan to insert McNown for a series every game, hardly an orthodox move.

Behind Matthews, a slimmer Curtis Enis and Crowton's peculiar offense, the Bears won Jauron's first game 20-17 over Kansas City. Former Bear head coaching candidate Gunther Cunningham now led the Chiefs, and after the defeat prophetically said, "This razzle-dazzle offense, once people figure it out, won't be anything."

After winning the opener, Jauron's club lost their next two, primarily due to their kicking game. Dependable veteran kicker Jeff Jaeger was injured, and the kicking duties were taken over first by rookie Brian Gowans, then veteran Chris Boniol. At midseason, the Bears were 3-5, and on November 1st Walter Payton passed away. His death came the day after the Bears were pummeled 48-22 by Washington, and coincidentally six days before the team traveled to Green Bay. On Saturday November 6th, a public memorial service was held at Soldier Field for Payton, attended by Bears alumni and the current players, coaches and staffers. As the team walked off the field to depart for Wisconsin, the crowd chanted "Beat Green Bay" at the top of their lungs.

The Bears did play inspired football the following afternoon. Journeyman quarterback Jim Miller led several inspired drives, and before Green Bay's final push held on to a 14-13 lead. Packer quarterback Brett Favre, known as a "Bear killer" over the years, drove his team into position for a chip-shot field goal with just seconds remaining. As Ryan Longwell's field goal attempt sailed toward the uprights, Bear defensive end Bryan Robinson thrust a hand in the air, blocking the kick. There will never be proof that Robinson had other-worldly assistance in blocking that kick, but he did comment that it was the highest he had ever jumped. Following the Green Bay victory, the team stayed in playoff contention with a 4-5 record, but would lose five of their last seven to finish 6-10 in Jauron's rookie campaign.

Late in the 1999 season, the Bears, led by new CEO Phillips, announced an ambitious plan to completely gut Soldier Field, replacing the aged innards with a state-of-the-art 61,500 seat stadium. Widely criticized for its architectural contrast to the older stadium's façade,

nevertheless the plan seemed to be the best proposal of many presented by the team to the city. In 2000, the plan was approved by the Illinois legislature. The team would play the 2000 and 2001 seasons in Chicago, then would travel to Champaign, IL to play their games while the new stadium was being constructed in 2002.

During Hatley's first two full seasons in Chicago, the Bears had not been able to make a major splash during the free agent signing period, mostly due to the costs incurred by the releases of Cox, Spellman and Mirer in the middle of their contracts. In the 2000 signing period the Bears were finally poised to make a move. In the first week they were able, the team signed the top defensive end and cornerback on the market in Phillip Daniels and Thomas Smith. Both players received close to $20 million contracts on five-year deals.

In 2000, McNown was named the team's unquestioned starter, and in the draft the team selected defensive standouts Brian Urlacher and Mike Brown in rounds one and two. The duo helped their unit to a late defensive resurgence, but after McNown started and lost the first five games of the season, it was too late. Offensive coordinator Crowton left the team mid-season to take the head coaching job at Brigham Young University.

Behind Matthews and new offensive coordinator John Shoop's run-oriented attack, the Bears won two of their last three games. Urlacher won rookie of the year honors, becoming the first Bear defender to be honored as such since 1990. Fans had appreciated the improvement Jauron and his assistants made on the team in 1999, but grew tired of the episodes with McNown in 2000.

Despite renewed public concern over the Bears coaching position, CEO Phillips made one thing clear, Jauron would return in 2001.

Season of Miracles: 2001

Prior to the 2001 college draft, rumors flew that although Mark Hatley felt good about the talent he acquired for the team during his tenure, he was growing frustrated at the lack of improvement in the team's record even after these acquisitions. It is undeniable that the talent level had improved since 1997; the Bears finally sent one man each to the all-star game after the '99 and 2000 seasons. But some of Hatley's high picks, notably Curtis Enis and Cade McNown, were not panning out. Rumor had it that Hatley was looking to leave.

Regardless, Hatley ran his fourth Bears draft in 2001, taking two Michigan players at the head of the selection process in receiver David Terrell and running back Anthony Thomas. The only other pick from that year that would stick for more than two years was offensive lineman Mike Gandy, taken in the third. By far the biggest acquisitions for the team prior to the 2001 season were twin defensive tackles Ted Washington and Keith Traylor, each weighing over 340 pounds.

In June, the team and Hatley announced a "mutual termination" of their relationship. Happily to most Bears observers, in the announcement CEO Phillips declared that he would leave open the possibility of replacing the personnel man with a true general manager for the first time since Vainisi was fired in 1987. Hatley headed to Green Bay, and for the second time in five years the Bears ran a draft less than two months before its architect departed.

The Bears hired an executive search firm to identify candidates for the general manager position, and ended up finding their man in their own division, long-time Tampa Bay personnel executive Jerry Angelo. One of Angelo's first moves was the trading of quarterback Cade McNown to Miami after a turbulent two seasons in Chicago. The move again entrenched Shane Matthews as the Bears' starter on opening day. Angelo also promptly cut Thomas Smith, signed to a mega-deal just a year earlier by Hatley. The terminations of McNown and Smith would once again create "dead space" in the Bears' salary cap, limiting their ability to improve. Although to the organization's credit, they have always managed the cap more responsibly than most teams.

Not many football prognosticators gave the Bears the slimmest shot at finishing the 2001 season with a winning record, let alone making the playoffs. Even fewer predicted they would stay competitive in their opener at Baltimore, the defending world champions. Chicago did lose the game, but kept it close and controlled the Baltimore offense through most of the game. In

the following four weeks, the Bears defeated Minnesota, Arizona, Atlanta, and the Bengals, the last game being a dominating 24-0 shutout in Cincinnati. Miller had supplanted an injured Matthews as the starter, and gave the team a spark. In Cincinnati, the Bears lost top wide receiver Marcus Robinson to a knee injury, but at the same time discovered a new weapon in rookie running back Anthony Thomas. The former Michigan star had the best game by a Bears rookie runner in history when he ran for 188 yards and an 8.5 yard average.

The following week against San Francisco, Miller was injured and the Bears fell behind the 49ers 31-16 in the fourth quarter. Led by Matthews' proficient passing and the rushing of Thomas, the Bears pulled to within a two-point conversion of a tie after a leaping touchdown reception by rookie David Terrell. With less than a minute to play, Thomas took the ball in for two points, and the Bears had engineered a 15-point fourth quarter comeback. More remarkably, on the first play of overtime, 49er receiver Terrell Owens bobbled a pass that was intercepted by Brown, who returned the pick for the game's winning points. With the win, the Bears started the season 5-1 for the first time since 1990.

The following week, CBS moved the Bears-Browns game from a Noon start to 3 p.m., emphasizing the fact that Chicago was again worthy of a national television audience. The contest began much as the previous one did; after a Browns sack of Matthews, the fumbled ball was returned for a touchdown by Cleveland's Courtney Brown. Porous defense and absent offense in the second half led to 21-7 Browns lead with two minutes left to play. In what appeared to be "garbage time," Matthews drove his team down the field against Cleveland's prevent defense and threw a touchdown pass to receiver Marty Booker. The score was then 21-14, just a seven point deficit, but with only 1:36 remaining in the ballgame, the Bears would be forced to recover an onside kick and score a touchdown just to tie the game. The ensuing onside kick was indeed recovered, and two plays later from the Cleveland 40, Matthews hurled a desperation pass about as far as he was able. As it traveled back to earth, it bounced off the hands of Terrell, only to be snagged two feet off the ground by running back James Allen. Vocal Browns fans hung their heads while Chicago's passionate followers reveled in the performance. The conversion was kicked, and for the second straight week the Bears went to overtime, having overcome a 14-plus point deficit in the fourth quarter.

The previous week had been crazy enough. Simply tying the Cleveland game the following week would have been extremely improbable. But on the Brown's first overtime possession, Mike Brown again intercepted Cleveland quarterback Tim Couch and returned the pick for a touchdown, streaking straight into the locker room as 20,000 or so remaining Bears fans jumped enough to tear down Soldier Field themselves. The team's back-to-back heroics were stunning, fascinating, and simply incomprehensible.

The following week, the 6-1 Bears hosted the Green Bay Packers in the two arch-rivals' first battle for the top of the division this late in the season since 1963. True, the Bears had not beaten Favre and the Packers in Chicago since 1993, and had lost 12 of the last 14 in the series, but the previous two weeks had proven that miracles could happen in Chicago. But another miracle wouldn't happen that day. The Bears held Green Bay's powerful offense to just 20 points but could only score 12 themselves. The Bears fell to a respectable 6-2 but trailed Green Bay by a game for the division lead.

For the remainder of the 2001 season, the Bears would win every game except the rematch in Green Bay. But thanks to other teams defeating the Packers, the Bears finished with a one-game lead in the division, 13-3 overall. This gave the Bears their best regular season record since 1986 and first NFC Central championship in eleven years.

The turnaround of the team from their performances of the previous eleven seasons was nothing short of amazing. Anthony Thomas, not even the starting running back until game five of the season, finished with 1,183 yards and seven touchdowns. This did not top another rookie rusher, LaDanian Tomlinson of San Diego, but it did earn Thomas NFL Offensive Rookie of the Year honors. Jim Miller played steadily at quarterback when not injured, and Marty Booker replaced Marcus Robinson and caught 100 passes for 1,071 yards. It was the very first time a

Bears receiver had caught 100 passes in a season.

Defensively, the Bears had become one of the most feared units in the league, holding opponents to an average of under 13 points per game, best in the NFL. The team had swept all its NFC Central opponents except Green Bay, finished 7-1 at Soldier Field in its last year of existence, and sent five players to the Pro Bowl, best since 1991.

As division champions, the team earned a first-round playoff bye, and found out it would face the Philadelphia Eagles on January 19th in Soldier Field's first playoff game since 1991. The Eagles featured a punishing, attacking defense and star-caliber players on offense, but had barely won the NFC East with an 11-5 record. The Bears were favored to win the game.

At halftime, the Bears trailed the Eagles 13-7, but in the third quarter cornerback Jerry Azumah returned an interception for a touchdown, putting the Bears on top 14-13. After the defensive back's touchdown, however, the game belonged to Philadelphia, as the Bear defense was exploited and the offense, without Miller after he was injured in the first half, couldn't move the ball. Just minutes before bulldozers moved on the stadium to begin its demolition, time expired and the Bears lost 33-19.

The Bears literally shocked the football world by coming out of nowhere and making the playoffs in 2001. Perhaps no one was more shocked than new general manager Jerry Angelo. Angelo had taken the Bears job knowing full well that Jauron's position was guaranteed by management for at least that season, and a good case would need to be made to Phillips and the board of directors to fire him after that. Additionally, Jauron was named NFC Coach of the Year for the team's turnaround.

Shortly before Christmas, a press conference was called to announce that Jauron had been signed to a new contract through the 2004 season. Proving that some turmoil still existed between boss and employee, the coach would not actually sign the deal until sometime in 2002, when his top assistants John Shoop and Greg Blache were given similar extensions.

As long as Jauron's team continued to win, as was expected, the new contract based on one great year would not be a problem for anyone.

Goodbye Dick, Hello Lovie: 2002–2004

Trailing 23-20 with less than three minutes remaining in the 2002 season opener, a momentarily rehabilitated Jim Miller fired a touchdown strike to David Terrell, giving the Bears their third straight win over Minnesota and hope for the team's followers. The following week at Atlanta, Chicago squeaked by the Falcons 14-13, thanks to a missed Atlanta field goal in the game's waning moments. It was the Bears' first 2-0 start since 1991. The next week, the Bears led the resurgent New Orleans Saints 20-7 in the second quarter, when kick returner Leon Johnson allowed a kickoff to bounce off his head, resulting in a Saint fumble recovery deep in Bears' territory. At precisely that moment, the 2002 Bears' hopes for consecutive playoff appearances ended.

After that week three loss, the Bears would not win another game until an overtime victory over lowly Detroit on November 24 th. The eight-game slide matched the team's record for most consecutive losses, set in 1978. The team's major problems were threefold: injuries, personnel decisions made at the end of 2001, and the seemingly stubborn nature of Jauron. That season, the Bears returned most of their starters from the 2001 playoff club, with a few key exceptions. Defensive backs Walt Harris and Tony Parrish were not re-signed, while the team heaped major dollars on cornerbacks R.W. McQuarters and Jerry Azumah, and defensive tackle Bryan Robinson. The trio had solid moments, but overall didn't play up to expectations.

On offense, left tackle Blake Brockermeyer was released in a salary cap move. Angelo felt that 2001 fifth-round pick Bernard Robertson would step right in for the veteran, but was benched by mid-season. Then came the injuries. Receiver Terrell, linemen Rex Tucker and Marc Colombo, running back Thomas, quarterbacks Miller and Chris Chandler, linebacker Warrick Holdman, McQuarters, Robinson, Washington, and Daniels were all lost before the season concluded. So comical had the Bears' starting lineup become that in the final game vs.

the Super Bowl champion Tampa Bay Buccaneers, young quarterback Henry Burris started and threw four interceptions and no touchdowns. The Bears were blanked 15-0 in the finale. After the team went eleven years without being shut out, they had now scored zero points three times during the Jauron era. The 2002 Bears finished 4-12, the third time in the last six seasons they had done so.

The day before the 2003 draft, Angelo traded the Bears' fourth overall pick in the first round to the New York Jets for their 13th and 22nd selections. In the first multiple first-round pick draft the Bears had since 1989, they took defensive end Michael Haynes and quarterback Rex Grossman. In the remaining rounds of that draft, considered by some to be the best in the NFL, Angelo selected cornerback Charles Tillman, linebackers Lance Briggs and Joe Odom, receivers Bobby Wade and Justin Gage, running back Brock Forsey, and several others.

Large ties to the past were severed when the team released long-time players Jim Miller and James "Big Cat" Williams in the offseason. Looking to provide sparks on the offense, Angelo signed quarterback Kordell Stewart and tight end Desmond Clark from the free agent market.

Days before the start of the 2003 campaign, Angelo declared that anything short of a playoff appearance that season would be a disappointment, and most considered this writing on the wall for Jauron and his staff. The Bears started 1-5 on the season. Most blame for this start focused squarely on the shoulders of offensive coordinator John Shoop. At 34, Shoop was the league's youngest offensive leader, and always received the full support of his head coach. But Shoop had been blasted by fans and the media for his conservative playcalling since the 2001 season. Despite ranking near the bottom of the league's statistics for three seasons, Jauron refused to acknowledge Shoop's performance was a problem, often stating that since the Bears had won 13 games under Shoop in 2001, he was a capable leader of the offense.

Particularly maddening in 2003 were some of the plays Shoop designed specifically for quarterback Stewart. At times, the scheme looked like it was emulating Nebraska's college offense, with Stewart running the option or quarterback draws straight into NFL linebackers. The low point of the season occurred on September 29th with the opening of "new" Soldier Field. The Bears had lobbied to host the Green Bay Packers on Monday Night Football in their inaugural game, and were slaughtered 38-23 in a contest that wasn't as close as the score indicated.

The team recovered to win five of their last seven games behind an improved defense and the play of rookies Tillman, Wade, Gage, and Briggs. After being eliminated from playoff consideration in week 13, the Bears started their rookie quarterback Grossman. The confident Indiana native responded with two solid performances before an injury took him out of the finale, a 31-3 pasting at Kansas City.

Jauron's future was not at all sealed, based on his team's strong finish, but in the end Angelo announced his firing on December 29th. Jauron had started his coaching career with a home win over the Chiefs and ended it with a loss in Kansas City. Along the way fans suffered through four agonizing seasons and enjoyed one that rivaled any other for excitement. Jauron was known as the consummate player's coach that practiced lightly in training camp, and was highly regarded throughout the league. But according to Angelo, the coach was dismissed on record alone, which was 35-45 overall. In fairness to the difficult task Jauron faced, the coach worked with three different "bosses" (McCaskey, Phillips, and Angelo), coexisted with two different personnel men (Hatley and Angelo), and suffered through 23 changes of his starting quarterback in five seasons.

In January 2004, Angelo embarked on his first crusade to hire his own head coach. Speculation centered on Nick Saban, a longtime friend and head coach of the NCAA champion Louisiana State Tigers. After denying the pursuit, it was finally revealed that Angelo met Saban in Baton Rouge, where the college coach turned the Bears' offer down. A few days later, St. Louis defensive coordinator Lovie Smith was named the thirteenth coach in Chicago Bears history.

In his first month on the job, Smith hired former Bear linebacker Ron Rivera as defensive coordinator and Kansas City quarterback coach Terry Shea as offensive coordinator. From his

very first speech with the press, Smith announced his intention to bring to Chicago St. Louis' cover-two defense, and a hybrid of the high-scoring Ram and Kansas City Chief offensive schemes. Both systems have proven to be successful in the NFL, unlike the vaguely-defined systems of their predecessors. To give power and speed to the new offense, Angelo struck quickly in free agency, signing running back Thomas Jones, backup quarterback Jonathan Quinn, tackle John Tait, and guard Ruben Brown.

After inheriting and working with a coach hired by his Grandfather for ten years, in 1993 Bears CEO Michael McCaskey cleaned house and hired his own coach and personnel man in Dave Wannstedt. Wannstedt had early success with many players left over from the Ditka era, but once his own personnel moves filled the core of the team, the Bears performed at a lower level than at any point in their history.

Frustrated by four losing seasons in six, McCaskey and his family tried to hire former Bear coach Dave McGinnis to replace Wannstedt in 1999, but were rebuffed. They ended up hiring their third choice in Dick Jauron, just days before Ted Phillips replaced McCaskey as CEO of the organization. During Jauron's seasons as head coach, he first worked for one team president that didn't hire him, then for a general manager that probably didn't want him. After four more losing seasons, Jauron was fired following the 2003 campaign.

With the exception of the unsuccessful Wannstedt era, the Bears will enter 2004 for the first time since the late 1970s with a CEO, General Manager, and Head Coach all acting with the same agenda. The team's fans have followed their heroes of autumn from Wrigley Field to Soldier Field to Champaign and now the league's newest stadium. Every Bears game has sold out since the 1983 season. Thousands of dedicated followers pack not only the stadium, but also the acres around the lakefront den to "tailgate" before each game, despite constantly changing rules and regulations to enjoy gameday.

The Bear fan is an ever-optimistic breed, and to the future they look for a rejuvenation of the club they have followed for 85 seasons.

The Bears defense bounced back in 1993, led by young defenders such as Alonzo Spellman (No. 90), Chris Zorich (No. 97), and Tim Ryan (No. 99). Steve McMichael (No. 76) looks on from the sideline in his 13th and last season with the team. (Photo courtesy Bob Baer.)

By 1995, the Bears had built another strong offensive line to protect quarterback Erik Kramer. Starting 16 games that year were Andy Heck, Todd Perry, Jerry Fontenot, Jay Leeuwenberg, and James "Big Cat" Williams. (Photo courtesy Bob Baer.)

The Bears braintrust (Michael McCaskey, left, and Dave Wannstedt) speak with Giants coach Dan Reeves prior to the team's 1994 preseason meeting. (Photo courtesy Bob Baer.)

Bears Head Coach Dick Jauron (left) and his defensive coordinator Greg Blache stand at attention for the national anthem prior to a 2002 game at Memorial Stadium in Champaign, Ilinois. Jauron was hired as the Bears' twelfth head coach in 1999, and he brought Blache onto his staff along with offensive coordinator Gary Crowton. The offensive coordinator would later be replaced by John Shoop. To the end, Jauron was fiercely loyal to his assistant coaches, despite the perception that they were partially to blame for his poor record. Jauron and his staff were dismissed following the 2003 season. (Photo courtesy Mike Proebsting.)

Rookie receiver David Terrell outleaps a San Francisco defender to narrow the 49ers' lead to two points during this 2001 game. During that contest, the Bears trailed by as much as 17 points late in the second half. But thanks to two touchdown passes thrown to Terrell from Shane Matthews, the Bears rallied to win 37-31 in overtime. The contest became the shortest overtime game in history when safety Mike Brown returned an interception for a touchdown on the first play of sudden death. The victory gave the Bears a 5-1 record for the 2001 season. (Photo courtesy Mike Proebsting.)

Quarterback Jim Miller hands off to 2001 NFL Rookie of the Year Anthony "A-Train" Thomas. Miller joined the Bears as a free agent during the 1998 season, and was not expected to make the final roster the following season. He responded with several 300-plus yard games in 1999. He was nagged by persistent injuries throughout his career, and was released following the 2002 season. Miller's steady play helped guide the Bears to a 13-3 season in 2001. (Photo courtesy Mike Proebsting.)

A large—no pun intended—reason for the Bears' 2001 success was the play of their defense, anchored by massive defensive tackles Ted Washington (No. 92) and Keith Traylor (No. 94). Also pictured (left to right) are LBs Warrick Holdman (No. 53) and Brian Urlacher (No. 54) and DEs Phillip Daniels (No. 93) and Bryan Robinson (No. 98). (Photo courtesy Mike Proebsting.)

Brian Urlacher, Jerry Azumah, and others gang-tackle Viking running back Moe Williams during the 2002 opener. The Bears won this game on a late touchdown pass. (Photo © Todd Buchanan.)

Bear linebacker Roosevelt Colvin dances with Minnesota quarterback Daunte Culpepper. Colvin delivered a pass-rushing threat for the Bears from 1999 to 2002, but was not re-signed due to salary cap limitations. (Photo © Todd Buchanan.)

Cornerback Charles Tillman was selected by the Bears with their second-round pick in the 2003 draft from Louisana-Lafayette. Tillman was rated as a third or fourth-round prospect by most analysts, but Bears General Manager Jerry Angelo and his staff selected him much earlier. In 2003, Tillman cracked the starting lineup by the fifth game of the season, and was named the NFL's Defensive Rookie of the Year by *Football Digest*. Pictured here is the biggest play of Tillman's season, when he stole a pass away from Minnesota's Randy Moss to preserve a 13-10 Bears victory. (Photo courtesy Mike Proebsting.)

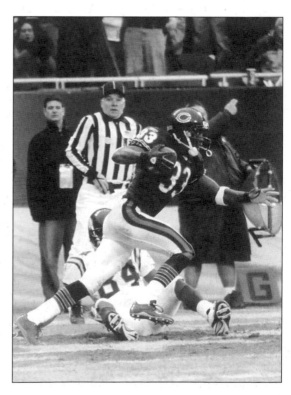

Bears All-Pro linebacker Brian Urlacher has a word with Green Bay quarterback Brett Favre during the teams' 2002 meeting in Champaign, Illinois, on Monday Night Football. While Urlacher has gotten in his licks on Favre—he sacked and intercepted him in a 2001 game at Green Bay—Favre has been the consummate "Bear Killer" in his 12-year Packer career. Since Favre became their starting quarterback in 1992, Green Bay has defeated the Bears 20 times in the 24 meetings. Notable during this game is that the Bears wore navy pants with navy jerseys for the first and only time in their history. (Photo courtesy Mike Proebsting.)

The Bears have struggled to find a dependable and durable starting quarterback since Jim McMahon left the team prior to the 1989 season. They drafted highly-touted Cade McNown in 1999, but the UCLA product disappointed fans and teammates with his attitude and play. McNown was traded prior to the 2001 season. In 2003, the Bears invested another first-round pick in a quarterback, Rex Grossman, pictured here, from the University of Florida. Grossman waited in the wings for most of his rookie year until he started the final three games of the season. Hopes are high for Grossman, as he seemed to take command of the offense better than any other quarterback on the roster. He enters the 2004 season as the unquestioned starter. (Photo courtesy Mike Proebsting.)

"New" Soldier Field opened on September 29, 2003, with a Monday Night Football matchup between the Bears and Packers. This photo was taken the following week as Chicago hosted the Oakland Raiders, which was the first day game at the stadium. The coliseum was completely gutted in the inside, and a state-of-the-art stadium was built within its 80-year-old shell. (Photo courtesy Keith Schuth.)

Fans have congregated before Bears games to "tailgate" from the Wrigley Field era to the present day at "new" Soldier Field. These fans are gathering on the lakefront prior to the Bears' 2002 playoff game versus Philadelphia. (Photo by Roy Taylor.)

"Bear fever" in Chicago hit a new level in 2001, as fans celebrated the teams' first division championship since the Mike Ditka era. On this day, however, the Bears lost their first of two games against Green Bay at Soldier Field. (Photo courtesy Mike Proebsting.)

These fans can't help proclaiming their disdain for Chicago's bitter rival from Wisconsin. The Bears lead the overall series between the two teams by a margin of 84-77-6 (through the 2003 season), which is the longest rivalry in the NFL. (Photo courtesy Mike Proebsting.)